Clayworks in Art Therapy

of related interest

Art as Therapy
Collected Papers
Edith Kramer
ISBN 1 85302 902 5

Studio Art Therapy
Cultivating the Artist Identity in the Art Therapist
Catherine Hyland Moon
ISBN 1 85302 814 2

Art Therapy with Children on the Autistic Spectrum
Beyond Words
Kathy Evans and Janek Dubowski
ISBN 1 85302 825 8

Contemporary Art Therapy with Adolescents
Shirley Riley
ISBN 1 85302 637 9 pb
ISBN 1 85302 636 0 hb

Medical Art Therapy with Children
Edited by Cathy Malchiodi
ISBN 1 85302 677 8 pb
ISBN 1 85302 676 X hb

J. L. Sullivan

Clayworks in Art Therapy

Plying the Sacred Circle

David Henley

Jessica Kingsley Publishers
London and Philadelphia

First published in the United Kingdom in 2002
by Jessica Kingsley Publishers Ltd
116 Pentonville Road
London N1 9JB, England
and
325 Chestnut Street
Philadelphia, PA 19106, USA

www.jkp.com

Copyright © David Henley 2002

Library of Congress Cataloging in Publication Data
A CIP catalog record for this book is available from the Library of Congress

British Library Cataloguing in Publication Data
A CIP catalogue record for this book is available from the British Library

ISBN 1 84310 706 6

Printed and Bound in Great Britain by
Athenaeum Press, Gateshead, Tyne and Wear

Contents

Contents

For Dawn Adele

One particle of dust is raised and the earth lies therein:
one flower blooms and the universe rises with it.

Anonymous haiku

Acknowledgments

I am indebted to many individuals who, over the years, have shaped my thinking and supported my work, both as an artist and as a therapist. Dawn Henley, wife, mother and art educator, inspired the original explorations into clay during my early vulnerable years of undergraduate fine art study. My children Kyle and Kim Henley Malito have long endured my late-night sessions in the studio, and continue to support my identity as an artist/father. As my first potter mentors, David Jones and Sy Shames, left an indelible mark upon my development as a potter, I came away with a respect for the historical legacy and expressive potential of the medium. I am indebted to long-time mentor, friend and colleague Edith Kramer, whose clarity of thinking has been an invaluable source of criticism and support during this project. Partners in Ethan Brand Studios, Tim Ryan, Michael Jennings and Michael Silbernagel, were all an early source of inspiration and illumination during the early lean years of artistic struggle. James Pruznick and Lou Johnson continue to be both professional colleagues and dear friends whose enthusiasm for professional and creative exploration continues to this day. My colleagues at Long Island University, Professors Christine Kerr, Frank Olt, Barry Stern, and Dean Lynn Croton, have been important influences on and supporters of this project. Several gifted individuals who have graduated from the art therapy program at Long Island University have consented to my use of their material – to them I am grateful: Michele Corker, David Pitts, Erich Preis, Denise Spitaliere, and Monika Tang, all of whom are now successfully practicing in the field as artists and technicians. Thanks also to art therapist Sara Glenn for her permission to use a piece of her art in the text. My clinical supervisor Dr George Hecht has been especially supportive of my art therapy work within his psychiatric practice. Other professionals who have long influenced my work are: Pat Allen, Ellen Dissanayake, Debbie Good, Carol Greene, Katherine Jackson, Pat Jennings, Bruce and Cathy Moon, and my sister Kathleen Peterson, whose love of educating children has long been a source of inspiration. I am grateful to

Frank Goryl A.T.R. for his numerous contributions to the text. I am also indebted to Joe and Lorraine Hallgring, both of whom have witnessed and endured my earliest struggles as a husband and artist. Frantic midnight consultations with Joe saved many a kiln-fire disaster over the years. I wish also to thank Jessica Kingsley for her enthusiastic support for this project, as well as her patience as I fuss over the editing and production values of the book. Of course, this project would not have been possible without all the children who, for over twenty years, have continued to teach me more than I could ever learn. Their parents, many of whom have consented to include their child's case material in this text, have also shown extraordinary courage and commitment. And finally to all the potters and clayworkers who have long toiled, often anonymously, throughout history – they and all the children are the heroes of this book.

Preface

I have long been fascinated with the hands of potters. Powerful hands, rough hewn from their labor, ply the clay with exacting force and an intuition that often seems miraculous. In watching the masters work, whether in person or on film – Taekezu, Temple, Volkus, Hamada – I often marvel at how effortlessly the clay moves under their hands. Such extraordinary facility cannot be taken for granted. As a young art student, I lost much of the function in my hands due to paralysis, which has since made my life as a potter all the more challenging. Thus this capacity – to possess the intrinsic manual strength to exert such powerful, controlled force – still remains a highly charged issue for me, as I write about the children and young adults who must also cope with weakness and fragility.

As a child art therapist, I am of course also fascinated by the hand as one of the pivotal sensory centers of the young child, one that directly furthers creative exploration throughout one's life. In a poem I once wrote:

> Our longing for a sense of place
> is made special by the new-born hand
> that plies the soft folds and aureoles
> of mandalas that beckon us still.
> Palms and lips model forth our sustenance
> conjuring the shining face of mother…
> an apparition hovering above –
> it is life's first image.

> (Henley 1999a)

During our most formative experiences from birth onward, the hands (and mouth) become the centers of organization for perceiving and bonding to the world around us. As we revel in the warmth and comfort that such contact provides, we set the stage for creative explorations that

persist throughout the rest of our adult lives. My friend Ellen Dissanayake (1999) notes that early paleoanthropologists chose for the earliest fossil representative of the genus *Homo* to be designated as truly human the adjective *Habilis*, which means "hand" or "able". By naming this species in this way they acknowledged the crucial distinguishing capacity it bestowed: that to be human is to be inseparable from the ability to create (hence Dissanayake's renaming our species "*Homo Aestheticus*" (1992)). The pleasure that comes with "making things special" (as Dissanayake defines creativity) is an in-born, hard-wired capacity that exists within us for good reason: our predisposition to create by hand not only enhanced the physical, emotional, and spiritual dimensions of our lives – it has long improved our chances for survival. To this day, in almost every culture, there are no products of human endeavor more valuable than our most prized works of art.

However, the use of hands as an instrument of creativity in contemporary culture is under peril as never before. Dissanayake writes that a chasm has developed between the need to work with our hands and the easy conveniences that require only the pushing of buttons or the clicking of a mouse. Unlike our forefathers, who were often well-versed in creating things of function and beauty from their own hands, such craft-work has all but atrophied. The time-honored practice of building a stool and handing it down as an heirloom has all but died out in our materialistic culture. Only in the poorest cultures do we see children still making their own toys (probably more out of necessity than anything else). Communities that were founded on the idea of joyfully dividing their labor into different craft areas such as pottery would seem very quaint to us today. To experience this form of "creative community", we must visit isolated developing countries, or "museum" communities such as the Shakers; or pretend in costumed Williamsburg. Those craft groups that do exist are generally linked to recreation or entertainment, rather than being truly integral to a community.

Creativity in children has especially suffered under the guise of modern technology, which precludes the necessity to make things for oneself. Kramer *et al.* (1997) writes that the advent of computer and video games has brought about fundamental changes in children's behavior. Like the young of all higher species, children are innately curious,

playful, endowed with inexhaustible energies, eager for life. I have come to regard video and computer games as an intractable addiction in the young. Among children with special needs in particular, such activity contributes little to the child except short-term pacification. Kramer asks: What are the seductive powers of these games that they can override children's innate appetites for action, adventure, companionship of peers, and put out of commission their inexhaustible energies? (Kramer *et al.* 1997, p.108) To answer Kramer's question is to confront the malaise of an entire generation which has few creative outlets at its disposal to act decisively and vigorously. Thus, when I come bearing gifts of art materials like the potter's wheel, which of course encourages robust activity, children invariably respond. As we shall see throughout the case material, there is a deep archetypal attraction to clay that transcends the contemporary child's seemingly endless appetite for novelty. Its capacity for inducing rich sensory experiences can sustain the attention of even the most materially spoiled, hyperactive or disturbed individual. The malleable, tactile quality of clay invites immediate manipulation. When clay is available to touch, to hold and squeeze, the hand comes to life. Before long, we can count on something special being created.

The children and young adults described in this volume almost all have trouble regulating their impulses. Most cannot easily engage in productive play with peers, or do not possess the self-esteem to take pride in their efforts. By using clay with these children and teens, I have sought to reawaken their senses and spark a creative spirit that is surely latent within. To witness and write about the children from my own practice and to hear of others from across the country has been a moving, often humbling experience. I have collected anecdotes and case vignettes from many art therapists, art teachers, and artists-in-residence from far and wide. I hope that their stories, as well as my own, will energize other art therapists to consider clay as an integral part of the therapeutic curriculum, despite the medium's technical and logistical demands. My hope is that we can come to appreciate the creative spirits that lie within even the most damaged children, and can reawaken this spirit through the magic of clay.

David Henley,
New York City

Note on How to Use the Book

As this is a text essentially psychodynamic in orientation, it has been a challenge to organize the case material according to clean divisions of content. Those practicing in this way know that in one case alone, a myriad of technical concerns, therapeutic issues, behavioral responses, and various interventions may be threaded throughout the narrative. How to extricate each content area for the reader's efficient use remains a problem that is probably unsolved in this volume. The sub-headings remain somewhat amorphous, only hinting at the rich dynamics within. For readers such as students or those who require quick references on a given issue or population, the index should provide the needed quick access to concepts or other reference material. For those unfamiliar with the claywork terminology a glossary is provided which defines most of the italicized words in the text. Otherwise the case material is written up in organic fashion – it unfolds its exploration of issues, techniques, styles of working, media adaptations and most of all, rich therapeutic outcomes – all of which have been born by the hand in all its drama and glory.

1. Devising the Claywork Experience

One summer day, a group of children attending a therapeutic day camp assembled by a sandy lake-shore for their group art therapy experience. As usual, I began the session by showing the children some works by other artists. Because it was an outdoor session, I chose to show works that utilize nature as a concept and medium. Of particular appeal was the work of Andy Goldsworthy, whose delicate constructions of sewn leaves, icicle archways, and spirals of scratched and cracked river stones (Figure 1) left the children awe-struck. They marveled at how such humble found materials could be formed into exquisite designs. Along with discussing the beauty of these forms, the conceptual aspects of the art were also explored, including the virtues that embody Goldsworthy's work: being in harmony with and respectful of nature, maintaining attentiveness and patience, being resourceful and ingenious in our approach to materials and ideas. Each of these values became the basis for exploring both imagery and issues during the children's group therapy – for it was no coincidence that many of the virtues discussed were often lacking in these bright youngsters with ADHD. Thus, our session was fueled by the example of a fellow artist, whose exploration of ideas, emotions and values stood as a model for the children's own therapeutic and creative journey.

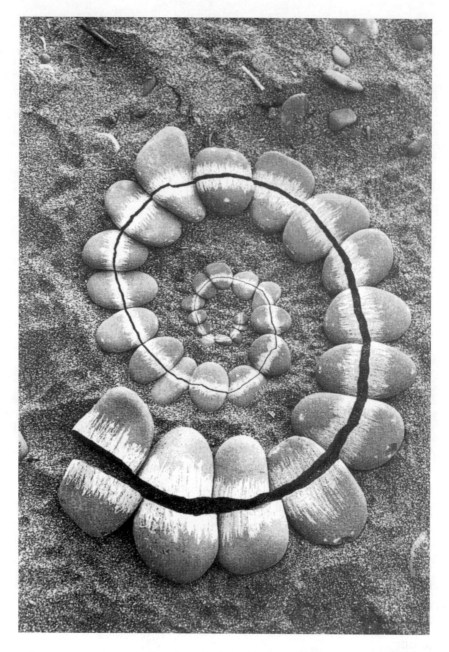

Figure 1: By using examples of art made by artists (in this case "Broken Pebbles" (1985) by noted sculptor Andy Goldsworthy) children may then model artistic behaviors, while projecting their own salient concerns through the art process (Goldsworthy 1990).

Struggles with process and product

In my approach to art therapy, emphasis is placed upon providing a quality art experience that may be inherently therapeutic. Rather than focusing upon the children's deficit behaviors or discussing therapeutic issues, they were instead aroused to make art from the abundant natural materials that scattered the lake-shore. Using Goldsworthy as an example, the children were encouraged truly to "see" the beauty in the elements around them: the multi-colored leaf-litter and grass, the textured driftwood, the organic forms of the scattered rock, and tactile quality of the mud – all of which could be transformed as a medium of self-expression. Because the children had known each other for over four weeks of camp, I decided to have them begin to work in dyads in the hope that they would interact cooperatively. They were formed into pairs and encouraged to work together to scavenge materials and sculpt in a collaborative effort.

One pair consisted of a spirited yet gentle boy of ten whose impulsive behavior and hyperactivity often created conflict with his peers. His partner was an eleven-year-old girl who was selectively mute due to severe post-traumatic stress. A refugee to the United States, she and her parents had barely survived a bloody guerrilla insurgency in the Philippines in which several of her family had died. Usually silent and remote, she was among our most fragile, yet one of the more creative, children attending the therapeutic camp.

Faced with being partners, both children found such forced intimacy to be awkward if not threatening. As was expected, there was only uncomfortable silence at first and little interaction between the two children. Each sat alone in his and her own space, scraping at the stones below their feet, staring uneasily at the gravely shore. After a while I happened by and paused to stack a few little stones in a small circular design, which I embellished with a few sticks and pointy leaves from a gingko tree. As much as I tried, the materials would not stay together. Observing my (intentional) incompetence, the boy took over, and after several tries, he managed to balance these few small stones. This small success eventually led to his stacking more rocks of different sizes. His play then evolved into work as the rocks grew into formations reminiscent of Goldsworthy's stone dolmens. I noticed that, much of the time,

our mute child would closely observe this activity from afar as she paced the shore-line. She too began to collect some stones which, surprisingly, she brought to her partner's work area. It was interesting to note that she would only deposit the rocks near his building site, carefully avoiding direct interaction. She would then silently withdraw back to the lake-shore. He accepted these "silent offerings" and began to include them in a tapered spire. I quietly urged him to call out to her by name, requesting more contributions of rocks in certain sizes and shapes. This intervention probably made her all the more reticent, yet eventually, in her own time, she began to bring more material, inching ever closer to her partner's work-site.

After these few tentative interactions their collaborative work began slowly to build in momentum. Groupings of small spires began to pop up around their feet. She then began to stack her own small towers, even accepting his occasional contributions of colorful stones. After thirty

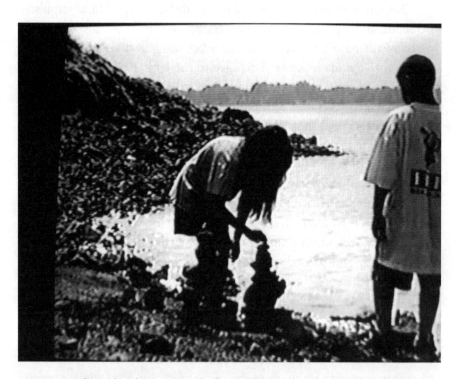

Figure 2: This video clip captures the first collaborative moments of two children creating stone "dolmens" along a lake-shore.

minutes of parallel work, I noticed that, almost miraculously, both children were busily collaborating on each other's pieces (Figure 2).

However adversity soon began to test the pair for, as the rocks grew in height, they became top-heavy and unstable. As more rock was added, many of the top stones began to topple. I noticed the girl, paused in a moment of frustration, surveying the steep bank of the lake. There she noticed a seam of ocher-colored clay embedded into the shore-bank. To my surprise, she approached me and in the smallest voice and gesture asked permission to collect this clay. She then began to extract clumps of the sticky yellowish material, using a piece of looped wire hanger to cut the clay out of the bank. After some experimentation with her partner, they began to use the clay to mortar their rock-pieces together. After one tower reached their upper thigh level, they began work on its twin. Once both towers were complete, I noticed the girl pinching a small rounded element out of the clay. As an armature, she used a discarded fishing float (or bobber), which she then fitted on to the peak of the sculptures. Both children then stood back, looking over their work in satisfaction. I approached and commented that, with so many rocks littering the ground near their sculptures, they may wish to "formalize" the space by doing some raking around the base. The boy took up the steel rake and pulled a bulls-eye circle around the twin sculptures. The multiple grooves left by the rake's tines reminded me of the raked designs used so prominently in Zen gardens. In the Zen aesthetic, such raked textures in the sand are intended as both a spiritual and an artistic element. The concentric grooved lines impart a resonating quality to the composition. I mentioned this to the children, that in Japanese gardens, raked designs would symbolize a stone being thrown into the calm waters of a pond. The force of the splash would send rippling lines expanding concentrically from the center, suggesting a sense of infinity and peace to this sacred space. Each took this in with interest but without comment.

Soon a crowd gathered to admire their works, whose innovative technique allowed them to work on a larger scale than anything else on the beach. The video sequence of this scene shows the children at work and their dolmens standing back-lit against the flawless blue sky (Figure 3). Their silhouettes seemed to stand in dramatic repose as the lake waters gently lapped near the twin rock pillars.

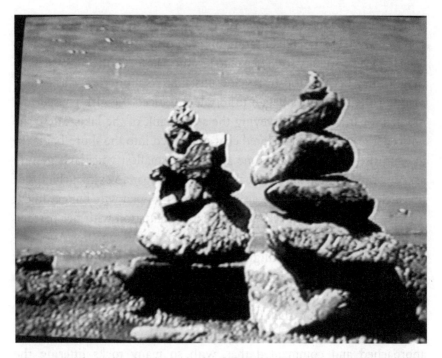

Figure 3: This video clip shows the finished spires of stone and clay standing in repose during the closing "critique" of the session.

Reflection and dialogue

After some moments of relaxing and enjoying our pieces in such a lovely setting, I began the final phase of the session, which is devoted to reflection and closure. I asked the artists if they wished to comment on their work or the process of collaboration. This question was meant to spark a dialogue between the artists and their group. Little was initially volunteered. After long pauses of silence, comments slowly began. A child from the admiring crowd asked the two artists how they were able to "work so tall." Their pieces appeared so stable while others seemed to be in a state of collapse. The boy proudly explained that his partner had made a crucial discovery: "She found some clay in the bank and we used it to glue the rocks together!" At this point I drew upon his comment to introduce a metaphor into the critique. "So, it's the clay that bound the work together?" "Yes," the crowd yelled in unison. "How then did the clay contribute to their working together on such a difficult project?" (knowing

that this question would necessitate a leap from the literal to the abstract). Another child in the group seemed to grasp the metaphor and responded: "The clay kept them from giving up!" Reframing his response, I then asked: "The clay cemented their ties as well as their efforts?" "Yes," said the child, "the clay kept the two working together and enabled the towers to become so tall and amazing." Another commented: "Yeah, with that clay those towers will last." Moving further into metaphor I asked: "So, if clay binds the work together, what provides the glue for a successful partnership?" "Patience," one offered. "Don't give up," yelled out another. "Figuring out new ways of working, like that English artist!" contributed the boy who made the tower. "Are there any virtues in this work, like those we discussed in Goldsworthy's art?" A resounding "yes" erupted from the group. Then to our amazement, it was our mute child who then found her voice which was barely audible above the blustery sea-wind. We all leaned in, straining to hear her rare spoken words. She whispered: "Finding the clay helped us make something beautiful together." This lovely statement seemed to sum up our experience on the beach. Struggle had given way to triumph: images were created, challenging issues were engaged, new relationships had formed, and two artists had found their voice.

The story of clay

As the session drew to a close, several children lingered while we cleaned up and collected the tools. One boy began asking some casual questions regarding the nature of the clay itself. "What about this yellow clay?" one boy asked, juggling an arm full of rakes and work gloves. "Where did it come from?" "Was there a factory once on this spot?" another one of the girls asked. "No," I smiled. We then found ourselves sitting down once more along the beach, as our schedule and other time commitments were dispensed with to attend to these all-important matters.

I began to tell them the story of clay, about the primal forces of geological change, of how, over millions of years, the constant action of water and erosion upon the lake-shore began slowly to break apart the beach-rocks into tiny particles. After countless cycles of freezing, thawing, and being bombarded with wind, sand and water, the rocks

were slowly ground to bits. Eventually layers of this disintegrated rock mixed with organic materials such as rotted leaves and settled into the lake-bed, where they were washed time and again. For millions of years these particles melded together, awaiting the sculptor's hands (Rhodes 1973, 2000). For thousands of years, potters collected this material, making art and creating myths about the miracles of claywork. I mentioned the Bible, which tells us that clay even played a part in our own creation: "The Lord God formed the man out of the clay of the earth and breathed in to his nostrils the breath of life and the man became a living being" (Gen. 2: 7, cited from Goryl 2000). "Scientists seem to agree with this ancient myth," I stated. Some consider clay to be part of the "primordial soup" in which original life was created. The group spurred me on to explain: "The clay acted as a 'silicon conductor' which is thought to have channeled lightning bolts through a mixture of gases that led to amino acids and eventually the organic molecules that eventually became us!" "Clay is like a computer chip?" one boy asked excitedly. "Perhaps," I respond, talking out of my league. "Clay is a powerful chemical engine: its structure is made up of silicon and aluminum whose crystals are layered in flat sheets, much like the shape of today's most powerful superconductors" (cited from Gleick 1987).

As we talked casually about clay and the origins of life on earth, I passed out a squishy blob of the yellowish river clay to connect the geo-chemical/biblical lesson to the material at hand. Staying "hands-on" also kept some of the more hyper or distracted children physically engaged during discussion. As we talked, they squeezed and formed the clay into a constant stream of ever-changing forms. As these forms took shape, another child asked: "How does the clay hold its shape?" "This is still one of the mysteries of science," I answered, "no one is really sure. But remember how clay crystals are shaped like other silicon conductors? This means that the flattened shape of clay particles is plate-like in form. The slightly indented finely-textured particles become suctioned together when mixed with water." I gave them an example: "Has anyone ever held a deck of wet playing cards or left a comic book out in the rain?" "The paper sticks together!" shouted the group in unison. "Yes," I answered, "when mixed with water the clay particles will adhere like paper, even when squished and bent into shapes." "What about the color,

is it paint?" another asked. I explained that there are different minerals present in these particles, such as iron oxide, which gives most of the earth a range of brownish tones. These shades can range from black, to tan, to red, to reddish brown, as well as the brilliant ocher yellow found in our river bank.

As our discussion finally ran its course, I had to promise that we would return to our discovery on the beach. For the rest of the summer, the children would constantly request mining expeditions to "their" vein of clay as part of their camp activities. Our excavations yielded enough material for a myriad of creative uses throughout this memorable summer.

2. Methodology

This case vignette highlights the dynamic, even poetic quality of clay as a therapeutic, educational and expressive medium. Yet it is not enough that our anecdotes celebrate our clients' self-discovery and creative expression. Human drama aside, there is a methodology buried within this modest summer art project and casual musings. These are as empirical and systematic as any in the behavioral sciences. Thus the methodology at work in this project can serve as a model for all others to follow. Its method provides history, structure, techniques, and aesthetics, as well as those interventions that brought these images into being.

The methodology used in this project and, indeed, throughout the rest of the text is simple in design with just a few basic tenets. It begins by the art therapist's knowing his or her material, its art history and its expressive/aesthetic possibilities. Only then can we realize the medium's full potential for eliciting therapeutic outcomes. This we learn partly from our training and own continued practice as artists. Our commitment to working in the studio and the art world at large can only enrich the outcomes elicited during our work with clients. As we ourselves struggle with material, technique and style, we develop a greater sense of empathy when our clients wage these same battles during their own therapy. The method then celebrates the "artist as therapist" as one who has mastery over the process and thus can model those behaviors which are therapeutic and expressive for the client.

Assessing client need

Assessment is the next important element in this method of claywork art therapy. I am not so much referring to projectives or other forms of psychological testing, which I see as being within the realm of the psychologist, but the process of assessing clients' needs from moment to moment before, during, and after the session. Assessment takes different forms: we evaluate the clients' readiness to use certain materials and art processes; we assess their potential and limitations and adapt the projects accordingly; we are sensitive to their issues, and especially the quality of defenses the clients employ. Sound assessment ensures that we anticipate the emotional risks of each stimulus and project. We take care that art experiences are developmentally accessible, culturally appropriate and will do no physical harm.

Assessments assist the art therapist in formulating appropriate therapeutic activities in which *achievable objectives* can be established. These objectives may guide our interventions, which facilitate the art therapy process and thus elicit *therapeutic outcomes*. Therapeutic outcomes are the culminating product of art therapy: they represent everything accomplished or not accomplished during the session. Because outcomes are measurable through both quantifiable and qualitative analysis, the efficacy of our therapeutic work can be clearly established in a systematic way. These empirical data can then be used for whatever purpose: supervision, research, teaching, as well as authoring texts of the subject.

Devising and defending therapeutic interventions

Sound assessment leads to sound interventions which facilitate the creative and therapeutic process. For the purpose of our methodology, therapeutic interventions consist of anything that the therapist says or does (or does not say or do) before, during or after the session. There are few instances where anything the therapist does or says in our sessions is arbitrary or meaningless – intentionality rules the form and content of our interventions. We must be highly aware of the potential impact of our interventions upon the client and be prepared to analyze them as part of the therapeutic outcome. The efficacy of our interventions can then be explored during our own clinical supervision.

Throughout the text we shall encounter interventions in different guises. They may take the form of verbal interventions which seek to explain, reframe, process, set limits, or cheer on those individuals whose motivations begin to wane during the process. Other interventions fall under the category of media adaptations, which Kramer (1986) has dubbed "Third Hand Interventions." These entail the therapist's lending a hand to effect positive changes in the form or content of the client's art or behavior, through direct interaction during the client's art process. For instance, we may assess that a client would benefit from a change in medium, such as the obsessive compulsive girl who could not handle the messiness of red clay and therefore required a switch to clean white porcelain. Techniques and tool use may also have therapeutic implications and require intervention. One young man with psychotic and aggressive tendencies needed to have all "sharps" (such as cut-off needles) removed from the tool box to ensure his impulsive behavior would not have dire consequences. Another boy needed modifications in the process of rolling out slabs of clay. A "jig" device was needed to ensure that an even thickness could be automatically created, so that his slabs would not tear or crack, and thus precipitate a tantrum (see Chapter 12). Modifications may also be made in the work space, whether we have the clients work at solitary desks, group tables or the wide open spaces of a lake-front beach. Even the quality of the work surface may elicit outcomes. One art therapy intern had her children rolling slabs on loose sheets of primed canvas which often stuck fast to the clay, creating mass frustration. Switching to unprimed cotton duck-canvas which was stretched and stapled to a flat board allowed for easy, problem-free rolling. Any one of these changes may influence the style, scale, and other formal elements of design, which in turn directly impacts upon the quality of therapeutic outcomes.

"Third Hand" interventions also include suggestions or modifications of content. Content interventions include introducing clients to images from art history, contemporary art, commercial or popular media. In some instances we may probe the clients as to their favorite animal, their family make-up, the house they live in or the country they come from – any one of these may influence content in the work. An example of a content intervention is found in the opening vignette, where the work of

Goldsworthy was introduced as a stimulus prior to art-making. My task was to assess whether Goldsworthy's art was accessible and stimulating for children: was his art too provocative, too alien, too complex to emulate? Did it stir up highly charged issues which threatened to overwhelm delicate defenses? Or was his work neutral yet stimulating enough to have a productive effect upon the children's therapeutic art process? These and other questions must be addressed as part of our analysis of content interventions which impact upon the final outcomes.

The role of theory

Therapeutic outcomes are also influenced by the theoretical constructs that are employed by the therapist to implement interventions and interpret their data. Psychodynamic theory, object relations, child-centered art education, behaviorism, archetypal psychology, aesthetic inquiry, even spiritual considerations such as Zen Buddhism are all utilized in this text as a means of lending context and structure to the analysis. While theoretical constructs often reflect the training and orientation of the therapist, they should also be chosen for their relevance and applicability to the client's art or behavior. For instance, in the following analysis of the session described in the opening vignette, I will utilize several theoretical constructs that seemed to "fit" the experience. Lowenfeld's "child-centered" approach of providing motivations was used as a basis for arousing the children's creative fervor (1957). Object relations theory was utilized as a means of analyzing the quality of relating between peers with regard to their art and behavior (Winnicott 1965; Mahler, Pine, and Bergmann, 1975). Aesthetic issues are also addressed in the analysis using Kramer's criteria regarding the "quality in art" and its relationship to achieving sublimation (1971).

The rationale behind using any one particular approach lies in its relevance to clients' experience: does a particular phenomenon invite a specific approach? It is conceivable that other constructs such as archetypal psychology or cognitive theory might have been just as evocative and effective a means of analysis. Therefore it must also be noted that almost all theory-based interpretations are subjective in nature. Identical phenomena can be explained using any number of theoretical constructs.

To avoid the dogma that often plagues a lively intellectual discourse, the clinician should remain open to different systems of interpretation, so that analysis remains an expansive rather than a limiting process. As art therapy is in fact a "hybrid" discipline, the integration of multiple theories should come naturally to our methodology as an organic approach to the process.

Working with metaphor

Another element of the methodological emphasis is moving the client from literal, overt meanings to abstract or metaphorical reasoning. Metaphorical thinking can directly enhance the therapeutic and aesthetic aspects of the claywork experience. Kris (1952) considers metaphor from a psychoanalytic perspective as being a stimulus for a "functional regression", meaning that it allows the client access to the primary process and the unconscious. By tapping into unconscious domains, we may begin to address underlying causation of psychic conflict through a means that is in itself "imagistic". Such images may bypass the mind's censor and become fruitful points of departure for the free-associative process (Naumburg 1966, 1987).

Winner (1981) writes that metaphors are a more memorable way of capturing meaning than is literal language. She cites Aristotle's idea that metaphors are needed to express new insights. He wrote in the *Rhetoric* that metaphors enliven our ideas and feelings: "Liveliness is specially conveyed by metaphor and by the further power of surprising others … from metaphors, we get hold of something fresh" (Winner 1981).

The use of metaphor allowed for the exploration of the children's social difficulties and inappropriate behaviors without having to confront the issues directly or resort to the usual negative criticism (Henley 2000). Instead, social and personal issues were addressed by finding ways to create symbolic equivalents for their thoughts, feelings and behaviors. Working with metaphor as a means of problem solving is also meant to be playful, novel and enjoyable for the children. Because the therapeutic work in the opening vignette took place as part of the children's summer holiday, our interventions needed to be consistent with the setting.

Analyzing case outcomes

In order to provide the reader with an example of how interpretive analysis is employed in this text, I shall return to our opening vignette and begin to tease apart the three main objectives of this project: facilitating personal investment in the art process, eliciting aesthetically rich images useful for therapeutic discourse, while also enhancing the quality of social relating between clients. In this way, the reader might begin to anticipate the methods of analysis, the theoretical constructs and other elements that bring the case material to life in later chapters.

Motivation and investment

The initial phases of this group project have already been identified: to provide a stimulus to engage the children and raise their motivation levels to ensure robust participation and a sense of personal investment in the activity (Lowenfeld 1957). For children with attention deficits and related disorders, staying focused and maintaining interest levels on the task at hand is often a major presenting problem. This issue was addressed by exposing the children to other kindred artists, whose work with natural material, including clay, would stimulate creative exploration. Looking at Goldsworthy's art also provided a means of structuring the group therapy process without having directly to confront painful or raw issues as the theme. For example, a child could discuss Goldsworthy's process of "cracking rocks in half" as a metaphor for his or her own aggressive need to "crack heads." One child interpreted Goldsworthy's spiral of cracked rocks as a kind of "question-mark," which perhaps resonated for this child, given his need to question me incessantly during the activity. As an archetypal symbol of uncertainty, the question-mark interpretation enabled this child to find a metaphor for his perseveration and anxious questioning – rather than confronting this behavior deficit through direct verbal intervention. In this way issue-laden material was camouflaged and tempered by drawing upon the artist's novel techniques, style and concepts.

Discussing the artist's work went beyond a critique on formal elements of style and design. It also set the stage for eliciting therapeutic themes that could be useful in group therapy. As previously mentioned,

Goldsworthy's work brought forth a range of therapeutic metaphors that I adapted during the session. For example, patience is an issue for most of the ADHD children who participated. Like Goldsworthy, the children needed to be patient in order to find the right rocks and place them in balanced positions to avoid collapse. By using the example of other working artists I also sought to create an atmosphere of parity, one in which the client is not so set apart from the so-called normal artist just because of disability or pathology. By looking, thinking and discussing art as an integral part of our approach, we also embrace a major position espoused in this book: that studio-art is central to our work in art therapy.

Another motivational factor in this particular session was the medium itself. As we shall see in each of the following chapters, clay excites the senses. Found as a naturally occurring substance, its spontaneous utilization by the children added to an exciting atmosphere of self-discovery and adventure. By working out in the field and extracting the clay themselves, the children developed a sense of ownership and investment in the process. The fact that the discovery was made by the children and was not a product of adult intervention seemed to further such investment, as well as social bonding. The mute child's innovations with the clay-mortar set an example of self-reliance and problem solving that ignited the passions of all the other children. The contagious nature of this enthusiasm almost certainly enhanced both the productivity and cooperation in the group dynamic as a whole.

Aesthetic integrity

During this session, a number of evocative images were created that contributed to the richness of the therapeutic session. But many would ask, what difference does the "quality" of art matter in the therapeutic setting? Doesn't our mission require "unconditional acceptance" of the client's efforts regardless of aesthetic outcome? It was Kramer who first made the contention that aesthetic integrity is closely related to the quality of therapeutic outcomes (1971). Kramer identifies three criteria that constitute a working aesthetic that, once adapted, is consistent with the aims of art therapy. For Kramer, an image which evokes feeling, is created with a sense of inner truth, and economy of means, is referred to as formed

expression. Using these criteria and concepts we can then proceed to "critique" these works.

Leading a "therapeutic critique" is essentially a series of verbal interventions. The critic makes comments in a measured and thoughtful manner that anticipates the potential outcomes. Anyone who has taken part in a studio critique knows how devastating thoughtless or hostile criticisms can be. Thus in this application, critiques should promote empathy, support, reflection and an appreciation for what the clients had accomplished. Kramer's three criteria provide the client with a value system that recognizes that the richness and thoughtfulness of their imagery stands as a metaphor for their therapeutic progress, that the two go hand-in-hand.

In critiquing the dolmens created by our two children, I pointed out that feelings were evoked by way of the figurative treatment of the two stone towers. As I made a reference to the towers as being symbolic as a self-representation, the artists and audience could immediately begin to shift from literal to metaphorical meaning. From there I could ask whether any feeling was evoked by these two figures. One child responded that they "stood up proud." Yes, indeed. I pointed out how impressive these two forms were as they stood like sentinels, resolute, forming a commanding presence on the beach. Their spatial proximity was also evocative, as each stood in a solitary pose yet the dyad composition suggested a sense of intimacy (one that I will expand upon in the following section on attachment dynamics). Feeling states were also evoked in the use of material, as the children struggled to transform the hard, heavy, sharply asymmetrical rocks into gracefully shaped spires. These dark jagged forms were softened by the yellow clay that eased the fit between stones, cushioning them like cartilage discs between the vertebrae of a spine. The crowning clay elements seemed to punctuate the pieces with a sense of victory – a postscript to a successful struggle against challenge and adversity.

We next gauge the quality of this work by one of the values imparted by Goldsworthy's art – that is, a reverence for inner truth. I asked the children: "Do these pieces lie to us?" Most of the children could not grasp such an abstract concept. Yet I persevered by stating: "In these works I don't think the artist attempted to mislead the audience about how hard

it was to work together and balance all that rock." Instead, the images bear witness to the struggles that came with creating these two works: the initial resistance and inhibition of being paired together; the intense physical energy needed to collect and stack all that rock; the technical concerns over crafting an elegant design; and the social awareness needed to coordinate their efforts successfully. "All this was hard," I noted. Despite these struggles, there is a sense that both artists remained true to themselves.

In designing the two works, part of imparting a sense of integrity and truth was to avoid overly embellishing them with superfluous decoration. The two children were not influenced by their peers' efforts, nor were they dictated to by current art-world stylistic fads. With the sculpture's off-handed, rough hewn forms, they seem not to seduce the viewer with their technical slickness or idealized beauty. Instead there is a sense of austerity and economy at work in these sculptures. Nothing more is needed, and yet the pieces would suffer if any one element were to be taken away. Even the circular raking around the piece did not seem gratuitous, despite it being essentially my own suggestion. Clearing the ground around the work by encircling the pieces with inscribed mandala-like lines seemed to punctuate the composition. There is a "yin/yang", positive/negative quality to the stark physicality of rock that contrasts with the softness of the ocher clay and the raked minimalist space that framed these forms. Creating such contrasts helps to convey that in the course of such collaborative effort, "hallowed" space has been created. The appeal of these dolmens rests in this sense of "union of opposites": they are at once raw, stripped down, and muscular, yet the delicacy of their balance suggests tenderness and vulnerability. These contrasts also come alive as the rock's muted earth tones shine against the setting of the gray-blue lake water and the cloud-dotted cerulean blue sky.

Aesthetic viability and sublimation

What then is the connection between the aesthetic viability of these pieces and the achievement of sublimation? This relationship is based upon the children's capacity to channel their energy despite the fact that their initial efforts remained chaotic, anxiously inhibited and defended. Another union-of-opposites is suggested in the pairing of the children:

the boy's physically robust and sometimes careless working methods contrasted with the quiet solitude and deliberate style with which the mute child worked. Either child could have lapsed into stultifying defenses, with chaotic overstimulation besetting the boy, and autistic-like withdrawal on the part of the girl (Henley 1998a). Yet with only minor interventions to support their process, these children turned their shared struggles into something beautiful and poetic. The mirroring quality of their works was also present in their working relationship, as each remained attuned to the other. The potentially destructive drive energy that threatened to overwhelm the boy and shut down the girl had been somewhat neutralized during the course of marshaling their creative energies. In this particular case, we may safely establish that the forces of sublimation were consistent with the powerful aesthetic outcomes evoked by these two children.

The critique process was intended to bring these insights alive by attempting to empathize with these images – to help convey the victory of this work rather than to tear it down by criticism. Yet in conducting such a therapeutic critique we try to resist the inclination to lapse into the stock phrases that we so often hear during "sharing" time in group therapy. I am not so interested in having the client consciously interpret or fake insights about their creations. Nor am I concerned over whether this or that element represents the client's "anger", or "fear", or "child within." I am convinced that such canned responses are a kind of "psychobabble" that is sometimes learned by clients in therapy as a means of ingratiating themselves to their therapist (sometimes with the tacit approval of the therapist). Instead of promoting such "therapy-smarts," I am interested in the spontaneous and authentic expressions of children who, in an informed way, can reflect over how their process worked or did not work for them – and whether it became powerful.

Attachment and social bonding

By having the children work collaboratively we sought to set the stage for quality relating between peers. Pairing a child with hyperactivity with a non-verbal inhibited child proved to be a provocative intervention on my part. As I have stated, this fragile mute child might well have become

completely overwhelmed by close proximity to the outgoing behavior of the boy with ADHD. Yet I assessed that their disparate temperaments might have a balancing effect: that this well-meaning yet exuberant boy might draw the girl out of her shell, while her calm, thoughtful participation might slow his pace and lessen his impulsivity. A key element of this intervention was the role of the rock and clay as a therapeutic conduit, through which interactions that would otherwise be too threatening could be tried without precipitating overwhelming anxiety. For it was the sheer sensory quality of the clay that became the binding agent in the sculptural process, while also assuming metaphorical meaning as the "glue" which held their working alliance together.

If we surmise that the children's "twin-sculptures" perhaps had some element of self-representation, we might also assume that the works referenced the quality of relating between these two children. That each of the sculptures stood in its own autonomous space, yet constructed within a close proximity, suggested a need for each child to maintain an "optimal distance" from the other (Mahler, Pine, and Bergmann 1975). This distance was altered as the relationship changed during the course of the session. Initially, our mute child needed to remain at a safe distance which allowed her to manage the anxiety that came with trying out peer interaction. Yet she clearly desired some form of contact, otherwise she would never have worked in such close proximity, nor would she have collaborated on the other child's project. Tinbergen and Tinbergen (1983) refer to such inhibition and ambivalence over relating as "approach/avoidant" conflicts. For example, initially she would only approach the boy when bringing stones to him. Once dropped off, she would quickly retreat back to the self-protective solitude of the shore-line. Eventually, as her stranger anxiety and concomitant inhibitions diminished, she began to tolerate sharing the same intimate space when sculpting. This is perhaps suggestive of Winnicott's (1965) object relation concept of the "capacity to be alone in the presence of the other." Each could quietly work on the project without the need for small talk or other social niceties. The two works seem to support the view that a sense of shared, relaxed intimacy had developed. The stone sculptures seem to stand in quiet repose in the presence of each other, peacefully coexisting in a state of quiescence rather than anxiety or conflict. The similarity of their forms suggests that

each of the children had become somewhat attuned to the other, that a kind of "mirroring" in the Mahlerian sense became part of the process, as each work affirmed the other. Like many collaborative efforts, their mutual effort might have generated its own emotional fuel to drive both creative exploration as well as the establishing of a new relationship.

The process of stacking rocks might also assume metaphorical symbolism, as each child emphasized his or her struggles with "stabilizing" their towers. Discussion over providing a "solid base" that anchored the forms into the ground allowed for the eventual growth and stability of these pieces. Mahler's concept of "safe anchorage" (Mahler, Pine and Bergmann 1975) may be applicable here, as the emotional fuel originally supplied by the mother is now symbolized by the collaborative effort at keeping the pieces intact. The struggle between both children and sculptures to maintain stable relations may be analogous to the children's own need for object permanence and security.

This case is perhaps unique since initially clay was not even factored into the process. Instead it was spontaneously discovered and utilized by the children themselves as a means of solving technical problems during their collaboration – which in itself is a metaphor for the therapeutic process. Its use allowed both art process and relationship to form and grow despite the fact that it never figured as an element of design. The applications of this dynamic medium are limited only by the scope of one's creative ingenuity and technical know-how, as the children proved that day on the beach. I hope that reading the following chapters will widen this scope, so that the full potential of clay can be realized.

3. Clay and its Processes

Potters' clay

Before we can elicit such poetic therapeutic outcomes, a thorough knowledge of the material and its processes is necessary. The most common form of clay is the naturally occurring material the children had discovered in the lake, which is termed *sedimentary clay*. The most plastic of clay bodies, sedimentary clays are formed through the erosive action of wind and water during the transportation of the material from its source until ending up as a layer in the lake-bed. However it is doubtful that the clay the children had found in its natural state would have been satisfactory as the art medium we utilize in our studio programs. It probably would have lacked plasticity or been contaminated with stones, excess sand, organic material or other impurities that would make sculpting and firing impossible. To rectify these problems, the clay mined by the children would need to be processed for studio use. The first task would be to wash the clay in order to rid it of impurities by letting it soak in a water-filled tub. Many impurities would float to the surface and would then need to be skimmed off the top. After soaking the clay, it would need to be passed through an exceedingly fine sieve (termed 30 mesh) to remove coarse particles. Once cleaned it would then be dried on *plaster bats* which soak up excess liquid from the slurry and dry it to a workable consistency. If the resulting material is not sufficiently plastic, it would then need to be combined with other kinds of clays such as ball clay, in order to arrive at a fully functional *clay body*.

Clay bodies are blends of different clays and colorants which are devised for various applications in the studio, either high fire or low fire.

A high fire clay body is termed *stoneware*, which matures at a temperature between 2,000 and 2,400 degrees Fahrenheit. This creates a dense, hard and durable material that is the choice for most functional pottery. Under *reduction firing* in gas or oil kilns, the warmth of the body's earth tones and subtle glaze textures make stoneware the most aesthetically pleasing pottery.

Most of the clay bodies used in therapeutic settings are lower firing *earthenwares*. These clays mature at a lower temperature, which is conducive to the therapeutic setting as well as alternative firing methods such as Raku or pit-firing. Most of the beautiful ceramics of the pre-industrialized world are earthenwares, such as the Pre-Columbian wares from New Mexico and Central/South America: hand-built and burnished wares that were fired using dried dung for fuel in shallow earthen pits. The smoky fire resulted in earthy reddish to dark brown or black tones that were decorated in zoomorphic or other indigenous designs. Earthenware clays are usually fired in electric kilns at temperatures ranging from 1,500–2,000 degrees Fahrenheit, and result in a light, porous material that readily accepts glaze or paint.

A successful clay body for use in therapeutic settings should be plastic enough so that when a coil is rolled and bent into a loop, it will not crack or break in the process. Often plasticity is not dependent upon the mix of clay so much as its age. Well aged clay (beyond two months or more) will be vastly superior to newly mixed material. It will have an extended work-life – meaning it will not fatigue and begin to crack apart when over-worked or pushed to the limits by clients. A good clay body will also have some *tooth*, which is achieved with the addition of fine sand or *grog*. Grog is ground up clay which has been fired and, when mixed into the clay, gives greater strength and workability. The addition of grog will also *open up* a clay body, meaning it will become more porous to ensure more uniform drying, which will in turn increase its chances of surviving the firing process (Nelson and Burkett 2002). Colorants in the form of *oxides*, such as iron or the yellow ocher described in the opening vignette, can be added to clay to give the body a desired tint. However, strong oxides such as iron or manganese may stain the hands or clothing of clients which may also have negative effects upon the therapy process (Henley 1992a).

The moisture content in clay is another attribute which impacts upon the workability of the material and thus affects the therapeutic process. In some cases inexperienced clayworkers will purchase clay in small 5lb boxes as a matter of economy and the lessened need for storage space. This proves to be a false economy, however, since the clay in this size container will not remain sufficiently moist. The small surface area of clay prepared in this size will have probably evaporated much of its moisture over the shelf-life of the material, leaving it hard, unworkable and frustrating. Instead clay should be purchased in bulk, with at least one fifty-pound box made up of two 25lb bags being the norm. These should stay tightly wrapped until opened and even then, a sprinkling of water spritzed into the plastic bag will ensure the correct level of moisture. Before use the clay must be properly wedged or kneaded to remove the air-pockets trapped within. Although commercially prepared clay is usually de-aired using a pug-mill, some additional wedging may be necessary. Considerable skill is necessary to master the wedging process effectively. Poor wedging may introduce as much air into the clay as had previously existed! Thus it is the art therapist who must practice wedging the clay as a means of building success into the throwing or sculpting process.

Processing natural potters' clay

Natural clay must undergo a fairly long and complex transformation from a moist plastic material to become a rock hard finished object. In most clinical or educational settings it is the art therapist and not the student or client who will be responsible for bringing about these changes as part of the work towards a successful aesthetic and therapeutic outcome.

After completing a work during its moist state, potters' clay must be brought through the different phases of the drying process on its way to the culminating fire. After being worked in its moist or plastic state, clay will reach what is termed the *leather-hard* stage. At this point the clay has dried sufficiently so that it no longer can be "moved," meaning bent or flexed. Works which have reached the leather-hard stage of drying are often worked using the *subtraction method*, meaning processes that take away material by carving or scraping. Most sculptures or pots are refined

during this stage by trimming or refining excess material until the desired finished form is complete. Conversely, *additive* methods are also utilized during the leather-hard stage: elements can be joined together using a form of adhesive made of clay which has been liquefied to the consistency of thick cream, which is termed *slip*. Slip-joining is often stronger than the clay itself. This means that a handle which is applied onto the pot using slip as an adhesive will not break when tugged apart – usually the clay itself will tear before the joint. During the leather-hard stage, clay is at its strongest. Therefore, operations such as fabricating forms, for example cubes or other geometric forms, which require maximum rigidity and strength, are almost always completed at this stage.

The success of the drying process may also directly impact upon a positive therapeutic outcome. If works are dried unevenly or too quickly, uneven evaporation occurs, which in turn causes uneven shrinkage. Shrinkage can range from 5–12 per cent during the air-drying process. If shrinkage is uneven (meaning some areas of the piece are drying at 5 per cent while other areas dry at 9 per cent) the result may be cracking that cannot be repaired, often to the client's dismay. Therefore, it is the art therapist who is responsible for drying a piece slowly and evenly to increase its chances of surviving these changes.

To slow the drying process while working a piece over long periods of time, the clay should be wrapped in plastic which has been sprinkled with a slight mist of water (never mist the piece itself!). Many potters and sculptors wrap their pieces in a damp towel as well as covering the work in plastic. Certain elements such as hands or fingers on sculptures, or delicate handles on pots, require even more careful drying. Ceramic sculptor and professor Frank Olt retards the drying process by coating delicate elements with wax, which completely insulates the clay from air-drying too quickly.

Even thickness is another critical element of the drying process. In order for the clay object to be successfully fired, the piece must be completely hollowed, with the walls never reaching more than half to five-eighths of an inch of thickness. Pieces much thicker than half an inch often blow apart during the fire. Because clients often lack the skills or awareness to sculpt to this refined level, it is up to the therapist to probe each work to determine whether the half-inch limit has been exceeded.

After each session, the therapist must routinely examine each of the clients' pieces using a needle-tool to gauge the correct thickness and strength, so as to increase its chances of surviving the rigors of the fire.

Once the clay dries out it reaches a state called the *bone dry* stage or *greenware*. Either of these terms refers to any clay that has dried to the point that it can no longer be moved, carved or fabricated. Bone dry or greenware can only be sanded, which most ceramicists avoid since clay dust is dangerously toxic when airborne. If sanding is necessary, it should always be done by the art therapist and not the client, working outdoors with a proper respirator mask to avoid inhalation.

Greenware is also highly fragile and breakable at this stage. Clients should not have access to their work when their work is bone dry, as handling pieces inevitably results in breakage and subsequent disappointment. Fragile greenware should be stored in a metal cage designed for the purpose of allowing air circulation to finalize the drying process while also protecting the works from inquisitive hands.

At some point the therapist must determine whether the piece has dried sufficiently to be fired. One test often used by ceramicists is to put the work against one's cheek: if it feels cold, it is still too damp to fire, while warmth to the face indicates a state ready to fire. I have never found this test to be reliable – indeed, it seems every piece I hold to my cheek seems cold and therefore not ready for firing! Color is another test used to discern dryness. The lighter the color of the clay, the more dry it should be. Yet again, this too can be unreliable. It seems that only by drying the work over a long period of time in a dry, airy environment can we be assured that a work is bone dry. Accurately discerning the dryness of a piece is especially crucial when processing a work that is particularly precious to a client or has had a lot of time invested in it. Once we are sure that the pieces are ready to fire, we are then ready to move on to the final drying process in which the work is fired, usually in an electric kiln.

Electric kiln firing

In most therapy settings, an electric kiln is the method of choice to fire the clients' ware. Electric kilns are relatively inexpensive, clean burning, long-lasting and safe to use. They require no chimney or outside ventilation other than an exhaust-hood or fan which I will describe later.

Electric kilns are basically cylinder-shaped brick boxes sheathed in a stainless steel jacket. Temperature is controlled using knobs which are not very different from those found on a standard kitchen oven, with low, medium and high temperature settings. Inside the kiln, wire elements conduct the electricity and fuel the tremendous heat needed to fire the ware.

The first step in running a bisque fire entails loading the greenware into the kiln so that breakage remains at a minimum. Handling the pieces by their thickest points (never by the pot's lip or a sculpture's limbs), the kiln-loader gently places the greenware onto the kiln shelves in a tightly packed arrangement. Unlike the glaze fire, where pieces must never touch since they become glued permanently together, greenware pieces can be situated next to, or if space is tight, on top of each other. Once fully packed, the kiln is ready for the bisque firing.

FIRING PRECAUTIONS

During the bisque-fire the kiln will be fired in small increments to a temperature between 1,700 and 1,900 degrees Fahrenheit. In the initial phases of bisque firing, final evaporation of the remaining atmospheric moisture in the clay occurs at around 400 degrees (200°C), while chemical moisture is burned off at 1,000 degrees (800°C). As these temperatures advance, the remaining trapped moisture converts to steam. Nelson and Burkett (2002) explain that if too much moisture remains, this steam will expand to the point of blowing up the piece. This is particularly the case when the ware is thick, since moisture will take longer to migrate to the surface to evaporate. The art therapist minimizes the risk of such a catastrophe by preheating the kiln at the lowest temperature possible over the course of a night. At this time, the kiln lid should be kept slightly ajar to allow the remaining moisture to escape. It is important to note that in the earlier phases of firing, small quantities of compounds such as sulfur dioxide and carbon monoxide burn off the surface of the raw clay. For this reason it is essential that the electric kiln be vented to the outside. Ventilation systems utilize a fan mounted within a hood which is lowered over the kiln. The fan is connected to a flexible hose which evacuates the fumes to an outside window or vent. This precaution

insures that the kiln can be fired even while the clients are in the vicinity without potential harm.

FIRING SCHEDULES

After ten to twelve hours of pre-heating (which is usually done overnight), the lid can then be closed the next morning and the temperature slowly advanced in small increments until the *cone* shuts down the kiln. The pyrometric cone is used in lieu of a thermometer in order to ascertain the correct temperature in the kiln. The cones used in electric kilns are small triangular pyramids composed of ceramic materials which are calculated to slump at certain temperatures. When placed in the automatic shut-off device (called a "kiln-sitter") which is found in most institutional kilns, the cone acts as a kind of circuit breaker. It will automatically shut the kiln down when the proper temperature has been reached, which ordinarily will take from six to eight hours after pre-heating. Pyrometric cones allow for the precise control of the firing temperature, taking the guesswork out of this crucial process (Nelson and Burkett 2002).

Once the firing is complete, the kiln is allowed to cool overnight. The next morning the lid can be cracked an inch or two to accelerate this last phase of the cooling process. Once the pieces are just warm to the touch, they can be unloaded using heat-resistant gloves. The pieces, which are now termed *bisque ware*, should be stored under plastic to keep dust from settling, which may complicate the glazing process. Gloves should be used when handling the ware, as oils from the hand can also create defects in the glaze. The bisque ware is now hardened to a state which is still porous enough to allow for the finishing coat of glaze or paint to be absorbed into the piece. Bisque ware is strong enough to allow for careful handling of the piece while the surface treatments are being applied. It is often a great relief to see our clients' work survive the rigors of the fire. We must next address whether the clients can tolerate surrendering their work to yet another, final firing of their pieces – a process known as the glaze-firing – or employ other alternative ways of finishing off the work, such as the use of paint and related surface treatments.

To paint or glaze

The finishing phase of the ceramic process entails adding colorants to the sculpture or pottery. The art therapist or client has two essential choices: to apply ceramic glaze to the work, which requires a second, glaze fire; or to paint the bisqueware with acrylic paint. Several considerations guide our decisions on this point. This decision may be taken out of our hands if the work will be utilized as functional ware. If the pot or sculpture will come into contact with food or drink, or will be expected to hold water, glaze-firing remains the only option.

Glaze is basically glass which has been ground to the consistency of dust, mixed with water, then applied onto the bisqued piece. Upon reaching the maturing temperature during the glaze fire, the glaze will melt onto the ware and then crystallize as it cools into a smooth, hard glassy coating. Because glaze is mostly composed of silica (which is basically sand), further additions of clay are added to the glaze formula, stiffening the glaze and allowing it to adhere to the ware as it liquefies in the fire. Different recipes or mixtures give a particular glaze its properties: transparent, translucent, or opaque; glossy or matt; vibrantly colored or subdued. The latter quality is achieved by the addition of oxides, which are naturally occurring minerals that gave the yellowish tint to the ocher clay found in our opening vignette. Glaze is usually applied to the bisque ware by dipping, brushing or spraying. Glazes can be covered over with two or more different glazes or overlapped to create nuances in color or texture. Once applied, the bottom of the ware must be scrupulously cleaned, as any glaze left on the foot of the piece will permanently bond to the kiln shelf. If this is the case, the piece is essentially lost as it usually requires a cold chisel to extricate it (usually in pieces) from the kiln-shelf.

GLAZING SAFETY CONSIDERATIONS

In most ceramic studios, glazes are made from scratch using individual chemicals in various recipes. In therapeutic settings, this would constitute a health hazard, as handling dry chemicals can be dangerous; therefore almost all glaze is commercially prepared.

Glazes with toxic components such as lead, cadmium, nickel, selenium, uranium, or barium should be avoided. Even without the

presence of these toxic chemicals a few safety measures should be taken around the glaze room:

- No food or drink should be consumed around glazes.

- Avoid using hands to mix glaze – rubber/latex gloves or stirring sticks are preferred.

- Avoid allowing glazes to dry on table surfaces which then require scraping to clean, creating potentially toxic dust.

- Always wear smocks, eye protection and old clothing when glazing (Qualley 1986).

GLAZE OPTIONS

Preparing to glaze requires forethought, in that it can be a messy, chaotic, and expensive process. Many studios will buy a range of different glazes by the pint, many of which languish on the shelves half-dried out and poorly labeled. I prefer to streamline the process by using just two basic glazes: an opaque white with a satin finish and a clear with a glossy finish. These glazes are deemed safe for food/water use and contain none of the aforementioned compounds which may be toxic. They are purchased in a premixed wet state, in five-gallon bulk containers. To create different colors and textural effects, I will purchase a variety of colored oxides or commercially prepared stains, which can be mixed for each occasion with the two base glazes in various combinations. Some experimentation will be necessary to arrive at the proper combination, but usually between 2 and 5 per cent of a stain will provide coloration to a glaze. Oxides should be mixed thoroughly into the base glaze, using a blender for small batches, or an electric drill fitted with a mixing wand to ensure complete saturation of the ingredients. Having just a few compatible glazes in the studio can bring order to what is often a confusing jumble of buckets or jars in varying degrees of disarray. Glazing can then proceed with a minimum of mess and waste.

Another option, particularly for younger clients, is to utilize dry underglazes which are sold in cake form like watercolor sets. The procedure is straightforward: simply moisten one's brush as though painting in watercolor, and paint on the underglazes. Colors can be

blended, overlaid or diluted as a light wash. Once dry, the piece is then covered with a clear glaze which allows the painting underneath to show through, while also giving the colors a vibrant sheen. Spraying may be the preferred method of delivering the clear-coat glaze, as brushing may smudge the painting underneath, thus ruining the client's efforts. Underglaze sets are expensive and thus are viable only as a medium for painting small areas of the ware. Painting the different parts of figures, doing impressionistic landscape scenes on pots, or free-form expression-istic brushwork on slabs, all lend themselves to this medium.

ISSUES RELATING TO GLAZING

The glaze process generates its own therapeutic outcomes and thus requires thoughtful assessment and intervention. Applying the dull-colored liquid (which bears no resemblance to the colors of its eventual fired state), and then seeing the vibrant transformation of color and texture after the fire, can be among the most gratifying aspects of the process. However, I have already pointed out that some clients have diffi-culty surrendering their work to the unseen forces of the fire which can be too anxiety-provoking. To abandon it to the kiln yet a second time for the glaze fire and then wait sometimes weeks for it to be fired may be all too stressful. For those who have difficulty with object permanence or object loss, such protracted absence may lead to lack of interest in or dis-sociation from the work, particularly if the end results do not meet the client's expectations. For this reason, the size of kiln may become an element in the outcome: if the kiln is too big for the studio, it will be fired more infrequently, thus the clients must wait even longer for their pieces to reappear. A smaller kiln which can be filled each week is ideal, as the studio can get into a rhythm of firing that is "object constant."

Another strategy which seems to help those who suffer from "out of sight–out of mind" problems is to keep a record of their creative output in a journal. In this note-book, clients can sketch each of their pieces and then label where glazes and oxides were applied and how they were fired. After receiving their finished pieces, clients can then note their results and reflect on what glazes or oxides worked to their satisfaction so that such results can be duplicated in the future.

PAINTING SCULPTURE

When the artwork is not functional (meaning most sculptures, reliefs, or decorative items), acrylic paint may be the preferred option of surface treatment. One potentially positive outcome of having the clients paint their work is the immediate gratification that comes with directly finishing off the piece. As soon as the piece is bisqued, it can be painted in acrylic, which dries quickly, allowing the work to be taken home in one session. Prior to painting the surface can be primed using gesso to create a ground that will enliven and opacify the colors, and also improve adhesion of the paint. Because acrylic paint is dull, matt medium can be added to the mix to give the colors a slight sheen. The work can also be sprayed with glossy or matt acrylic after the paint has dried. Like all potentially dangerous operations, the clear coat should always be applied by the therapist and not the client. Spraying should be done outdoors or in a spray booth built for that express purpose. Either way, a professional cartridge respirator mask should always be worn by the sprayer to ensure no toxic vapors are inhaled or ingested. Once clear-coated, the sculptures may come alive with rich color, texture and other effects which stimulate the senses.

ENGOBES: THE IN-BETWEEN OPTION

Engobes are slips which are composed of liquefied clay to which oxides have been added as a colorant. Their function lies somewhere between glazes and painting, and thus they contribute a unique outcome to the finishing process. For instance, engobes can be applied directly to the wet clay, which then requires only the one bisque fire to complete the finishing cycle. In the case examples, we shall encounter numerous instances where engobes were applied right after their creation and then decorated using a technique called *sgraffitto*. In this technique, the engobe is scraped or cut through to reveal the underlying clay body – which is usually of a contrasting color. This sgraffitto process is one of the earliest known decorating techniques, and was used with unsurpassed brilliance by the early Greeks, whose amphorae and other ceramic forms were masterfully painted with black engobes onto the red ware. Figurative compositions were created as vehicles for historical or mythological

story-telling: from commemorating the deeds of heroes or gods, to more mundane functions such as serving as trophies in athletics competitions.

Because engobes are composed mostly of clay, their surfaces will range from flat to satin, depending whether a piece has been burnished to a luster. Clear glazes can be used over engobes, which is a simple solution that renders the ware safe for use as dinnerware or other functional ware. Without being glazed, slipware remains soft and relatively porous and is thus not ideal for functional tableware or other works which will come into contact with food or water. Slipware may be clear-coated to impart a sheen, though such coatings must never be utilized as a replacement for glaze in functional ware.

4. Alternative Clays

Self-hardening clay

Should the processing of natural clay be too daunting to the art therapist, almost all of the aforementioned processes can be circumvented by using self-hardening clay. With the advent of chemical technology, clay manufacturers have made significant progress in developing clays for decorative purposes which do not require firing. These materials possess the plasticity and other usual properties of potters' clay, but carry within them a chemical agent which hardens the clay body when exposed to air. In years past, these clay bodies were composed of highly caustic salts which had strong odors and left a chemical residue on the clients' hands that was highly disagreeable. Current products no longer suffer these flaws. Self-hardening clay is limited to sculptural purposes and is not meant to be utilized as a medium for functional pottery. It cannot hold water, nor can it be used in contact with food.

Because self-hardening clay does not require long involved processing such as drying or firing, it is ideal for simplifying the ceramics processes for therapist and client alike. Drying takes place in one step – from a plastic state to hardened object within twenty-four hours of air drying. It is also a versatile medium. Unlike potters' clay, which cannot be used in conjunction with other materials, self-hardening clay is ideal for mixed-media projects. Any object can be embedded without concern over shrinkage, cracking or other defects. Stones, wire, feathers, glitter, or found objects can embellish and enliven any clay object, thus broadening the client's expressive potential. Unencumbered by logistics and technol-

ogy, some clients feel liberated. Works become more about personal expression rather than medium or process.

Self-hardening clay is often the medium of choice in clinical or non-studio settings such as pre-schools, psychiatric day rooms, orthopedic hospitals or nursing homes. In such facilities, ceramic equipment may take up too much room, make too much dust, and consume too many resources to support such a specialized art form. By using self-hardening clay, all that is required is a modest space, a pail of water, sturdy tables and chairs, a few sculpting tools, and imagination.

Another advantage of self-hardening clay is that the clients no longer have to risk surrendering their works to the unseen forces of the kiln firing. Clients with object permanence issues no longer need to be concerned over the disappearance of a work during the firing process, which may be interpreted as a loss of that object. In many cases this is an accurate perception, as pieces are indeed lost or destroyed during the loading or firing process. Self-hardening clay keeps the work within the client's field of vision so as to reassure the individual of its continued existence and well-being. This constancy often provides an added therapeutic benefit: reducing the anxiety that comes with such separation and object loss, particularly if the client is very attached to his or her work.

There are of course disadvantages to self-hardening clay, most of which center around its high cost. Self-hardening clay is usually four times as expensive as natural potters' clay, which limits its use to small-scale works and clients who will not consume a lot of material. Having to manage its consumption may directly impact upon therapeutic efficacy. Some clients *need* to waste or freely experiment with the material, or work large-scale, as part of their therapeutic experience. Having to worry over the costs of consumption may lead to a sense of preciousness with the material on the part of either client or therapist. The atmosphere within the session may no longer feel unconditionally accepting or expectation-free, as there is a sense of "withholding."

One often-heard criticism, particularly from potters, is that self-hardening clay is an adulterated, artificial medium. For many potters, it is the natural, earthy quality of clay that awakens the senses and invites creativity. It is also the process of working the clay, of being attuned to its different phases and moods, that creates a rhythm all its own – one that

contributes to the overall experience. Purists argue that by cutting out the firing process, we acquiesce to one more short-cut technology that dilutes the creative process. Ryan (2001) writes that self-hardening clay is a fake material – one that only mimics the claywork experience, and has only the illusion of substance. Increasingly, experiences in art education are becoming more about *knowing* about art rather than the actual doing. The timeless fine arts and crafts seem to be threatened or overwhelmed by the digital arts and other technological innovations of the computer age. Digging for muddy clay in a lake-shore bank, and firing pots with sawdust or dung in an earthen pit, seem quaint by comparison.

It can be argued, however, that the focus of clayworks in art therapy is not to remain true to any one romantic ideal or one particular process. Our task is to encourage self-expression unfettered by technical logistics. While the full extent of the ceramic process is indeed a noble, even venerable process, as clinicians we should freely embrace any medium which furthers the goals of both art and psychotherapy.

Polymer clay

If the idea of self-hardening clay is troubling to many purists within the field of ceramics, the innovations with purely man-made modeling media may be especially disturbing. Polymer clay produces a wholly new generation of ceramic-like materials which bring together the most desirable characteristics of non-firable plasticine or oil-based clay, self-hardening clay, and potters' clay. Polymer clay (if it can be considered a clay at all) is a plastic material which consists of PVC particles and pigment suspended in a plasticizer (Thompson 1999). The minute size of the plastic particles gives the material a fine, non-greasy texture and soft malleability. It is a clean, non-toxic, odorless material which leaves no dust or other residue on hands and does not readily stick to table surfaces. It does not dry out when exposed to air and remains workable for several years. The Polyform company's "Primo-Sculpey" and "Sculpey III" are two brands which I prefer to use with the children in my practice. Both materials are extraordinarily soft to the touch and plastic, with little or no kneading required to work them into a malleable state. The clay can be rolled,

twisted, stretched, and molded without cracking. One hyperactive ten-year-old girl twirled and braided a foot-long strand of Sculpey for the entire clinical hour and it did not fatigue. It seems that it cannot be overworked, even for this relentless child.

The clay body is not actually self-hardening, but is oven-baked. A small toaster oven is used to bake the material for a short period of time – usually one half-hour at most. The material matures at an unusually low temperature range – from 265 to 275 degrees Fahrenheit, depending upon brand. It can be fired multiple times and, amazingly, will accept new additions of soft material even after it has been fired to a hardened state. When fired the clay remains slightly flexible (some forms are as flexible as rubber after baking), yet it is hard enough to be filed, sanded, drilled, and even buffed to a slight sheen. Polymers come in a myriad of colors which can be combined, blended, marbleized, feathered, and inlaid as appliqués. They are often used in the tradition of Venetian glass craftsmen who work with loaves or *canes* of glass for sculptural effects. Simulating this glass process entails using colorful laminations and strands of polymer to create *millefiori* techniques. There are even translucent clays which create unique depth-of-field effects, especially when used in concert with gold leaf. Surface treatments include varnishing for special applications, such as giving glossy effects for bead-work or other forms of jewelry-making. Antique and other unusual surface effects can also be achieved using commercially prepared metallic pastes such as bronze or pewter. Some surface effects even mimic fossilized ivory or bone, or simulate wood grains. Like the prototypical "silly putty," the latest generation of polymers can be used for image transfers from colored printed illustrations or monochromatic text. Client-made magazine collages, word-processed or printed text, or colored-pencil drawings can all be transferred and then manipulated. One child delighted in transferring images, then stretching and distorting them to caricatures. Yet unlike the silly putty of old, the image transfers with the new polymers can be permanently hardened on to the clay by instituting multiple firings.

For years polymer clay has been used in industrial applications such as model-making in product design, jewelry, animation, doll-making and, in the case of silly putty, as a unique kind of toy. Its versatility, its mildness and cleanliness, its ease of manipulation, its range of colors or

surface effects, and especially its low-tech requirements for processing, make it a most appealing choice for small-scale sculptural works. Of course the material should not be ingested or used for functional ceramic applications that come into contact with food. Nor can the material hold water. It is prohibitively expensive, which becomes problematic for the same reasons as does self-hardening clay: concerns over wastage and cost-benefits may lead to an atmosphere of anti-therapeutic preciousness. Yet when this versatile material is used judiciously and strategically, it is well worth the cost.

Edible clays

Our last medium under discussion is edible clay. For young children and those populations for whom ingesting materials may be a concern, clay made from edible materials may be the only option. These clays can be utilized as sensory stimulation materials which are meant to stimulate playful manipulation. Even making the clay can be a stimulating experience for young children, given the simplicity of materials and the ease of preparation. Pouring, mixing and kneading are all coordination movements which young children delight in and need for their development. After playing with the material, edible clay can be hardened or baked to become lasting products. Kohl (1989) has amassed a comprehensive collection of edible recipes and is the most invaluable resource on this subject. She divides her clays between two basic types: cooked and uncooked. Cooked clay is essentially a dough-like material which cooks to a pure white color. Kohl's recipes are simple. One such recipe, "play clay," requires one cup of baking soda, half a cup of cornstarch, two-thirds of a cup of warm water and food coloring if a tint is desired. The baking soda and cornstarch are mixed into a saucepan, to which the water is added. This mixture is stirred until smooth. Over medium heat, it is brought to a boil and stirred again to the consistency of mashed potato. It is then poured onto a bread board and kneaded when sufficiently cooled. Objects made from this material can be painted or finished with clear nail polish or shellac. This recipe is of course completely non-toxic and harmless if ingested (Kohl 1989, p.18).

Kohl describes a recipe for cooked clay (Baker's Clay) made with four cups of flour and one cup of iodized salt, which is then mixed with one and three-quarter cups of warm water. After mixed in a bowl, the material requires ten minutes of kneading until a clay-like consistency is attained. The clay can be left to harden in its uncooked state or baked to 300 degrees Fahrenheit for a more durable finish. This material too may be mixed with food colorant or painted and sealed after hardening (Kohl 1989, p.29).

Edible clays are sometimes actually presented to young children or lower functioning populations such as the developmentally disabled as a kind of creative play-food. This may be confusing to these individuals, sending mixed messages that art materials can be eaten. When working with the learning disabled in particular, part of the rationale for working with edible clay is to use the material as a developmental stepping stone to prepare them for real art materials. Therefore, edible clays should be presented in the same way as any other non-edible medium. In this way we train our immature clients to work with more advanced materials, which may not be so forgiving if ingested.

5. Ceramic Techniques and Processes

Befriending the clay

Claywork techniques are among the most dynamic and accessible in the practice of art therapy. Whether utilized with the lowest functioning developmentally disabled child or the college art major with attention deficits, claywork processes are sure to stimulate all of the body's senses. Upon engaging this soft squishy material, one may experience an element of constructive regression, as the material invites playful manipulation with the frequent effect of diminishing inhibitions. Emotions which have been repressed or inhibited often find expression through clay, as the deepest reaches of the psyche may be touched. Clay is the ideal process for absorbing strong emotions such as aggression. Throughout the case material we shall encounter children whose work with clay does not culminate in a product but remains mired in what Kramer terms "chaotic discharge" (1971). Pounding, slashing, breaking and smoothing may all constitute their claywork experience. Psychosexual issues may also be stimulated as some children fixated at certain stages may be inclined to act out their oral, anal, phallic or genital fantasies through clay. The most obvious examples are children mired in the anal phase, such as the learning disabled, whose toilet training issues may result in compulsive cleanliness. In some instances the drives are fused, with the anal phase linking up with aggressive impulses. Kramer cites a case where a child created volcanoes and enacted repeated eruptions as a symbol for anal explosiveness (1973). Clay used in this guise is also helpful for reinte-

grating after regressive episodes. Elements which have been broken during behavioral episodes of destruction can often be reassembled without any hint that a behavioral breakdown has ensued. Kramer writes that "... the tangible earthiness of clay and its malleable, cohesive quality convey a sense of reality and substance" (1973, p.251). Kramer feels that the propensity for clay to induce regression is outweighed by its power to stimulate integration and self-control (1973).

To encourage integration in balance with raw emotional discharge, claywork requires sufficient cognition so that some degree of skill can be achieved. More so than other media, clay is a technically demanding art form that requires *practice*. Berensohn (1972) writes that once its rudiments are learned, techniques give way to a kind of dance, giving rise to robust physical movement and rhythmic manipulations that are poetry in motion. In her preface to Berensohn's book, potter and philosopher/poet M.C. Richards writes that technique allows us to experience the freedom to move the clay by way of gestures, which echo the elasticity, the balance, the life in our bodily movements. She writes that with sound technique and an open mind we "befriend the clay" so that "the feeling of our lives will come awake in our fingers" (Berensohn 1972, p.13).

The claywork process allows the client in art therapy to explore the senses, to balance technique along with a means of understanding oneself. As these two paths intersect, we set the stage for the work to move from inception to fruition; from ideas and feelings to workable design; to exploration and fabrication while in the clay's wet plastic state; to the process of "letting go" as the finished piece air dries on its way to the first bisque fire; to the process of reconsidering the surface by glazing or decorating; and then on to the culminating fire where we sacrifice our work to the blind forces of intense heat and flame in the hope of its final transformation. As discussed in the previous chapter, any one of these processes may come alive or falter during the course of this journey. Each stage provides both an element of struggle and one of potential. Each process may color the art therapeutic outcome: from disappointment to the thrill of opening the kiln and beholding the object transformed.

Because of the investment of time, energy and resources needed to achieve a positive outcome, we have already identified the use of natural

potters' clay as a comparatively risky art form – particularly if the idea of "built-in success" is part of the therapeutic curriculum. Given the multi-faceted nature of claywork, it is easy to understand why many art thera-pists revel in the potential of the medium, yet at the same time may be hesitant to use the material as widely as other media in therapeutic settings. Goryl (1995, 2000) found, in his comprehensive survey of several hundred art therapists, that while 99 per cent found clay to be inherently therapeutic, only 25 per cent used the medium in their practice.

Eliciting images rather than objects

The goal of claywork in art therapy settings is to avoid allowing the material to stand in the way of the art therapist's mission: to engage clients in a creative process so as to elicit spontaneous images which may function as a kind of symbolic language (Naumburg 1966, 1987). If we become too concerned over the material or its processes, we begin to limit the outcomes of a potentially rich creative experience. Claywork programs are sometimes criticized for just this reason – their affiliation as a "craft" often demotes their status in art schools especially, because they do not deal with *images* per se, but with *material*. While some ceramics programs do indeed view clay as just one more medium in our imaginal tool-chest, others continue to recognize the primacy of clay as determin-ing the outcomes of the creative process. To avoid perpetuating this kind of "ceramics-centricity," it was no accident that I began this text with a project that was not dominated by clay. Rocks, sand and mud were all essentially clays in different physical guises; to discriminate between these would be an arbitrary and pointless exercise. Along with these other "clay-in-process" materials, the use of plastic clay was just one more means to creating an image. Thus, the creative therapeutic process was not dictated to by the material, but rather was enhanced by it.

Naumburg writes that art therapy is guided by the process of project-ing interior images into designs, which then crystallize and fix in lasting form the recollections of dreams or fantasies which would otherwise remain evanescent (1966, 1987, p.2). If we become overly concerned with the medium, or technical proficiency, or the finished product, we

then run the risk of losing the spontaneity, richness and other dynamic qualities that come with image-making. If the evoking of images is central to the mission of art therapy, it may then be necessary to bypass certain technical problems by simplifying processes, ideally without diluting or compromising the integrity of the art form. In some cases, bypassing means using alternative modeling materials or solving technical problems that might stand in the way of the client's self-expression. Therefore, in the case material I shall describe instances where it is I rather than the client who centers the clay on the potter's wheel, or forms a generic figure for the client to embellish, or rolls out a slab for the client – if this technical support is necessary to achieve the therapeutic objective. Without such interventions, I may be needlessly setting the client up to struggle or fail in the crucial initial phases of the art experience. By staying focused on the *imaginal* experience of clay, we choreograph the dance rather just than teach the course.

One of the objectives of this book is to adapt a few basic techniques which will allow even the inexperienced clay therapist to elicit strong images in both sculpture and pottery using natural potters' clay. These include adjusting techniques to special populations, simplifying surface treatment, and exploring different concepts which may enhance creative expression and promote insight. As the case material will bear out, clients use the ceramic processes to advance their therapy in unexpected ways. We will encounter a deaf/blind child who runs his hands over the pieces I myself have thrown on the potter's wheel as a vehicle for verbal free-associations, while another, autistic young man utilizes his throwing lessons with an intern as a means of developing his first attachment to a nurturing figure. We will experience claywork with a group of children with attention deficit disorders whose work in ceramic architecture attempts to overcome social phobias by creating a community-village in clay. We'll look at a gifted college freshman whose unorthodox approach to sculptural relief compensates for her perceptual impairments and idio-syncrasies. Another college freshman initially learned to throw purely to strengthen his extremities after becoming paralyzed. Unbeknownst to him, he would later became a professional potter and art therapist. In each scenario, clay became a vehicle or outlet which gave symbolic and narrative form to ideas, feelings and relationships.

Technique

Pinch method

The cylinder is the point of departure for almost all ceramics. From this form, most images can find expression, whether they be sculptural or functional. Because clay cannot be fired if it is a solid mass, the first problem of ceramic technique is to hollow out the clay. One basic yet versatile technique is the pinch method. Berensohn (1972) can be credited for breathing new life into this often overlooked process. He writes that pinching offers the most direct contact with the clay: that one immediately experiences the moist plasticity of the clay, the rhythmic motion of its forming movements, as well as the frustrating limitations that come with over-working the material. Berensohn celebrates the meditative, spiritual quality of the pinch process. Taking his lead, I often use the technique as the initial, introductory ceramic experience for both clients and art therapy students in clinical training. After becoming familiar with the process I often encourage them to pinch out their forms with eyes closed. As the piece grows in the hand I hope to attune their senses to the subtle nuances of the material and its expressive possibilities.

Pinching requires a moist, well-aged ball of clay which fits comfortably in the palm of the hand. While supporting the ball in one hand, the thumb on the other is used to depress a hole vertically into the center of the ball, stopping approximately three-quarters of an inch from the bottom. Then the opening begins as the thumb pinches gently outward from the centered hole while the other four fingers pinch the clay from the outside, compressing the walls of the form. After each pinch, the ball must be rotated slightly in order for the walls to be thinned and spread with even thickness. If the piece is rhythmically pinched and rotated in small, even increments (I often use the example of the ticking of a second hand of a clock as a metaphor for this precise movement) the form will grow symmetrically outward and upward, creating a cylinder or bowl-like form. As each revolution is completed, the hand then moves to slightly above the course of the last rotation, which thins the piece in a spiraling upward movement. Pinching should taper off just under the rim or "lip" of the pot so that cracking is minimized. Surface cracks are an inevitable part of the pinch process. If undesired, they can be smoothed

over with fingers moistened with slip or water in order to reinforce the finished form or ready it for the next operation.

With repetitive pinching, finger-tip depressions are usually left on the outer wall of the form. These finger-prints indicate how evenly the potter applies the pressure and consistency of rotation during the pinching process. Most ceramicists leave these pleasing rhythmic textures on their pieces as they become a kinesthetic record of the potter's touch. Even pinch pots from antiquity will still retain the freshness, vitality and precision of the potter's rhythmic movements centuries after their creation.

Once a hollow form is complete, one may then decide upon its function. Left unadorned, these simple yet elegant forms can be finished off as the "tea-bowls" in the oriental tradition that are described in detail on pages 161 to165. Berensohn (1972) describes a variety of finishing techniques that enhance the surface and form of the bowl. These include impressing textures such as burlap or string into the outer walls, paddling the form into organic asymmetrical shapes, inlaying contrasting colored clays, and writing poetic reflections in "haiku" form. Single forms can be pinched together on their sides to form clusters or joined at the lips to create a closed, spherical form. The latter process is useful as a basis for sculpting small circular globes which can be left as pottery forms or as a departing point to create sculpture. Figure 4 shows a form created from two small pinched pots which were joined together to create a small sphere. The piece was part of an experiential project created by Monika Tang, who was at the time a graduate student in art therapy at Long Island University. The directive was to add some figurative element to the students' pinched forms which could evoke a sense of narrative or drama in their pieces. After pinching and joining her hemispheres together, Tang then sculpted a small-scale figure which she integrated into the composition. As the figure climbs out of the delicate globe I was reminded of Herman Hesse's epigraph to his novel *Demian* (1925, 1965). As a metaphor for the adolescent's struggle to find himself, Hesse wrote:

> "The bird fights its way out of the egg.
> The egg is the world.
> Who would be born must first destroy a world."

Figure 4: Pinched and modelled form by art therapist Monika Tang demonstrates the expressive potential of basic clay work techniques.

For Tang, the sculpture deftly explores the issue of life transition: from leaving family and friends in British Columbia to settle in the New York area for graduate studies, to negotiating the cultural differences posed as part of this move, to the eventual transition from student/intern to successful professional. This basic technique effectively employed by Tang is well within the sculptural expressivity of many clients in therapy. The key is not to become bogged down in pinching or other forming processes, but to integrate different techniques as a tool for personal expression.

The use of joined pinch pots is also an ideal method for creating small-scale portrait busts. As we shall see in the case material, one blind teen became proficient at creating self-portraits by pinching out two hemispherical elements, one of which became the face, while the other served as the back of the head. After joining the head together, a third pinched form was then inverted and elongated into a set of shoulders which was thick enough to support the head assembly. In just this one basic pinching process, the client, student or artist possesses enough technical know-how to create the simplest or most sophisticated small-scale portraiture.

Marvering

Many ceramic projects require cylinders that can be made quickly with minimal skill, yet are aesthetically pleasing. Marvering is one such technique that is utilized in therapeutic settings as a point of departure for both functional and sculptural small-scale forms. The technique is unique in that a cylinder can be created without a seam or applying a base, which are often the most time-intensive operations in the hand-building process. Like the pinch forming technique, marvering dispenses with the laborious processes of welding, slipping, scoring, smoothing and worrying about cracked joints during the drying and firing process (Henley 1992a). Once a seamless cylinder is made, the client can then focus on the real objective of the process – to build upon the cylinder to create an interesting and personally relevant image.

Marvering begins by rolling out a thick cylinder between two and four inches in girth. The length of the coil should be roughly equal to the desired height of the finished cylinder. The first operation is to find the center of this coil, which is then penetrated by a half-inch dowel or tapered paintbrush handle to almost the end of the coil's length. The client must then grasp the exposed end of the dowel and begin to roll (or marver) it back and forth. Marvering should be done on a unprimed canvas-covered board in order to minimize problems related to the piece sticking to the table. The illustrations (Figures 5 and 6) show the position of the hand and coil, as the coil is rolled on its side. As the piece rolls, the inside of the coil expands and the walls become increasingly thinned, in a way that is similar to the pinching process. As the hole is enlarged a larger

Figure 5: Marvering allows for a seamless delicate cylinder which may form the basis of sculptural or functional works.

Figure 6: Once the cylinder is formed added embellishments may then be applied.

dowel is next placed inside and the process is repeated. Two or three dowels of increasing size are usually required to achieve the thinness needed to survive the fire. Yet the cylinder must be of sufficient thickness so that its support base can support the weight of added clay as the form is further elaborated. (If the clay sticks to the dowel, this indicates that the wood has absorbed too much moisture and should be put aside in favor of a dry dowel.) The second illustration shows the finished form: a sleek, strong, seamless cylinder which, after a short period of firming up, can support whatever sculptural or functional elements the client desires. An example of a series of small-scale marvered bottles with slab-built and thrown elements is shown on page 182 (Figure 38). First the base was marvered, then it was built up with textured slabs that contained the delicately thrown bottles that top off the pieces. The glaze was chosen for its propensity to "break up" into different shades of earth tones, which served to accentuate the texture of the slabs. Created by a college freshman art major in the process of recuperating from viral quadriplegic paralysis, these elegant stoneware pieces have sculptural elements yet combine these with functional use as weed or bud vases.

Slab-building

If a cylinder is to be larger than 3 inches wide and 8 inches in height, the marvering method may be impractical. Moving that much clay with a dowel requires too much force which few clients could effectively control. In such cases, the art therapist may decide to use slabs to form the cylinder. Slab-building can be adapted to clients such as this teen with special needs (Figures 7, 8 and 9), by using a few basic procedures which take the guesswork out of this process (Henley 1992a). As with the marvering process, an unprimed canvas should be utilized to keep the clay from sticking to the table top when the slab is being rolled. A simple jig can be devised which will evenly force the clay slab into the prescribed thickness. This jig is made of two strips of wood which can range from three-eighths to five-eighths of an inch in thickness, depending upon the size of the piece. The strips are set up in parallel with each other at a width which will determine the height of the finished cylinder. This process is shown in Figures 7, 8 and 9, in which a young man with multiple disabilities became quite adept at rolling out an even, flawless slab which would

Figure 7

Figure 8

Figure 9

This child with multiple handicaps became adapt at slab-building, with only minimal adaptations. His work is both self-expressive and aesthetically integral.

spread and thin itself to the thickness defined by the wooden strips. The rolling pin used is a professional model of turned rock maple with high quality ball bearings which roll the pin almost effortlessly. This indispensable tool is worth the extra expense as the momentum provided by the extra weight of the maple and the precision of the ball bearings allows clients with extremity weakness to roll out even large slabs with greater ease. After rolling the clay, a cardboard tube is wrapped in paper and then placed on its side atop the finished slab. The child is shown wrapping the slab tightly around the form, which is then welded closed. The seam is then smoothed over using a concave shaped rubber "rib" tool. The wrapped slab is then righted and placed upon another slab which will form the base. These two slabs are *scored* and *slipped* together, which will form a bond stronger than the clay itself. Using a butter knife, the base of the slab is cut away by tracing around the form. An extra quarter-inch of clay should be left around the cylinder so that this excess material can be brought up around the piece. This seam is then cleaned and refined by using a another type of rib with a right angle shape. The piece can be gently rolled on its side, which smooths the clay further, leaving a cylinder without a visible seam. Once the slab firms up, the illustration shows the child gently sliding the cardboard tube out from the clay cylinder, leaving the paper sleeve inside the clay. This paper sleeve keeps the clay from sticking to the tube as it is pulled from the finished ceramic form. Once complete the finished clay cylinder can be modified with additions of coils, more slabs or thrown elements to create sculpture or pottery. This boy's preference was to leave the slab plain, except for a small clay appliqué in the form of a maple leaf, which he affixed to the outer wall. The child formed this delicate element by forcing a small ball of clay into a plaster press mold – another useful process to which we will turn next.

Press, slump and sling molds

In the last vignette, a clay medallion in the shape of a leaf was used as an appliqué to embellish the basic cylinder. This element was formed using a small mold which I salvaged from a collection of discarded commercial "greenware" molds which one often associates with "paint-a-pot" shops. This is a non-creative process which entails pouring liquid clay into

molds that take the form of various curios, vases or lawn ornaments, which are then painted by the hobbyist. While these establishments make mostly kitsch, some interesting molds can be found when taken out of context – such as the maple leaf appliqué described in the last case. I have collected some strange and interesting molds, which range from a family of toads, to a set of umbrellas, Roman coins, miniature cars and other odd forms. Again, these forms are never used as the art object itself, but as added figurative elements that embellish the hand-built form. When used judiciously, press-molded elements may give a work humor and irony. With some clients, such as the learning disabled or multiply handicapped, having a process requiring only gross-motoric control which results in objects that are automatically realistic can in itself be therapeutic. In using these molds I prefer to use regular clay which is pressed into the form, rather than pouring liquid slip into the mold. After the plaster has drawn the moisture from the clay it will be firm enough to handle and be extricated from the mold. The element can then be embellished further or appliquéd to any ceramic form, as illustrated by the last case.

Slump molds are also made of plaster of Paris, though they tend to be larger than their press-mold cousins. One excellent slump mold is that of a sphere, which I cast in halves, enabling one to press slabs or coils of clay and then join them to create a globe. The illustration (Figure 10) shows a boy who is steadying a series of pieces created from coils that were pressed into slump molds by many different students. Elementary school students from a school for the deaf worked with their deaf/blind neighbors as a social collaborative session. Even the weakest or most disabled child seemed to enjoy rolling out numerous long coils and placing them haphazardly into the mold. Once each hemisphere was filled, the seams were welded together using a rubber rib and then a plastic ball was rolled around inside, melding and smoothing the coils further. Once the coils were set up, a colleague and I joined the halves together (as this process required much coordinated effort) by slipping and scoring each of the lips. One group elected not to join the halves, but left their pieces to assume the shape of bowl-type forms. To stack the individual elements to form a large-scale piece, holes were left at each of the poles, allowing a one-inch steel pipe to run through each sphere. This

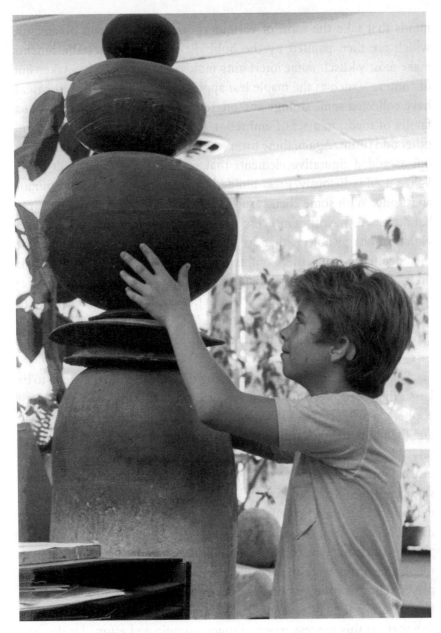

Figure 10: This modular outdoor sculpture was a collaborative effort between children with various disabilities. Coils were used to form spheres, cylinders and small sculptural elements.

pipe was loosely screwed down to compress the spheres slightly (too much pressure might have cracked the globes). Once locked together with a bead of caulking compound, the entire piece was sufficiently rigid and supported to be installed outside in the school's sculpture garden (Henley 1992a).

Some plaster molds may come in the form of platters or plates. Once again, a bundle of coils placed into the mold is then melded together. As the clay is forced against the plaster surface, it can assume an almost perfect shape. As the coils or slabs firm up, they can be taken out of the mold. Among the most dynamic of forms, these flat pieces are ideal painting surfaces. Underglazes, slips, glazing pencils or regular glazes can be used to create varied two-dimensional designs.

Sling molds are another option for creating larger-scale slab pieces. In one session a young woman with profound developmental disabilities rolled out a large slab on a piece of unprimed canvas that was temporarily tacked to a board. Once the general shape and contour of the piece was cut with a fettling knife, we removed the slab as though it was an arm in a sling: the ends of the canvas were picked up and brought to a stationary object where it would be positioned until it firmed up to leather hard. The curve of the sling was created by the gravity pulling the slab downward. The severity of the curve was determined by the distance between the two end-points of the canvas: a shorter distance would create a heavily arched form, while a stretched out canvas would produce little curve. Once firmed up, the slab could be removed with its curve intact, and stood up to receive its base and other embellishments. These pieces were also included as part of an installation for the school's sculpture garden. Slightly buried in mulch with bedding flowers planted around it, the work itself seemed born of the earth.

Extruding

Many well-equipped ceramics studios have clay extruders, devices which manufacture different clay elements such as tube forms, coils, cubes, and other custom shapes. As shown (Figure 11), the extruder comprises a rectangular steel barrel and a plunger which, if pulled downward, will force the clay through the different dies. As more clay is added to the barrel, a continuous extrusion of either hollow or solid shapes can be

Figure 11: Extruding clay elements encourages collaborative learning while facilitating the sculptural process.

created. In Figure 11 two boys are shown extruding tube forms, which required much exertion and applied force. Of course they reveled in climbing up onto the table to pull the great lever in a show of strength.

In Figure 12 they are shown working collaboratively on a piece using their hollow tubes. Once firmed, the tube forms were bent, twisted and played with, until eventually they became a free-form sculpture. In this session the goal was not to derive insight from creating images but rather to use the equipment productively, play cooperatively and, in the process, release pent-up tension and aggression through constructive means. In some cases, coil-built projects are best approached through extruding rather than hand-rolling the coils. Long continuous coils of different diameters can be extruded which can be used for pottery or larger scale projects, such as the spherical sculpture shown in Figure 10, which was donated to the school's sculpture garden.

In some projects the clients enjoy "drawing" with coils, creating designs using contour lines that resemble free-form pretzels. The scale of clay drawings can be adjusted by using miniature clay extruders which can create fine, hair-sized coils, such as the case described on page 106. The versatility of extruded coils adds another dimension to the sculptural and pottery process without the need for advanced skill. However, because coils are stacked atop each other, seams are left between each piece. Therefore it is probable that more cracks will develop in coil-built works than in methods where there are fewer seams, unless each coil is completely melded into the next. Despite the problems inherent in this technique, many art therapists and educators persist in using the coiling process. Working so many elements together is a labor-intensive task that may not be suited for those clients who cannot handle the disappointment of lost or damaged works.

Figure 12: Once extruded, the children are free to experiment with their forms, encouraging cooperative and expressive work.

6. Techniques
in Figurative Sculpture

Bringing the figure to life

Perhaps the most challenging yet therapeutically useful technique in clayworks is figurative sculpture. Children and adults alike are often drawn to creating everything from family members and pets, to refrigerators and battleships. Modeling human and other figures is difficult enough for skilled artists. Even at university level, I have witnessed gifted art students struggle with the process of "seeing" three dimensional forms in proportion without distortion. Body proportions may be off, particularly when sculpting different genders (which have decidedly different body structures) as well as subtle details such as the hands and feet. Different poses also complicate the process, since these too will change the proportions and thus distort the figure. One key element of accurately sculpting the figure is to work from life, observing and studying a live model for as long a period as possible. This point is borne out when looking at the extraordinary sculptures of bisons and other prehistoric animals that were crucial to the lives of Paleolithic humans. These near miraculous works reflect the countless years of observing the animals and their natural behaviors: from lying down in a snow-field, to running away from predators, to mock-fighting and butting heads during the mating season. In these sculptures, the bison come alive because Paleolithic artists *knew* their subjects. Being so intimate with their subjects (as their lives depended on them), the artists seemed to recreate them from memory effortlessly while deep within their sacred caves.

In art therapy settings, it is unfortunate that therapists rarely emphasize studying one's subject from life. Instead, students or clients often work from photographs which essentially flatten the form and distort it in the process. Also, by using a photograph one cannot view the object from multiple perspectives, which is crucial for gaining an understanding of the mass of the figure and how it is rooted firmly on the ground (Luccesi and Malmstrom 1980; Langland 1988). Such reality-based work has important implications in therapy. For clients with reality-testing issues or somatic disturbances, observing and working from life may contribute to an increased sense of groundedness and solidity of objects.

In situations where a live model is not appropriate or practical, I have spent unending hours in sessions with clients posing my own hands, head, and entire body in a particular position for this very reason. Clients in some cases will also request to pose, which is a situation that must be sensitively handled. For instance, a twelve-year-old boy with severely deformed hands enthusiastically volunteered to pose for his class (Henley 1992a). In order for him to control what body parts his classmates would sculpt, I provided him with a piece of drapery to use as a prop in case he decided to cover up his hands or any other area of his body. Being a well-adjusted, uninhibited child, he freely left one of his hands in plain view despite the obvious disability. Interestingly enough, three out of five classmates sculpted his deformed hand, with one peer modeling it as it appeared, while the other two rendered it with anatomical accuracy. This suggests that his peers were comfortable with his disability, that he was accepted as an otherwise normal cohort.

In my training of art therapy students, modeling from life is always included as an experiential part of the curriculum. Particularly in the case of students coming from a non-art major background such as psychology, this opportunity to work from life in their art therapy studio classes might be their only life-sculpting or drawing experience.

Distortion in figure modeling

In art therapy, distortions will occur not only due to poor models or undeveloped sculpting skill, but also in response to the client's own emotional or perceptual disturbances. Issues related to sexuality, gender,

weight, bodily injury such as paralysis or amputation, as well as cultural stereotypes of what constitutes the ideal voluptuous figure or muscular body-build, may all contribute to body-image distortion when rendering the figurative form. Dealing with the body naturally invites projective identification into the art process. Frailties, insecurities, and trauma may all enter the form or content in anyone's art work, whether they be artist, therapist, or client. Examples of projection, within both normal and pathological limits, abound in the case material. Distorted or idealized bodily perceptions or disturbances of the body-ego can be reflected in any self-representation. For instance, a normal yet sensitive sixth-grade girl in a mainstream school worked and reworked her budding breasts in highly detailed self-portrait. As hard as she tried, they would end up sticking straight out like stiff cones, or were cut away until only puny lumps were left. Given this child's fragile and changing body-image, a realistic depiction of this emotionally loaded area seemed developmentally out of reach at that time: thus whatever the outcome, she was left to her own devices without interference. Other middle-school students idealized their portraits: they straightened hair or teeth, added high cheek bones, and so forth. Again, such narcissistic idealization is a wholly normal and appropriate expression during pre-teen development.

In those with impaired reality-testing, distortion may become even more bizarre. One psychotic and combative young man sculpted what seemed like a realistic self-portrait, except for the modeling of his hands, which looked like seal-flippers. Since the hands were a source of conflict, particularly when he lost control of his rage, this distortion was not surprising. Another psychotic man, who was also profoundly deaf, sculpted his head as being left open, which revealed an elaborate machine inside. One young teen-age girl with eating disorders not surprisingly obsessed over her figure's mouth, which ended up as an impenetrable slit. A learning disabled yet gifted boy with a history of biting others depicted the mouth of his pet cat as bristling with sharp spikes for teeth, and so on.

It is obvious then that sculpting human or other figures may be emotionally taxing for both our clients and others who must cope with insecurities and inhibitions about their body. Art therapists in training experience this first hand. Throughout the figure sculpting component of their

clayworks studio class, the graduate students struggle to develop their own skills at rendering bodily proportion, or model the subtle expressions of the face without undue distortion. At the same time they must also deal with their own conscious and unconscious unresolved issues related to their own bodies. If they themselves once suffered an eating disorder, what can we expect of their own sculpted mouths and bodies? Might their own issues be unsuspectedly imposed upon their clients or have they been worked through in therapy or supervision? It is imperative that when working with clients, the therapist must at least be aware of these issues and strive towards their neutralization. Kris (1952) termed this neutralized state as "the conflict-free sphere:" meaning that the therapist's own distorted body-ego or any other issues must not trespass into the client's therapeutic experience. If we consider art therapy as a "corrective" experience, then the therapist must be able to model those behaviors that encourage neutralization and sublimation and not feed into the pathology.

Kramer (1986) taps into this dynamic in her drawing experiential in which she cultivates the use of the "Third Hand" which I have adapted to figure sculpting. In this exercise students work with an image created by a client whose figure displays obvious pathology. This image is worked over in three different phases. They must first study this work, and then faithfully recreate each element, including the distortions evident in the client's figure. In the second part of the exercise, the students once again sculpt this figure, only in this version, they create an idealized or "corrected" version of the figure. Through modifications in form or content, they try to erase all traces of psychopathology according to their own fantasies of what constitutes a state of idealized mental health. In the third phase, the students must devise an appropriate intervention for this case – one that, in some modest way, reflects a reasonable increment of growth. The figure might be resculpted focusing upon a problem area of the figure – such as helping our combative psychotic patient with the seal-flipper hands to become more oriented to reality by helping him sculpt less distorted hands. I have seen such corrective intervention exert a kind of sympathetic magic with some patients – as the seal-flipper sculpture became less monstrous, his perception of his own hands changed and he modeled them with less pronounced distortion. With

more realistically sculpted hands, he began to raise his awareness of how his hands carried out the impulse to act out his uncontrollable fits of rage.

To encourage any client to modify his or her art is a provocative intervention which must be defended. If warranted, changes in form or content must be approached in a way that is non-threatening, non-intrusive, and developmentally accessible to the client. Modifications must also be in line with the client's intentions. The man with the flippers might once have been an artist who decided to exaggerate his hands intentionally as an interesting design device, or a way to provide emphasis or convey absurdity or humor in his work. With the artist's conscious intentionality considered, intervening to "correct" or rescue his work might be grossly inappropriate.

The intention of Kramer's experiential is threefold. In the first phase of the exercise, the students copy the disturbed figure in a bid to increase their own empathy for the client and his or her art. By "mirroring" the client's efforts, we might begin to understand the forces which brought that work into being. Upon sculpting the second figure – the idealized version – students can become better sensitized to their own rescue fantasies and other counter-transferential feelings that might interfere with the therapy. In sculpting the final version, we explore interventions which may help the client resolve certain elements in their work, to restore a sense of wholeness, without implying that their efforts are inadequate and have been rejected.

Dealing with such countertransference material is among the more challenging aspects of claywork in art therapy, as even the healthiest individual is liable to defend against unresolved issues related to one's self-image. Again, this is often exacerbated by the propensity for clay to precipitate temporary regression, given the rich sensorial aspects of the material alone.

In art therapy, anatomical accuracy should not detract from the expressivity of the figure sculpting experience. Clients and students alike need to be freed up when working with the body, using whatever stylistic devices are chosen to explore the figurative form. Many of the pieces I have encountered, both in art school and in therapy, which possess perfect proportion are often stiff, lifeless and void of emotion. To address this rigidity, we may decide to work with dynamic poses that accentuate

gestures, movement, and action. One such example is a work by art therapist, Michele Corker, who sculpted this figure as part of an open-ended experiential while an art therapy graduate student in training (Figure 13). Unfazed by anatomical detail, yet provocatively posed with spread legs, her abstract figure evokes a sense of mystery. The figure's seated posture seems ambivalent: it is strong and powerful in presence, yet it appears battered by some unnamed trauma. The broken arm (which broke after the fire), strung haphazardly on its chest almost like a medallion or amulet, remains a mystery. The strong, convincing modeling of the intact arm evokes a sense of angst as it is flexed against the neck as though trying to relieve some psychic pain. The head is featureless, yet it conveys a sense of drama given its slightly bowed position. The use of loosely wound yarn tangles the figure in bondage while, at the same time, it seems to keep it intact. Much is evoked in this figure despite its economy of detailing or paucity of narrative information. Ambiguity and existential drama coexist with a commanding, sure sense of form.

Techniques in figurative sculpture

It is evident from this image that anatomical accuracy is not a necessity for creating strong figurative self-expression. Therefore, as we scale down techniques to the level of the client – usually by simplifying or abstracting the figure – it may not be necessary to sacrifice the aesthetic integrity of the work. With a strong motivational stimulus and quality materials (including mixed media such as yarn) even the youngest or lowest functioning client may be capable of creating expressive figurative work.

One technique for younger or lower functioning individuals is the "cut-out" method. While working with a multiply handicapped deaf/blind child, I cut a slab of one-inch thick clay into a generic figure which I then invited her to complete – a process termed the *closure method* by Lowenfeld (1957). Because the head and all the limbs are already formed, little effort was required to fabricate these different parts. Instead, the cut-out figure is simply pinched to round out the torso and limbs and then bent to suggest that it is in action. The figure in this case was shown bending down to the floor, to feel around for her hearing aid – a reenactment of a constant problem in this child's life. However, one

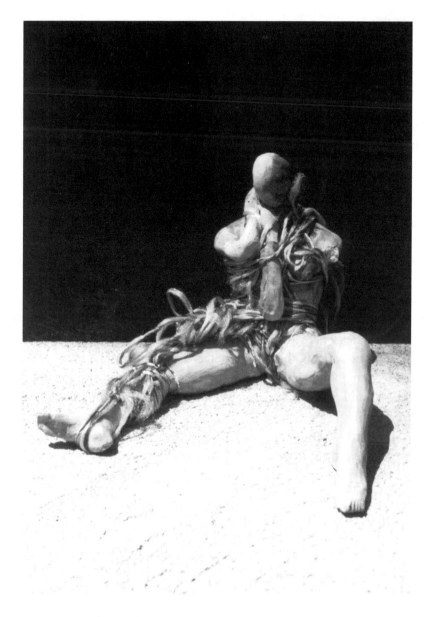

Figure 13: An abstract figurative piece by art therapist Michele Corker, who utilized twine and other elements to celebrate rather obscure post-fire breakage.

disadvantage of this intervention is that some clients may not wish to work further in order to personalize the generic figure, which leaves a disagreeable cookie-cutter look. It is tantamount to handing a client a stereotyped image which is already finished and is thus preferred over something more expressive. However, if one is running a group of nine hyperactive six-year-olds, or has four autistic children to monitor, a one-piece stamped-out figure becomes the technique of choice to get the process going.

Another approach to modeling small-scale figures is to form individual pieces and then join the elements together. The torso is usually the starting point, which is formed from a squared-off piece of clay with the neck and head being pinched out from this form. The thickest part of the sculpture, the torso, often needs to be hollowed out with a modeling loop tool. This thinning-out process may need to take place out of the client's sight. This is because the hollowing process is most often accomplished by cutting and removing excess material through the figure's back, crotch or buttock area where it will not affect the detailing of the modeled form. Witnessed by patients, this may be perceived as a kind of invasive surgery or evisceration. Thus, just thinning out a client's piece can be a potentially disturbing intervention that can arouse powerful effects, unless it is done with sensitivity.

Sometimes the figurative sculpting process is facilitated by giving the pre-hollowed torso/head assembly to the client as a point of departure. With this element in hand, the next operation is to roll out arms and legs using coils. I demonstrate how to taper the coils for use as limbs by keeping the hands at a slight angle so that pressure is intentionally uneven. In assembling the limbs, a "ball and socket" technique is employed. This consists of making an indentation in the shoulders and lower torso, so that the limbs fit snugly inside the socket. The ends of each element should be slipped and scored to promote better adhesion. Once the figure has all the needed parts, we can then begin to pose the figure according to the client's intentions. The figure could be running, standing with hands on hips, bending down, holding something, hugging another figure, walking a pet – any number of scenarios can be explored. In some instances the client may not have a clear concept in mind, necessitating that the individual explore the figure's body by

adjusting or bending it into different forms. The hands should also be pinched out from the arms, so that they remain in one piece. Usually one pinch to the end will flatten out the palm in the form of a mitten. Fingers can then be cut into the mitten form and further refined. Only the thumb should be a separate piece, which gets laid across the palm to give the hand a sense of architecture rather than being a flattened pancake. The face is a critical area which challenges even the gifted client. My approach is to utilize the modeling tools to create the face without over-sculpting or even touching the clay. In most of the case illustrations to follow, the clients pinched indentations towards the top of the head to form the brow ridge and indented areas to place the eyes. As the basic form of the head is pinched out, the features are then modeled in the most economical fashion possible. By using the tools, simplified yet expressive features can be formed. Adding the nose, eyes, ears and hair completes the figure.

One area that I emphasize is how the client poses the figure. The works of art therapists Michele Corker and Monika Tang demonstrate how dramatic posing contributes narrative and emotion to the sculpture. Stiff, unfocused figures have a Frankenstein-monster look that does little to enliven and animate our clients. Therefore, after a sculpture is completed, I take the time to help the client pose the figure. Many of the illustrations of figures in the case material show how a simple twist of the head implies that eye contact is taking place, that the figure is fully animated and alive. Again, there is no need for anatomical detail to make such figures a success. The power of the form, the sense of its animation and relatedness all contribute to the figure's success. Such criteria have been in place for eons, as evidenced by the vignette which introduces the next chapter.

7. Developmental Considerations in Clayworks

The mysterious Venuses

In the dawn of history the shaman and his clan gather around the fire-pit and gently place a number of clay figurines into the glowing coals. Each of these small sculptures depicts a full-figured woman with massive breasts and a rotund belly. Around the small, otherwise featureless head is a delicately incised headband of plaited hair. The fire-sitters sit transfixed, staring at the blackened faces that peer out of their bed of embers and ash. Flames lick into the night sky. Moments pass and the silent night gives way to a round of loud popping sounds and thuds. Razor thin shards of the red-hot clay shoot like stars out of the fire, signaling to the clan that their figures are blowing apart. The group scatters – not in fear, but to rejoice in celebratory song and dance: for these explosions symbolize the fertility power latent within these tiny figures. With the release of this potent magical ceramic energy, many children will now be conceived and born to the clan.

Archeological evidence of the exploding figurines marks the earliest record of clay being used as both an expressive and a magical medium – some 28,000 years ago in what is now Southern Czechoslovakia. The originators of this theory (Soffer and Vandiver 1993) surmise that these figurines, nicknamed the "Venuses", were elements of ritual as well as aesthetic objects of the highest order. In the fire enactment, the figures played the lead in a passion-play performance in which the seed of the clan would now be cast amongst the ovulating females. The symbolic

power derived from this ritual was drawn from the Venus's abstract, nat-
uralistic design. As part of a prehistoric conceptual performance, the
ancient sculptors would intentionally fire their figures while still in a
moist state – which every potter knows would result in a thermal shock.
Expanding water vapor would blow the pieces into the night sky.
Ironically those Venuses which survived the sacred firing would be
viewed by the ancients as nothing more than duds – not the revered
artworks so coveted by archeologists and art historians throughout
modern history. According to Soffer and Vandiver (1993) they were
simply fireworks that "failed to go off." Indeed to many non-technologi-
cal peoples the concept of art being a "commodity" is a foreign, even
profane concept. To the Dogon people of West Africa or those of the
Sepic River in New Guinea, even the most beautifully crafted ritual
objects are discarded after the ceremonies as their magical power is
deemed to be "spent." Naturally, these tribesmen look upon the many
Western collectors who rush to covet and profit from such "primitive art"
as being quite stupid. To them, the physical bodies of these objects were
as disposable as a winter scarecrow.

Thousands of years later, artists and art therapists continue to utilize
the figure as a vehicle for self-expression. They draw upon the archetypal
form's curative power and utilize human, animal or other effigy forms to
explore one's self-concept, relationships, culture and gender. The latter
theme was explored by art therapist Denise Spitaliere, whose interest in
Venuses, Sheelas and other fertility or apotropaic symbols found form in
her miniature sculptures (Gimbutas 1991). These diminutive goddesses
were sculpted from a novel material called "art clay silver", which is a
compound composed of silver dust mixed with organic binders to form a
slip-like paste. Spitaliere laid down almost twenty layers of the paste
around a tiny cork armature to form the two-inch Venus shown in Figure
14 – which was then fired until only a thin hollow shell of fine silver
remained. Writing on this piece, Spitaliere expresses her personal
struggle in creating a professional identity which satisfies both the
yearning to bring forth life and a commitment towards helping others
through her art. With a legacy that reaches back to pre-history, the
creation of such archaic figurative forms assumes the suggestive power of
a talisman, as the figure's metaphorical or magical meaning supersedes its

aesthetic appeal (Sutterlin 1989). Beittel writes that the Japanese word *hara* signifies the universal bodily roundness, the centering of gravity in the sphere of the belly – that breasts and belly swell with the spherical pressure of growth and giving life, out from the center (1989).

Figure 14: A minature "Venus" sculpted in "silver art-clay" by art therapist Denise Spitaliere.

In the following section I shall describe, in vignette form, how other artists, patients, and children all strive for wholeness out of the center. In the following case studies we shall encounter a remarkable diversity of figurative sculptures, from a young blind man's life-size full-bodied self-portraits, to a four-year-old's depiction of his new puppy, to the delicately modeled "command" computer supposedly embedded in the brain of an acutely psychotic young man: the metaphorical meaning in these and other cases may not be so very far removed from the magical power evoked by Venuses from then and now.

Early experiences in clay

Thirty thousand years after the clansmen of the prehistoric tribes mined their clay for the Venus rituals, our summer camper dug her own ocher clay from the lake-shore deposits. As the clan dug their clay for their goddesses, a cave-child might have played nearby on the river banks, perhaps someone not unlike our own mute child who was drawn to the ocher shore-line. Both might have plunged their fingers into the soft, impressionable mud to mortar up their own cairns of rock built in the lake's shallows.

When at play, a Paleolithic three-year-old was probably not very different from the modern child smearing pudding at the highchair. No child needs to be taught to smear their baby food – it occurs seemingly every time we take our eyes off the toddler who is supposedly finishing their meal. The tactile pleasure that comes with such play perhaps lingers in our memory, leading us to partake in similar sensory experiences throughout our adult lives.

In therapeutic settings, the first experiences in clay may not be all that different from smearing baby food. Young children as well as others functioning at infantile levels may require clay which poses no health risks if the material is ingested. For instance, in my therapeutic work with young primates such as the male chimpanzee named Ciri, the introduction of food-colored edible clay elicited much tasting and smearing behavior almost identical with that of two-year-old humans (Henley 1992b). Figure 15 shows how the introduction of an unfamiliar food-like material generated such enthusiastic play that the project bordered upon becoming an all-out food-fight. This energetic baby overcame his initial reluctance to touch the unfamiliar material until his natural curiosity led to exploring the material with abandon. In order to discourage popping lumps of clay into his mouth, I watered down the material to a slip-like consistency. This intervention seemed to displace the need to eat the doughy clay. Instead, he is shown wrestling around with both me and his art project, as he clearly became overstimulated by the bright blue, orange and brown dough-slip. I became his playmate who provided a secure emotional base to express his natural curiosity for all things novel. The clay became a vehicle for releasing his pent-up frustrations that came with being confined to a zoological institution.

My interventions focused upon containing this chaos while allowing him to channel his energies to express himself in a robust way. His behavior oscillated between displaying his physical prowess, with much posturing and raising of hackles (notice his fur standing on end), which was then interspersed with the most infantile hugging which occurred whenever he would inexplicably startle himself. In this case, we can begin to appreciate how clay can serve as a powerful stimulus. It provides a strong sensory experience that can easily regress the youngster into naughty behavior that requires firm limit-setting (in this case he was now so overstimulated that setting limits was futile. While washing up, he proceeded to tear the soap dispenser off the wall with his prehensile feet and then smear both the orange slip and viscous green liquid soap all over the tile walls in an "action" splatter painting worthy of a Pollock!)

Figure 15: Food-dyed slip smeared onto a canvas board over-stimulated this young chimpanzee, who received play-art therapy by the author at the Lincoln Park Zoo in Chicago.

When working with handicapped children, the issue of stimulating such infantile behavior while clay-working becomes an ongoing presenting problem. The illustration (Figure 16) depicts a multiply handicapped child we shall call Violet, whose autistic symptoms included "pica," which means that she would eat almost any inedible object as a form of oral gratification. Monitoring her closely, the therapeutic aide is shown preventing Violet from ingesting the material. Despite her profound handicaps, this child's movements could be lightning quick, thus it was inevitable that some clay would make it to her mouth. Because of this propensity, we utilized an edible clay made from water, salt, flour, and cornstarch, described by Kohl (1989) on page 18. With such a safe material in hand, this child and others with oral fixations can safely enjoy exploring the clay in any way that gives them pleasure. Whether it be a normal healthy two-year-old chimp, or an autistic child with pica, at this stage of development clay remains a sensory, kinesthetic experience, with there being no concern over the creation of a product. However, we can prepare these

Figure 16: Keeping clay out of the mouths of young severely handicapped children requires both vigilance and patience!

children to model their first images by teaching the movements needed, such as smacking, stacking, rolling coils and rolling out slabs with a rolling pin – activities which are almost always a pleasurable experience. During this period of free exploration, therapeutic objectives such as overcoming tactile resistance, establishing eye contact with the material, practicing hand coordination and eliciting pleasurable affects may all be addressed.

First images

Although clay is inviting to most young or handicapped children, the development of figurative sculpting does not unfold as naturally as it does in drawing. E.V. Brown (1975, 1984) found that clay figures are developmentally one or two years behind the figure drawings of children during ages three to six. However, this development can be accelerated in normal or healthy children given some instruction and practice. Demonstrating how to roll a coil or ball and then attach the pieces together is almost a prerequisite to eliciting figures of symbolic significance. It was Kellogg (1969) who conducted the most comprehensive research on sculpting development in young children. She found that in children as young as three, sculptural forms run roughly parallel to the stages of drawing development if a few basic skills have been mastered. These include the process of rolling coils and balls which may then be smacked flat, which creates the first circular forms or mandalas. In the early stages of sculpture development, the mandala form appears to organize and lend structure to the child's perceptions. These mandalas are referred to by Kellogg as "aggregates" which are usually within the potential of intact three-year-olds. Brown (1975) found that 18 per cent of three-year-olds could make recognizable heads or bodies of the "tadpole" variety. Most were essentially circular balls or slabs which were then added to or elaborated using different coils or smaller circles to form crosses, radials, and other gestalts. By the age of four these aggregates may be combined into the first figurative representations. Figure 17 shows these small but complex radiating patterns that seem to suggest the imminent arrival of body, limbs and head-like forms. Although such figures may not be anatomically accurate, they often do possess symbolic significance. Like

Figure 17: The development of a figurative schema in young children often makes use of radiating mandalas.

Lowenfeld's "named scribble stage" (1957) in which even random lines may represent fully formed ideas on the part of the child, so too may these elementary clay forms assume meaning for the young child. This piece, a simple circular radial with seven spokes, was described in great detail by a four-year-old we shall name Jess. After forming this piece, he described it as his: "new puppy who always has to go outside to pee." The inclusion of seven rather than the correct number of limbs may allude to this child's kinetic sensory impressions. At the risk of reading too much into this sculpture, we might surmise that the inclusion of numerous legs meant to convey something about the puppy's constant, uncoordinated motion. Perhaps too the extra coils refer back to his original association and represented the puppy's toilet training – which for a four-year-old may still be a sensitive issue. Since this was a "normal", healthy child, these issues were considered a part of his normal development, and were thus not addressed therapeutically. Instead, they form a record of this child's sensory impressions, including his relationship to the puppy. It is this conceptual understanding that gives meaning to his world. Much of this world revolves around his feelings for the puppy, who provides much

love and comfort in his day-to-day life. The puppy also kindled feelings of sibling conflict, as he made several comments about the attention paid to the new "baby" by his mother. We might liken the investment in this pet as representative of the capacity to give and receive love. Despite his jealousy, feelings such as these suggest a favorable emotional climate, one established early on by the mother through her own contact comfort and holding during infancy. The clay perhaps stimulated this association, given its tactile and molding qualities that correlate to the mother's touch. In this sense the puppy may stand as an advanced form of transitional object, not as a replacement for mother as much as an extension or symbol of the mother's emotional availability (Winnicott 1965).

Rubin (1978, 1984) writes that intentionality at this early stage of symbol development is protean, with a multiplicity of associations possible with a single modest abstract form. She cites the case of five-year-old "Rose" whose scribbly images ranged from "snakes tangled up", to "two snakes kissing", and finally, to a "boy who's goin' to eat grass" (p.58). Each of these fluid associations has meaning for the young child. Interventions which attempt to fix these associations are thus inappropriate, as the young child requires a free, even magical hand to give meaning to her experiences.

Claywork and play

As the child develops the capacity to symbolize through claywork, playful animation of clay figures may lead to productive therapeutic outcomes. For instance, a normal, healthy four-year-old girl we shall name Katy, and her six-year-old brother Tom were seen in art therapy as a means of providing emotional support during their parents' painful separation. The mother had just left the home and the father was shuttling the children back and forth for visits. Such transitions often present the most disruptive and emotionally unsettling consequence for many children of divorce. Much of this transition anxiety became apparent during our initial art therapy sessions.

When we began our work, each child became intrigued with my demonstration of making small clay figures. Stacking the small clay balls upon each other in the style of the stereotypical snow-man, I showed the

siblings how to build and integrate the different body parts. They followed my lead, rolling out a series of balls which they proceeded to stack one atop the other until a whole family of figures populated the table. While these figures were almost identical to each other, what differed was how each of the children conceptualized his or her figures after completion. Katy playfully animated her figures while narrating the characters' dialogue in different voices. Although difficult to follow, Katy's narrative included one figure which "flew like a bird," while another "fell into the ocean." In contrast, brother Tom's figures were more akin to artistic productions rather than objects of play. He created a rudimentary boat (which required my hands-on assistance) and placed the figures according to his familial relationships. Still in the throes of developmentally normal egocentricity, Tom made himself the boat's captain. With Daddy's new-found roles as both bread-winner and house-father, he was designated both "motor mechanic and cook," sister Katy and a cousin were lower rank passengers, and so forth. Conspicuously missing in the composition was the mother. After admiring his sculpture, Tom began to move the boat around the table making different sound effects. In all probability, Tom would not have begun playing with his work if his sister had not been in the session. When working with siblings, a dynamic often arises in which developmental and maturation levels fluctuate along with the protean nature of their art. As evidenced in this session, the younger child sometimes rises in her level of functioning while the older brother may temporarily regress to more childish forms of expression – all of which is normal and appropriate in young children. We should come to expect this phenomenon when the children are confronting emotionally sensitive issues in therapy.

Kramer (1977) has observed that unlike the ephemeral quality of play, where scenarios shift and take different directions in a dream-like way, art requires the making of concrete objects that permanently embody meaning – and are thus symbolic expressions. This added symbolic dimension requires highly complex cognitive and emotional processes. Kramer contends that the making of art places greater demands upon the child who may have to "face an unwelcomed truth, make far reaching decisions, or renounce easy gratifications" (1977, p.8). As Katy's figures soared around in a flight of free-form fantasy, Tom's

efforts appeared more linked to the family's new reality: that mother is no longer available. This he subtly suggested by omitting her in the composition and by assigning Daddy with the dual roles of cooking as well as keeping the vessel afloat. It is significant that Tom designated himself as the captain of the boat that he himself created. We might read this perhaps as a symbolic "life-boat" – one that rescued Tom from the "sinking ship" that threatened the family's dissolution. His role as the captain may be in reaction to the new roles required of children of divorced parents. Often they must step into realities usually reserved for adults, such as having to shoulder more responsibility around the house (Tom was often providing child-care for his sister). The children are often used by parents as a "splitting device," which sets one parent against the other during custody disputes. It is possible that Tom reverted to play as defensive posture that softened the reality of having to face these and other harsh realities – particularly his mother's absence. This loss was perhaps expressed by Tom's constant "checking" on his piece as it passed through the drying process. As with other children with insecurity or anxiety issues, this checking back might represent a lack of object permanence or libidinal constancy related to the abandonment of the mother (Mahler, Pine, and Bergmann 1975). It seemed that only through sustained visual contact could Tom feel secure in the hope that his piece would survive the drying and firing process and not inexplicably disappear.

The fluctuation between immature play and more symbolic formed expression is seen as a healthy opportunity for the child to regress safely during therapy. As both children became secure within the holding environment of the studio, Tom and Katy could then begin to create symbolic equivalents for their loss – one that they could not otherwise express in words.

8. Figurative Sculpture and Case Material

As the child develops the capacity for more sophisticated use of the material with greater technical competence, the therapeutic process advances accordingly. The following clients, for the most part, developed sufficient sculpting skills to explore complex issues through their art. As their form and content became more articulated, both aesthetic outcomes and therapeutic insight became a possibility. Sublimations abound in this material, as the quality of transformation inherent in these pieces coincided with the developmental gains and emotional relief that were often generalized into the client's everyday behavior.

Clay and object loss

It is devastating enough when a child is separated from or abandoned by a parent. It is unthinkable that both parents could die as a result of the father killing his spouse and then taking his own life, leaving four young children to cope with the loss. This nightmarish trauma was endured by one ten-year-old boy we shall name Ken, for whom the devastating loss of his mother and father by gunfire at age four was further complicated by a severe attention deficit disability. Pre-morbid symptoms included hyperactivity, auditory processing problems and affect dysregulation. After his loss, symptoms expanded to include selective mutism, fits of uncontrollable wildness, social inhibition, and periodic regressions into autistic-like withdrawal. Bowlby (1969) cites evidence that such trauma

will often precipitate psychiatric symptoms, particularly major depression. Bowlby cites three stages that are manifest when a young child is separated from or loses the mother. The initial response is one of protest, such as crying, attention seeking, tantrums or other urgent efforts to recover the lost object. If the mother and child cannot be reunited, as in this case, despair may set in. Bowlby observed that the longing for the mother persists but the hope of its being realized fades. The third and most intractable stage occurs when the child gives up hope and becomes apathetic and withdrawn. In this case, repression set in that spared the child from consciously processing traumatic memories. However, the defensive exclusion of memory is rarely complete. Bowlby explains that some material seeps through so that fragments of memory are activated. In this child, there was no indication that such seepage occurred beyond his propensity to act out, which might be a product of the pre-morbid ADHD (Henley 1999b). Ken's sculptures support the repression defense theory, as his figurative work centered around animals which are hunted for sport. As a product of a rural family used to taking a deer each hunting season, Ken's proclivity towards this theme is culturally within the norm. However, it is the perseveration on this theme which suggests its defensive nature. Countless figures of skillfully rendered hoofed animals were drawn, painted and sculpted in various scenarios, hunted by bow or rifle. The illustration shown in Figure 18 is one example of this genre. The bighorn sheep was modeled with the most economical hand and tool-work. It is depicted sitting chewing its cud in a diorama painted as a peaceful mountain habitat. This piece was unique in that it was not conceptualized as part of a hunt. Rather, the animal sits unmolested, its form in no way suggestive of overt anxiety or distortion. The painted diorama gives the animal a sheltered quality, as though the borders of the cardboard box provide enough containment to keep it safe from dangerous predators.

Figure 18: Dioramas which incorporate figurative sculpture can increase the narrative richness of the work.

We might consider the repetitive nature of the hunting themes as sugges-tive of this child's annihilation anxiety. This anxiety perhaps illustrates Bowlby's ideas on attachment loss involving psychic "seepage." Trauma enters consciousness as though recalling a night terror or dream – such intrusions indicate that the violent nature of his parents' deaths has not been fully repressed. It is probable the child was left feeling that he himself could be the next victim, despite the reality that the murderer had perished and could no longer do him harm. In reaction to this fear and other magical thoughts, Ken became the hunter. Operating on a precon-scious level, this child was able to channel these intolerable thoughts and feelings through themes which left him in control and master of the hunt. Whether it be reaction formation or identification with the aggressor, Ken's defenses seem at risk since repression is highly tenuous at best. Yet we are relieved that this child has found an outlet for his despair – one that offers a modicum of intra-psychic relief for his unspeakable suffering.

In another case, a sixteen-year-old boy we shall refer to as Len also utilized his figurative work as a means of discharging the rage and hurt that came with the traumatic loss of his father. A gifted sculptor, Len often created fantastic characters in drawing and, in this case, from polymer, which depict various mythological monsters. One such character is supposed to be a "tribal demon" who is posed sitting naked, nonchalantly combing the strands of his knee-length hair through his claw-like hands (Figure 19). Creating a series of such frightening figures effectively sublimated this young adult's inner rage, though the evidence of conflict has not been fully transformed in his art productions. The disturbing quality of his figures suggests that sublimation remains in its formative stages. Yet Len's clever use of humor remains an effective vehicle to release pent-up affects as well as tempering the raw feelings held within.

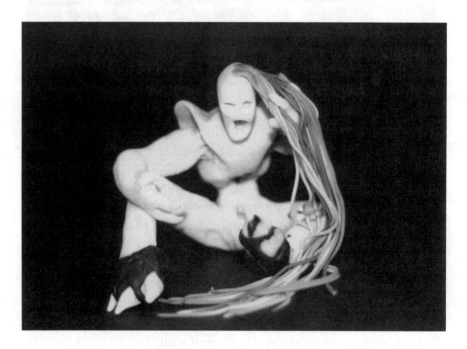

Figure 19: Polymer clay can absorb tremendous aggression given its extensive work-life. This young man has given form to powerful and potentially overwhelming rage through constructive means.

During our critiques of these pieces, our conversation about the piece led to a discussion over the various influences in his art. Aside from the usual video games and other popular media, he commented how he and his father shared an interest in the campy macabre – particularly "B" horror movies of the 1950s. Perhaps then, this work can also be viewed as a symbolic homage to their relationship, one that was infused with ambivalence about being abandoned, as well as symbolizing the wish for reunion. By creating this image in the company of his therapist, Len's wish for reconciliation with the lost father could be symbolically "practiced" via the positive transference. By magically restoring the lost object, some degree of psychic relief could be achieved. My quiet appreciation of this and other ingenious works seemed to provide "emotional refueling" for further creative work which engaged his feelings about his father (Mahler, Pine, and Bergmann 1975).

Child life and clay

Aside from losing one's parent there can be no greater tragedy for a child than being terminally ill. The sometimes long, drawn-out process of dying can be excruciating for the child and family, who must often cope not only with the horrors of impending loss, but with treatments which are as traumatic as the specter of death. Child life therapeutic programs are set up in hospitals as ongoing therapeutic support programs. Here a child can participate in group or individual sessions in which their fears, anxieties and feelings about impending procedures or treatments can be addressed. They are free to play, make art, and read stories which are often chosen as a means of clarifying the children's perceptions about the procedures that they are about to endure. One such program was set up at Children's Hospital in Chicago, which had contracted with a local clayworks group to provide art experiences for medically ill children. The child life program was essentially set up as a play room, where toys and games as well as mock medical equipment were available for the children to explore. Therapeutic art educator Dawn Henley added claywork to these resources, which allowed the children unstructured experiences of playing and sculpting with the material. D.A. Henley (1993) reports that the children often utilized the play-medical equipment such as stetho-

scopes, needleless syringes and plastic scalpels in concert with their
claywork. In one case, a child of nine who had already survived one
surgery and whose cancer was now in remission, attended the clayworks
session prior to her chemotherapy sessions. This child was in the "middle
phase" of treatment, in which the patient was being supported through
the long-term stress of ongoing therapy (Councill 1993). During her
unusual approach to claywork, she used a whole 25lb block of clay to
make a roughed-out form of a body. Barely sculpting or working the
outer shape at all, she would run an elephant ear sponge over the block,
smoothing and smoothing until its squared edges became rounded into a
belly-like form. This type of activity, in which a high quality natural
sponge was used as a self-soothing agent was an integral part of the
therapy. Quite methodically, she would then assemble her tools and
begin to perform "surgery" on the clay block. She began by opening up
the chest cavity and carefully placing "life support" tubes inside. Copious
amounts of water were then poured into the "body" as a kind of irrigating
or cleansing action (creating a slimy mess probably not so different from
that produced in real surgery), which she then siphoned away with the
plastic tubes. What appeared to be malignant material was cut away and
disposed of, using a loop sculpting tool. Much gauze and sterile packing
would then be placed inside to wipe and absorb what water was left. This
child would then enlist Henley's support to close up and suture the body,
taking care to leave the clay torso smoothed out once again to "prevent
scarring" as the child put it.

This activity was not so much a form of play, but a symbolic
enactment in which the clay was used ritually to cope with the trauma of
past and future invasive procedures. This remarkably creative child also
utilized the clay extruder as a method of producing clay hair for use on
her other figures. For children with chemotherapy hair loss, the use of the
extruder became one more quasi-medical tool, one that helped to retrieve
symbolically what had been lost and master the fears that arose with the
realization that full restitution may never come. Thus, the soft plasticity
of clay, the watery sponge, and medical play-equipment all allowed for
the appropriate projection of feelings in ways that facilitated physical and
emotional recovery from the child's ongoing ordeal.

Attachment and family dynamics

Coping with the effects of early traumatic loss does not only cover issues related to premature death. With the influx of adopted children from Eastern Europe, therapists are again seeing trauma-based attachment disorders first described in the early 1940s. John Bowlby (1969), Anna Freud and others of the Tavistock Clinic worked with these child survivors of the death camps and orphaned casualties of the war, finding many deprived of maternal attachments (Freud and Burlingham 1943, cited in Bowlby 1980). Sixty years later children are still being deprived of secure, nurturing attachments due to the collapse of the communist block and regional warfare, which has left thousands of children in orphanages. With Eastern Europe an increasingly popular source for adopting infants of European ancestry, these children have been placed in stable homes with adoptive parents throughout the West including Great Britain and the United States. It appears that a significant number of these neglected children have exhibited a range of attachment related patholo-gies which are now known collectively as "reactive attachment disorder." Symptoms include emotional dysregulation with rage reactions, poor impulse control, lacking a conscience, cruelty to animals, poor peer relations and disturbed relationships with family or others (American Psychiatric Association 1994). Therapeutic approaches have been found to be lacking, with experimental techniques involving forcibly "holding" a child, to release rage and promote physical intimacy, being untested and controversial (James 1989). It is probable that such a provocative approach may further traumatize an already disturbed child. In art therapy, the need to embrace while also releasing fear and rage can be accomplished through the medium of clay as an ideal material. The creation of figurative sculptures such as self-portraits or kinetic families has been used effectively in my own practice, to the extent that relation-ships can be symbolically broached and then "practiced."

One eight-year-old girl we'll name Connie, who suffered with RAD (Reactive Attachment Disorder) and ADHD, was adopted by an American family. She had spent her first three years in a Romanian orphanage where she had been neglected and possibly sexually abused. Connie's approach to clay seemed to correlate to her relationships with others. A gifted, resourceful child, Connie created a recurring image each session in

which she pinched out a series of small empty houses, "one for each family member." She would then attach each of the small teepee-shaped structures to the others, like a cluster of row-houses. The metaphor here was obvious: there was a wish for intimacy and relatedness within her family unit, but there was also the need to remain distinctly separated, which she accomplished by creating the substantial interior walls. It is significant that in each house there were no interior doors between the rooms, but rather there were only doorways which led to the outside. We might liken the lack of access within the structures as a form of "stimulus barrier" – a concept described by Spitz as the incapacity to ward off incoming stimulation resulting in "emotional overload" (1965). This barrier's substantial interior walls seemed a metaphor for Connie's heightened ambivalence over relating to others. This resulted in the need to form a protective barrier that insulated her from many interactions between family members that she deemed to be aggravating or a threat. As with many "reactive" children, forced relating or intimacy (such as family meal-times or car-rides) often triggered reactions similar to that of our mute child in the opening vignette. In this child, aggressive responses occurred that took the form of "fight or flight" reactions (Tinbergen and Tinbergen 1983). For instance she would sometimes invite her younger brother (who was natural born to her parents) to join her in play with her Lego® blocks, but then found that his presence was intolerable. At the slightest provocation she would end up either barricading herself in her room (by slamming her interior doors) or lash out at him in an aggressive fashion. In therapy our objective was to help her to anticipate how and why these rage reactions occurred. She learned to recognize the antecedents of conflict situations, such as her need to interact and play, yet realize that such play was difficult – that she really did not want to share her toys. We then devised a strategy in which some Lego® play-times were limited to just "process," meaning that no finished product was intended – which was an ideal time for sharing with her brother. If, however, she was intent upon creating a lasting structure, she would move her project up to the top of her bunk bed where she would be out of reach of the smaller brother. Up in her eyrie she could observe the comings and goings of her family while remaining secure in her redoubt. She was then

encouraged to invite her mother or family members to visit her creation in her own territory, on her own terms.

During our discussion of her clay row houses, Connie was eventually able to describe her ambivalence over relating to others within the household. From these conversations we devised a new form of door for her home which addressed her feelings for security, yet allowed accessibility. The outcome involved having her parents install a "Dutch door" in her room, which is designed as two independently hinged halves. Thus the bottom could be closed off to limit access, yet permit taller individuals like her parents to look in and relate on a limited basis. With this adaptation she was able to resolve some of her ambivalence over interacting and manage the approach/avoidant anxiety to tolerable levels without resorting to tantrum behavior (Tinbergen and Tinbergen 1983).

Clay and regression

Although Connie was able to contain her anxiety with intensive therapeutic support and behavioral contingencies, regression came often and severely. For instance, if she was not feeling well or was upset with her parents, this child's already tenuous defenses would collapse and ferocious acting out behavior became almost a certainty. In those instances clay had to be introduced with care so as not to further the regression. It is common knowledge that clay has the propensity to loosen controls given its fecal, smearing qualities and its dirtiness, which can rekindle early psychosexual conflicts (Schlossberg 1983). In Connie's case, the loosening of controls led to dangerous actions. During summer camp, she became upset with another boy and hurled the clay like a missile. When lacking impulse control, access to this material had to be closely monitored. However, during these moments of regression, Connie was able to gain access to affects which she often repressed for fear of losing control. Claywork allowed for a "controlled" cathartic release. Kris (1952) termed these temporary regressions as being "in the service of the ego," meaning that dipping into primary process strivings actually replenishes the ego, making defenses more resilient and the art more affectively meaningful. This dipping into was perhaps the case in the monster figures created by Len, who was able to commune with the

dark forces which were fueled by the traumatic loss of the father by creating images of evocative power that symbolized such trauma. In our child with cancer, self-soothing with a fine-grained sponge allowed for a safe, contained regression. In Connie's case, however, progress in therapy could not be furthered unless she exhibited and exorcised her inner rage in our sessions. As her art therapist I constantly had to assess Connie's capacity to utilize clay as a medium that invited such "dipping into" without precipitating outcomes that would be destructive to the therapeutic process.

Claywork and assessment

Varying forms of regression were stimulated by clay sculpting in a study conducted with children who were suspected of being sexually abused. As the third component of Kramer's Art Therapy Assessment procedure, clay sculpture was given as the last task after creating a free-drawing and free-painting (Kramer 2001). The rationale for Kramer's order of tasks was based upon the element of controlled regression that was necessary to uncover past trauma. The first task, a free-drawing, provided a glimpse at the developmental level and defenses at the command of the child. Drawing also indicated the child's quality of relatedness, especially when a kinetic family drawing was created. The second task, a free-painting, was meant to loosen these controls and elicit more intense affect, again by dipping into more primitive material. In the last task, clay sculpting built upon the intensity of the painting process and continued the flow of affects, while also reintegrating the child to create a recognizable figure. Of seventy-two evaluations, disclosures relating to abuse were elicited in thirty of the children during or after the completion of their clay figurative sculptures.

One memorable girl of seven calmly created an androgynous figure that, while generic, was well-crafted and was left relatively undistorted. However moments after completing her piece, she began to ram a modeling tool repeatedly into the figure's genital region, destroying it in the process. Unusually, a tearful verbal disclosure soon followed this reenactment of the trauma. Attempting to head off further regression, I quickly pinched a small bowl which she accepted and continued to

embellish with this same tool. Shifting to more of a craft-like process seemed to neutralize some of the overwhelming effects and provided a moment of consolation.

In another dramatic case, a six-year-old boy we'll refer to as Rasheed created two figures: one sexless figure possessing a full body, the other composed of only a massive head. He then cut a large gash running across the mouth area, which was the head's only discernible feature. When I invited Rasheed to have the figures interact, he calmly placed the full figure in a position that straddled the head and mouth area. After a few moments of contemplating his composition, he began to mash the figure's legs deeply into the face until the boundaries had all but vanished. He continued his melding of the two figures until they were all but obliterated. He then abruptly left the table and walked to the sink area in silence. During these quiet moments of washing up, he spontaneously blurted out how his aunt "freaked me" by forcing him to straddle her face during oral sex abuse. This disclosure occurred during what I have termed the "after-wind." This phenomenon occurs after the struggles with the creative process have drawn to a close. Rituals such as having refreshments, or washing up, allow the child and art therapist to share a quiet respite together, often in reflective silence. It harks back to our opening vignette, when, after the rock towers were completed, we were able to relax and muse over the nature of clay while each child reflected "alone in the presence of the other" (Winnicott 1965).

This victim's older sister failed to make anything at all during her evaluation. Despite my intervention of creating a generic figure for her to embellish, all she could manage was to dig at the figure until it was completely destroyed. For this fragile child, the trauma of being kidnapped and abused led to such tenuous defenses that the clay precipitated regressions of a more destructive nature. While not every case is as dramatic as these, other results bore out that under certain conditions, clay may induce regression in ways that intensify affective reactions, weaken ego-controls and encourage both direct and symbolic "acting out" (as the last case attests). It is up to the art therapist to assess whether a client possesses sufficient ego strength and impulse control to handle this sometimes provocative medium. Used judiciously, clay can be a formida-

ble diagnostic aide given its propensity to uncover previously repressed affects that can find expression through the sculpting process.

Clay as a projective medium

In those cases where the client may not be able to handle the regressive pull of the medium, interventions may be necessary to adjust the material so as to keep tenuous defenses intact. One such intervention took the form of using polymer as a medium that did not exacerbate one child's tendency to regress. Drawing upon its neutral tactile qualities and its tensile strength, the polymer clay proved to be an effective means of absorbing aggressive discharge in a child who lacked self-control. For instance, this ten-year-old boy, who had also sustained a traumatic loss of a parent, was so filled with rage that the introduction of potters' clay resulted in unmitigated chaos and destruction. As an intervention, I decided to switch to Sculpey polymer which was used in concert with a small-scale extruder (which is the size of a garlic press). From a collection of interchangeable dies, the child chose one with numerous holes the size of a small pin. Filling the cylinder with soft, black-colored Sculpey, this boy of ten delighted in pressing down the plunger in order to extrude the clay "spaghetti." The polymer allowed him to form the finest strands of almost one foot in length without their tearing or breaking. If potters' clay was used in such a die, the strands would have dried almost immediately. Any manipulation of the natural clay strands would easily have crushed them to dust. The durability and softness of the polymer material meant that the strands were able to be extruded and manipulated vigorously without concern over breakage. However, it still took great force to press the clay through these small orifices. This child seemed to enjoy the physical exertion however, as it appeared to focus his energies and channel his tremendous aggression through productive means.

Figure 20: Extruded polymer clay was used in this instance as a projective medium for free association as it assumed shifting forms and content.

In most applications, clay strands are usually utilized as hair, as with the child who lost her hair during chemotherapy. However, this child decided to use the strands as the form itself. Once extruded, he placed the bundle of black "spaghetti" (as he termed it) upon a piece of illustration board and spontaneously began to manipulate the material into various forms as a kind of clay scribble. First he formed the bundle into an abstract looking "dragon", which then morphed into a "winged snake," that he said "flew through the night biting the legs of people" (Figure 20). He embellished his story, stating that during one such bite, "the fangs of the snake got stuck in the person's leg and they broke off." As the fangs remained in the victim's flesh, the boy explained that they would continue to drip venom into the victim, "killing him slowly" in this morbid process. He then stated that the person's only hope was to fly in a "bush plane" to find a doctor who could remove the poisonous fangs and "save the person." This free-associative story was told in a dream-like way without much affect or intonation. Its content perhaps stems from the previous session, at which time I had discussed my plans to be away for

two weeks on holiday in Costa Rica. During our animated discussions of the natural history of this interesting country, he casually pointed out that there were many species of poisonous snakes in the jungle. It was clear that this child's associations might have combined his natural enthusiasm for having an adventure, with concerns over losing me in the jungle. I had mistakenly told him of my plans to take a small plane to a remote region of the rain forest, which had initially piqued his interest (as we both are avid naturalists). Sharing this plan with him had generated much abandonment and annihilation anxiety. Discussing these details during a therapy session was obviously thoughtless and constituted an inappropriate intervention for such a fragile child, no matter how fascinated and conversant he was in such matters. Yet the clay allowed us to work this material in a way that gave productive form to his fantasies of annihilation, and thus proved to be a positive therapeutic outcome. Once we baked these different designs, he gave me a small bundle of strands to carry on my trip. With such a fetish in my "medicine bag," perhaps I could be magically protected from the bites of vipers and other misfortunes and thus allay his anxiety that I might not return.

Little did I know that in this session polymer would be used as a medium of projection – similar to that of ink blots or other free associative stimuli. It was the child himself who dictated how the material would be used as a therapeutic medium. Such choice-making had a therapeutic effect, as it allowed this child some control over potentially distressing events. His choice of the extruder die led to the innovative use of clay as a medium of contour drawing. The material and its spaghetti-like form was sufficiently amorphous that its images stimulated spontaneous free-associations, which raised therapeutic issues while avoiding destructive regression.

Controlling regression

In the last case polymer was utilized as a means of sparking free-associations by providing a neutral material for self-expression. Although fragile, this child was healthy enough to withstand the pull towards regression during his dreamy moments of free-association. He was able to muster sufficient reality-testing to work through his concerns

over my potential loss or safety (helped by some magical thinking in the form of a medicine bag and amulet). This problem becomes even more grave, however, when working with disturbed or delusional individuals who do not possess such inner resources. When working with more severe pathologies, the question arises whether to enter into or work with the primary process material or to set limits upon it to stem further regression. Like their verbal counterparts, art therapists struggle with issues related to permissiveness and accommodation of regression in therapy, as opposed to "keeping a lid" on delusional or other material (Waller 1996). Waller cautions the art therapist that permissiveness may also come into conflict with the therapeutic team, who may see art therapy as irresponsibly "unbuttoning" clients, leaving a therapeutic "mess" for others to clean up. This is a particularly difficult issue in group art therapy settings, where images of graphic sex or violence may have a destructive or regressive impact upon impressionable or fragile group members (McNeilly 1983) or alienate others in the therapeutic community (Waller 1996).

When clay is introduced without directives or much structure, the therapist should anticipate the potential for regression. When material is introduced which is potentially disturbing one must again anticipate regression, which I had failed to do when I shared the details of my holiday plans with the previous child. For another young man of twelve with severe hyperactivity and Tourette Syndrome, the clay itself intensified an obsession with drug use and paraphernalia. Though it was unclear whether he actually used drugs, most of his sculptures would start out as unspecified cylinder forms but would end up inevitably as pipes or "bongs" used to smoke cannabis. He was greatly motivated to create this drug paraphernalia – attempts to broaden his interests met with failure. Limiting these objects met with resistance or was overcome by the child's manipulations. In consultation with the therapeutic team, it was decided to address his obsession by allowing him the opportunity to research cannabis use through an appropriate academic treatment of the subject. Magazines such as *National Geographic* were brought in which featured stories on the history of cannabis and poppy cultivation, as well as articles on the social ills caused by the use of these products. This intervention sought to temper the obsession by allowing it controlled or guided

expression, not unlike Kris's ideas on functional regression (Kris 1952). Upon implementation, this intervention backfired terribly. I only succeeded in pouring fuel on the fire, which drove the obsession to more intractable levels. In the last disastrous session of this series, we decided to work outside the studio in the garden. As we relaxed, modeling our clay on the spring lawn, he quickly reformed his piece into a pipe-like form. In a manic flash, he then stuffed the bowl part of the form with ripped-up grass, pretending it was marijuana. Before I could react, he then set his piece on fire with a concealed butane lighter, which of course I immediately wrestled from him while dousing the tiny flame.

Clearly my attempts to channel his interest and enhance our therapeutic alliance had instead overstimulated this child. Because I had allowed him to act out, he probably could not feel safe during our session. Apart from my failed intervention, he no longer trusted me. I then attempted to censure this theme outright, which precipitated further outrage from the child. The claywork was supposed to become a vehicle in which to enter into the client's world. It turned out that he needed to be protected from that world. Needless to say, I came under criticism from other members of the team during group supervision, as they had only reluctantly approved of engaging the child on his terms. However, given the fact that all past strategies had failed to engage this difficult child, we all conceded that there were few options left to try.

This issue also arises when working with psychotic individuals whose claywork may precipitate an acting out or feeding into delusions. In a case reported by Ryan (2001), a disturbed child of ten was obsessed with creating hundreds of "mice." Each of his sculptures was deemed to be a mouse, although they were not realistically rendered as such. The therapeutic team decided as a matter of case policy that this theme would not be accommodated in any form as it led to an increase in delusional and disruptive behavior. This decision reflects the setting in which Ryan worked: in public schools emphasis is placed upon suppressing disruptive symptoms as opposed to allowing them judicious freedom of expression. The "behavior management" devised by the public school required Ryan to set limits on this theme. He would attempt to redirect the child away from this bizarre mouse theme that would often precipitate bouts of wild delusions. The child responded by creating a series of seemingly innocent

vessels, which appeared to suggest that he was departing from the obsession. However upon discussing this small series of pots, the boy referred to them as "funeral urns" which would be used to "hold the ashes of mice" on the altars he had created at home. This vignette is instructive, as it reminds us that the primary process will often find expression no matter what: if not in form, then in secret concept or symbol. Artistic self-expression is often subversive in this way. Sometimes censorship is defied by clients' withdrawing into a shadow world – one that pays only lip service to the authorities that attempt to control their thoughts and behavior. As the psychotic or obsessive client wards off our demands to function within the accordance of our wishes, fight-or-flight reactions may escalate. Clients may retreat further into autistic states that allow their delusions free reign without interference. Relationships with "secret" friends or voices take on an inner life of their own (Bender and Woltman 1937).

In these two vignettes, the therapist attempted to "go where the client was" as a matter of demonstrating respect. However in the first vignette with the cannabis child, going "with" these drug interests was an intervention that led to the child's regression. In the case reported by Ryan, the client successfully side-stepped attempts at censoring the obsessive content in his work by creating pottery forms that "the therapists wanted." While the content remained unchanged, the form of an urn successfully camouflaged his obsessive themes while fending off the interventions of his teachers.

The art-brut aesthetic

In the last vignette, a child was obsessed with mice for reasons we might never know. Perhaps this child's compulsive need served as a defense against the anxiety that accompanied frightening delusions or inner voices. Perhaps too they symbolized his own lack of self-esteem, if we consider his obsession with "vermin" as a matter of self-identification. The creation of countless mice might have become a metaphor, as ceaseless thoughts or sensations "gnawed away at him from the inside." Sculpting the mice could have been a form of sympathetic magic – as the child created these images he might have gained mastery over them.

Bringing them to the "outside" might have symbolically exterminated them within (Henley 1994). As these figures were sculpted in a primitive, unrealistic form they may have functioned more as effigies than been intended as realistic depictions. Many so-called "primitive art" objects are devoid of realistic features or embellishment, particularly when they are used for ritualistic or enactment purposes (Eibl-Eibesfeldt 1989). Installed in overwhelming numbers, the visual impact from this seething mass of rodents may have been in itself "strong medicine." There are numerous examples of cases where autistic-like obsessions would lead to extreme repetition in the art (see the case of the "bird man" in Henley 1989, 1992a, or that of Henry Darger in MacGregor 1989). However, it is not only autistic artists who utilize extreme perseveration in their imagery. This art-brut sensibility has been emulated in clay by ceramics professor and sculptor Ron Hartshorn, who, like the mouse boy, would obsessively repeat the same modeled clay figures seemingly *ad infinitum*. Hartshorn's icon was the "frog," which he would replicate in hundreds and then exhibit *en masse* on the floor of the university gallery. Hartshorn's goggle-eyed frogs could have been sculpted by any four-year-old. Their identical schemas consisted of four coils bent over for legs; two flattened pancake shapes joined together and left agape for a mouth; and two splotches for eyes. Squatting alongside their identical brethren, these vast armies of frogs seemed to come alive on the floor. Their overwhelming numbers created an organic, seething mass – probably not unlike that of Ryan's mouse child. On the floor they seemed to pulsate and move in currents, like meandering rivers flowing into others. When queried in class over the "meaning" of his frogs, Hartshorn was characteristically reticent – he would mumble something about a "magic flow", his words often trailing off, giggling to himself. Hartshorn's monosyllabic responses seemed in keeping with the pre-verbal, autistic nature of his art. Indeed, it was perhaps the autistic repetition of the work which made it so compelling. Can we however compare Hartshorn's obsessional aesthetic to Ryan's disturbed "mouse child?" Just because one artist was installed in a highbrow art gallery while the other's work was intended for his own "private viewing" – can such intentions change the acceptability or viability of the art?

Cardinal (1988) writes that art-brut is so compelling because the art is a by-product of "an unusually intimate engrossment whereby the maker of objects engages so unreservedly with the materials that the two entities – creator and created work – seem as one... Some processes, powerful and even fearful as they may be, have about them some of the qualities of magical possession" (p.46). We sense from Cardinal an amazement about this art and the "mad-genius" artists who explore uncharted territories of the psyche and thus create unique, but often disturbing images. Yet much art-brut is appreciated without taking into consideration the intentions of the artist and circumstances which bring the work into being – circumstances such as acute mental illness. Should such enthusiasm be indifferent to the fact that much of this art is born from those who are suffering? Many aestheticians and clinicians value intentionality as a criteria for aesthetic viability; both groups may question whether Ryan's mouse child is fully in control of his art. We might speculate whether the compulsive, rigid, and driven quality of the work remains more in the realm of the "symptom" which fuels and drives the imagery. These naive, eccentric or mentally ill individuals of art-brut are quite different from artists who use compulsive-like elements as a calculated design device – one that is consciously employed to intensify the visual/visceral impact of their work. However, those who have embraced R.D. Laing's "anti-psychiatry" (1969) may be inclined to reject "conscious control" as an aesthetic criterion. For Laingians, psychopathology is not about one's psychic defect so much as an act of oppression by "authorities" such as the medical establishment, who define and enforce the conventions of "normal behavior." In the "anti-pathology model," eccentricity or even mental illness in this context can be viewed as a reasonable reaction to a culture that itself has "gone mad." According to the tenets of art-brut, we might consider the work of both of these artists as having integrity just because they are in conflict with group norms.

The question then remains: is art which makes extreme use of repetitive or obsessive elements an aesthetically viable art-form – or should the work be dismissed as one more symptom (albeit a sensational one) of the individual's pathology? One criterion may be of assistance in this question. In both cases it was not so much the art that was a problem, but the behavior of both artists, which the art seemed to symbolize. In the

case of the mouse child, the school authorities saw his art as exacerbating his loss of self-control. Hartshorn was criticized because his armies of frogs were consistent with his eccentricity with regard to teaching – he seemed completely indifferent to assessing quality in art or upholding standards in his students' art. Hence, there was an anarchistic quality to both his art and his teaching that was anathema to some, but liberating for others. The art-brut aesthetic then may be well celebrated by aficionados for its raw power and unblinking honesty. These individuals, though, have the luxury of appreciating these traits without having to follow the artists home or deal with them at university. Yet like most artists who embrace the subversive, untamed aspect of art, we feel like secretly rooting them on. As the mouse boy secretly gives dramatic form to his disturbed ideas and Hartshorn giggles his way through a ceramics lecture, each contributes something to the pantheon of art and spares us the predictable, dull norms of everyday art and life. One potter who embodied the art-brut aesthetic was George Ohr, who at the turn of the century was derided by the public as the "mad potter" of Biloxi, Mississippi. Ohr's pottery (which he tellingly called his "mud-babies") was thrown and altered into whimsical, humorous, and even erotic shapes. Although Ohr was a colorful showman who seemed as interested in clowning as potting, he was also a consummate technician, throwing paper-thin vessels that were ruffled, pleated, twisted and pummeled into fantastic forms (Reif 2001). Ohr's life imitated his art, as he was known for his eccentric persona, often posing himself for novelty photographs. An illustration in *The New York Times* shows Ohr making an outlandish face with his bulging eyes, "Wizard of Oz" hairdo and eighteen-inch waxed mustache with matching goatee beard (8 July 2001). Like all genuine outsider artists, Ohr was all but ignored during his lifetime and forgotten after death. His attempts to peddle his innovative ware (from door to door on a homemade cart) met with complete failure. In true outsider tradition, he abandoned his work and started selling motorcycles until he died. His work languished for over fifty years until it was discovered by an antiques dealer in the attic garage of his descendants. Over *seven thousand* pieces were found and, slowly, the work found an audience in the more eccentric folk-art collections, as well as enthusiastic modern artists and art-brut aficionados. Today, Ohr's legacy remains in his

wholly original approach to the traditional functional ceramic form. Few potters have "reframed" the relationship between form and function like Ohr, who could take an unremarkable Victorian-looking teapot and alter it with dazzling facility. His trademark voluptuous bulges and fleshy indentations which are offset by lush steamy glaze surfaces were lewdly erotic for the time. Yet for all their sensuality, they do not take themselves seriously – the most suggestive pieces are hilariously slapstick. Ohr was a skilled caricaturist as much as a potter, whose work anticipated a whole generation of contemporary potter-tricksters such as Robert Arneson and Clayton Bailey. His melding of persona and art exemplifies Cardinal's definition of the outsider artist as one who engages in his or her art so unreservedly that there seems some magical possession about them (1988).

Alternative perception in sculpture

In his seminal research with the blind, Lowenfeld (1957) identified two modes of perception which he termed "haptic" and "visual." These two modes are useful for the art therapist, for they assist us in understanding how clayworkers like Hartshorn and the mouse child organized and perceived their worlds.

In those whose dominant perception is haptic (whether blind or not), the center of the sensory apparatus is not vision, but is rather a visceral feeling of the world. Because in haptic perception sight is not the dominant organizing faculty, objects may not be perceived in integrated gestalts, as with the mouse child who could only respond to masses of rodents rather than their individual bodies. In another example, an autistic boy named Jon also created many sculptures of his favorite animals. On one occasion he brought me his sculpture of a horse which he had ridden during his therapeutic riding program. It seemed that he could only perceive disparate elements of the horse. Rather than constructing the figure as an integrated whole, he began to bring me the horse in pieces. To accommodate this, I quickly pinched a small bowl. Inside he carefully placed each of the disconnected elements: numerous legs, a big shapeless head with a deep mouth and lots of cut-up, highly textured fragments that he proudly identified as the mane. He delighted

in going through the inventory of pieces, remarking on the smoothness of the tail as he stroked and held it up for my inspection. The intervention of pinching out a small bowl seemed to do more than serving the logistical purpose of providing a method of transport. It seemed also to unify the fragments into a whole and thus integrate and organize his perceptions.

A late-teen whom we shall name Tina was a sculpture undergraduate student taking a sculpture class at my university. An accomplished and productive artist, Tina's compositions often consisted of sophisticated, yet disparate small textured fragments that seemed markedly haptic. In one installation, glazed bits of stoneware clay were mounted en masse onto the gallery wall, much like Hartshorn's frogs. Like a kind of loose mosaic, these disconnected elements formed an integrated image when viewed from afar. The tactile relief suggested a flock of birds flying in swirling aerial patterns or a school of glimmering fish changing direction in unison. Like the ripples that emanated from the beach children's stone works, the hypnotic patterns made by these myriad fish seemed to be intended to promote a sense of expansiveness and reflection. Their delicate individual elements formed a greater gestalt that bespoke the idiom: "united we stand – divided we fall." Metaphor aside, Tina remarked that, in making studies for this work, she "saw with her body:" that each element was experienced like parts of her self, from skin sensation to organs such as the beating heart.

It was significant that Tina's studio space was consistent with her art, as it was visually chaotic, with fragments of clay sculptures, found objects, and other junk being strewn about the space in what seemed like complete disarray. Unfazed by the mess, she seemed to thrive in this chaos. Tina almost never appeared prepared for her critiques. Chronically late, her lack of temporal awareness was perhaps also a hallmark of haptic sensation, as time seemed to float by in some incomprehensible, nonlinear way. In describing her works during critiques, such as the relief previously mentioned, she focused more upon the visceral feelings they evoked than the work's formal visual elements.

Haptic sensation can assume pathological proportions when individuals cannot reality test or make sense of their surroundings because of disconnected or distorted perceptions. Consequently, their lack of

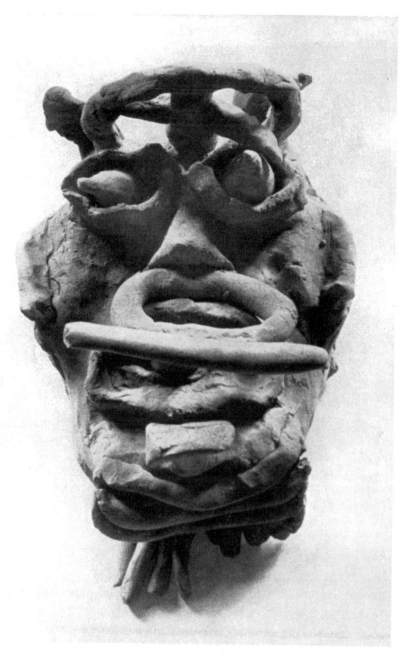

Figure 21: Lowenfeld was the first to develop the concepts of haptic- and visual-minded perception as they related to figurative sculpture in clay. This particular portrait represents the haptic mode as its features remain isolated as partial impressions on the final product (Lowenfeld 1957).

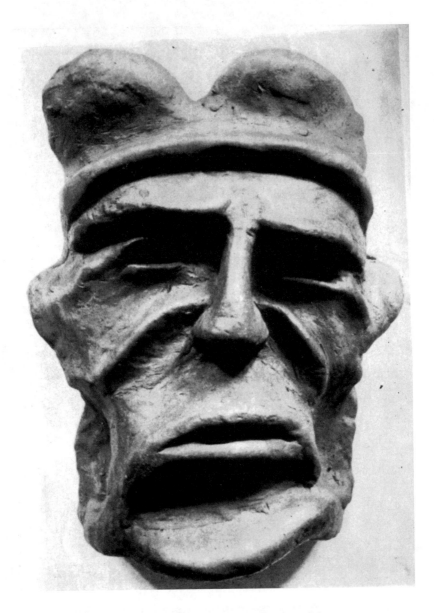

Figure 22: Although heavily formed in relief, the features of this portrait are unified and are thus "visually minded" (Lowenfeld 1957).

adaptation may come into conflict with the demands of the everyday world. The art of Jon, the autistic boy, was symptomatic of this inability to discern the "big picture." I recall noticing how once he crossed the street on the way to our session. He seemed more preoccupied with examining bits of concrete in a pothole than paying attention to the oncoming traffic. While Tina's haptic modus operandi was a source of frustration for others, her level of functioning was only mildly impaired. Like the mouse child, and Hartshorn, Tina was a colorful, nonconforming artist, though she remained more within the "eccentric" end of the haptic continuum than the profoundly disabled Jon or mouse child.

Masks, portraits and perception

Haptic perception is most noticeable when sculpting the human face. Examples provided from Lowenfeld (1957) demonstrate that the haptic-minded portrait was guided by the "inward senses" of this artist's experience and was not concerned with portraying the face (Figure 21). The visually-minded piece shows this contrast, as it is less concerned over tactile contrasts and is more aligned with accurate proportion (Figure 22).

In another example, a deaf/legally blind woman of twenty-one worked on sculpting her likeness after I cast her own face from life as a reference guide. Using moulage as the mold-making material, the rubbery negative mold was then filled with hydrocal plaster, which created a durable and detailed cast of her face. After placing clay around an armature, I placed the cast next to it and encouraged her to run her fingers over her cast, trying to make the connection between this face and hers: a process which required a formidable cognitive leap for this multiply handicapped woman. After much demonstration of touching each face, she caught on and began to model her clay using the cast as a tactile reference. Curiously, she would always hold the plaster cast looking away from her rather than having it face-to-face. In keeping with her haptic perception, each element was translated by purely tactile sensation, and thus bore little resemblance to her own features. Coils and small slabs were placed over the face in an interesting yet unrealistic composition. One element that seemed to be clearly represented took the

form of two large disc-like shapes that were draped over the head. She signed that these forms represented her thick-lensed glasses. Perhaps this element, which was so critical to her survival, required a more literal translation resulting in a relatively accurate visual likeness. However, her haptic relationship to these glasses was duly represented by their dominating scale, which covered the entire scalp and forehead. Again, in haptic perception the sculptor is more concerned with the representing the significance of her relationship to the object rather than its likeness.

It may be surprising to learn that even those who are congenitally blind may be more visual minded than haptic. Another young blind woman whom we'll refer to as Cheri was constantly preoccupied with the way things looked to sighted people (Henley 1991b, 1992a). An accomplished sculptor, Cheri often created small-scale self-portraits which she insisted on painting in realistic skin and hair colors. The head forms were created by pinching out two cup-type forms, which were then joined at the lips to form a closed hollow ball. The ball-form was then mounted atop another, more thickly pinched, form which formed the neck and shoulders. Meticulous in arranging each element, Cheri even created an exacting (yet highly emphasized) representation of her plaited corn-row hair style. To ensure the style's accuracy, each braid was counted and then applied to her sculpture. When I mixed the necessary colors for her skin-tone, she would quiz any passerby, asking them whether "David got the colors right." For a child who had never seen color, and therefore could not have comprehended how her own black skin differed from white, such visual-mindedness was all the more unusual. For Cheri, the way she looked to sighted people was the means by which she enhanced her own self-concept and self-esteem. Looking good to others was an expression of healthy narcissism for a teen who yearned for romantic as well as platonic peer relations. Utilizing the sight of others as her own contributed to a secure sense of well-being which served Cheri well in her daily and artistic life. Perhaps the need to create exact and exaggerated likeness can be compared to that of the symbolism of the Paleolithic Venuses, whose own plaited braids and round bellies served as a kind of wish fulfillment and sympathetic magic to get the results wanted. As the cave-clan received the wish of fertility, Cheri was rewarded by making

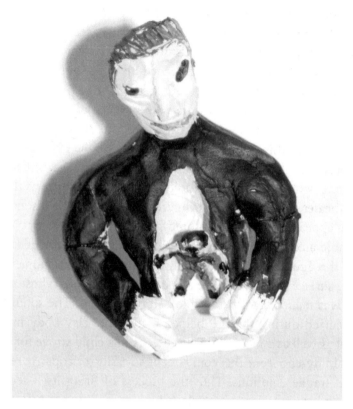

Figure 23: For many children, clay objectifies feelings which may otherwise be difficult to express in words. This boy's anxiety was portrayed as a figure which always lurked within.

friends and establishing connections with the sighted world. Clay became a means of granting these magical wishes.

Visualizing bodily feelings

In some cases haptic sensation may become confused with somaticization – a process by which a client's anxieties are internalized and expressed as physical symptoms. Since almost any stimulus may be translated into some form of somatic complaint, we might be misled into interpreting this behavior as haptic perception. For example a ten-year-old boy we

shall refer to as Ted was a chronically anxious child who was able to sculpt a literal likeness of his fears and anxieties (Figure 23). His self-portrait indicates how his sense of body awareness is based upon concrete thinking that is translated into a visually accurate conception of his disturbed perceptions. The distortion of content in this piece is obvious, since the torso has been opened up to the gut to reveal a tiny figure which Ted referred to as his "anxiety." The anxiety figure was an after-thought to creating this otherwise unremarkable sculpture. Ted took up a round loop-tool and excavated the chest in one smooth motion. Perhaps this evisceration acted as a symbolic purging of all the inner sensations that accompanied his anxiety. In its place is this curious little figure, whose arms seem to hold the chest cavity open as though it were a theater curtain. The inner figure seemed not to be disturbing for Ted, but appeared to be ego-syntonic for this child. It gave form to Ted's unbearable anxiety while also providing him with a sense of solace, as though the figure kept him company during his anxious moments. The soft clay surface seemed to serve as a delicate skin – one whose stimulus barrier was tenuous and permeable before its firing. The solidification that occurred during the fire helped mature the clay body in both a physical as well as a metaphorical sense, as this child strove for a stable sense of body-ego – one that could not be so easily torn open to reveal his raw and fragile emotions. Thus the process of firing itself seemed to stabilize what was once a soft vulnerable figure. Firing transformed the child once again, via sympathetic magic, into a being that was "thick skinned:" impervious to further evisceration or other possible insults. This fear of annihilation remains an ongoing feature among those clients who occupy a place on the autistic continuum with regard to their disturbed relatedness. Finding metaphors in the sensory qualities of clay and the firing process remained central to the dynamics of this case.

Art therapist as mentor

Kramer (1971) describes a case of long-term body-ego work with an adventitiously blind young man we shall refer to as Christopher, who, over the course of several years in a school for the blind, was able to achieve a degree of independence as both a person and an artist. Their

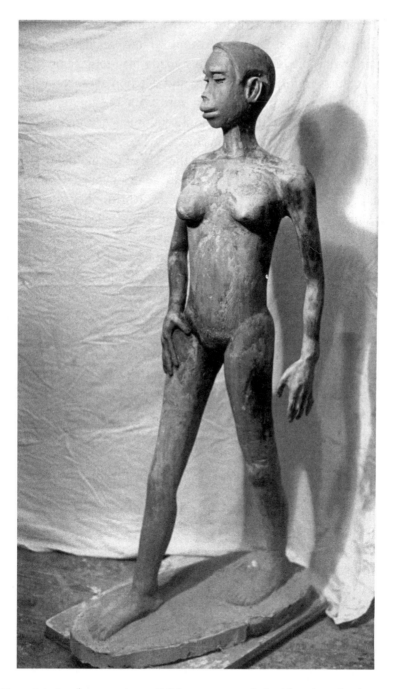

Figure 24: Art therapy pioneer Edith Kramer worked with a client for three years to create this near-life-sized portrait.

work together lasted regularly for over five years and then intermittently for over twenty years! During this time Kramer remained a refueling force, providing the resources for this young man to develop sufficient ego-relatedness to form relationships and function autonomously. This was accomplished in part by their work with the figure, with both self-representations and those of significant others being explored over this astounding long-term relationship.

Although their work together at the school for the blind included many ambitious projects, Christopher had yet to attempt a work of monumental scale. With Kramer as his mentor, Christopher attempted to create a near-life-sized portrait of a woman that reached over five feet in height (Figure 24). Set up in Kramer's apartment (as Christopher had already left the school for the blind where their work had begun), Christopher began work in the converted living room. With Kramer's guidance, a armature of wire and plaster was created, upon which thick clay slabs would be applied. Slowly the sculpture took form, with each body part being carefully modeled for visual accuracy. Particular attention was paid to the mouth, which is often the primary sensory organ for the blind (Fraiberg 1977). He painstakingly worked the inside of the mouth, palate, and teeth, then curiously closed the lips around this fully articulated part of the figure, which effectively obscured all this detailed work. This is one more example of how haptic sensation may impact upon form and content: that the mouth functioned not so much as a visual element, but formed a pivotal organizing structure which provided ego function itself. Christopher relied on this organ to commune with the world, thus its elaboration and attention to detail signifies its critical importance.

Another issue of significance arose when Christopher attempted to change the pose of the figure, which had already set to the leather hard stage. He constantly agonized over the position of the figure's limbs. The reasoning behind this ambivalence could be linked to any number of issues that emerge in work with the blind. For instance, given Christopher's incapacity to see and thus have lasting impressions, there were almost certainly problems with object permanence. Perhaps the only way to reassure himself of the figure's continued existence and well-being was to revisit the work and animate it by constantly reworking the limbs.

Once again, haptic sensibility could have come into play, as Christopher might not have been able to feel secure and derive pleasure from the figure unless he set the limbs into motion. Only then, perhaps, could he bring his figure to life. With such an extraordinary investment in this large-scale work, the need to imbue this figure with a sense of magical animation and even sentience would not be so unreasonable. Many myths and stories of archetypal proportions are predicated upon the wish or fantasy of bringing inanimate objects of attachment such as dolls, puppets, or other such effigies to life.

Attachment theory may also explain Christopher's reluctance to leave the piece alone. Given his strong, almost symbiotic bond with Kramer, finishing the sculpture might have spelled the end of their relationship. By constantly needing to rework the piece, which required Kramer's assistance, Christopher ensured that her continued attention would be forthcoming – thus he staved off their inevitable separation. Again, Christopher's immature sense of object permanence (which is almost normal among the blind) would have equated the ongoing sculpting process with a continued relationship with Kramer – one could not exist without the other.

Kramer (2001) ascribes Christopher's need to rework his figure to more high-level cognitive capacities. She reasons that because this ambitious sculpture took all of three years to complete, Christopher's level of skill continued to evolve. As he evolved into a more perceptive and skilled artist and his technical proficiency developed, modeled features from the early efforts became inadequate to the task. Thus the artist might have become dissatisfied with his earlier efforts, which then required that he continue working the piece in accordance with his higher expectations.

In all probability a combination of all of the aforementioned dynamics was the reason why this work could not be finished for a long time. Whatever the case, Christopher's need to change poses led to logistical problems of how to move the clay when already hardened. Throughout this tortuous process, Kramer indulged Christopher as a matter of therapeutic imperative. She believed that the blind require such a large-scale, articulated figure in order for them fully to perceive the

whole gestalt of their experience. This is an observation supported by Lisenco in his many years of sculpting with the blind (1971).

It is perhaps most significant that once completed, Christopher eventually destroyed this work during an argument with his then live-in girlfriend. Perhaps the threat of dissolving their relationship rekindled the threat of separation that he experienced during the protracted creation of this piece. We might consider this work a symbol par excellence of libidinal object constancy, as the creation and continued existence of this work remained inextricably linked to those women who remained pivotal love interests in this young man's life.

9. Claywork and Group Process

In the last several cases the universal themes of attachment and self-concept were explored through the creation of figurative sculpture. Using clay to explore relationships between self and significant others may also stimulate a lively group dynamic. In this setting, self-representational figurative expression can also encompass family and peer relationships. Because of the malleability possible in clay and polymer figures, there is the propensity to animate the models in playful or narrative ways when engaged as a group. Telling stories through the clay characters is an effective means of facilitating communication of both individual and group concerns. Claywork provides a medium that the individual can utilize to explore social issues that may be too raw or disturbing to confront otherwise.

Channeling group aggression

One of the most outstanding qualities of clay is its propensity for regulating the discharge of anger and other expressions of the aggressive drive during art therapy. For many chronically angry individuals, the clay process stimulates raw or chaotic discharge of aggression which only rarely results in a product. For instance Macks (1990) describes a woman being treated for eating disorders who in one session only dug her nails into the clay, resulting in a crude ashtray form that was covered in slash-like fingernail impressions. For this usually passive, helpless client, such digging constituted a therapeutic victory. Finding socially produc-

tive ways to express frustration, rage, and conflict remains problematic
for individuals suffering from emotional dysregulation.

One group of children addressed a range of aggression-related issues
in our therapeutic summer day-camp (Henley 1999b). These six children
from nine to eleven years of age also presented with various emotional
problems, attention deficits, hyperactivity, Asperger Syndrome and mood
disorders. Under unstructured circumstances, these children would often
regress when given clay, with smearing, crumbling, pounding, throwing,
and other forms of "chaotic discharge" (Kramer 1971). To avoid such
chaos it is necessary to provide some structure in order to keep the
children in control of their impulses and the session productive. In this
particular session, a stimulus in the form of a rhetorical question was
posed to the children – one that stimulated issues related to their anger
under controlled circumstances. As the group was quite athletic, I chose
the question: "What would happen if contact sports had no rules?"
Almost immediately several of the older children became aroused by the
question, nearly to the point of being over-stimulated. For example, one
child of ten proposed that football players could spear their opponents
with spiked helmets with poisoned tips. While this association was
clearly fantastic, others of equally disturbing content were rooted in fact.
One nine-year-old boy described seeing a televised bull-fight in which
the bull was stabbed with a sword and killed before a cheering crowd. To
this sensitive child, the violence in this "game" was so unfathomable in its
cruelty that he seemed unconvinced that the show depicted something
real. In frightening tones, he described a man in "girl's pants and Mickey
Mouse hat who teased the bull with a red flag until it went crazy." This
frightening stimulus seemed to reflect this child's own behavior with
regard to his social and sibling conflicts, as he would sometimes erupt
into blind rage and lash out when teased. He then reported that as the
animal rushed blindly at the matador, he simply stepped aside and "ran
his sword right through the bull's head" until he collapsed. The children
sat mesmerized by this tale of cruelty that was thinly disguised as sport.
This motivational stimulus led to a chain reaction of powerful and dis-
turbing associations: peer teasing and the fury that such torment causes,
the idea of a "red flag" as an archetypal symbol of rage and alarm, fears of
annihilation that such losses of control may elicit, as well as confusion

over what is feasibly real and false in the world of media violence and sport. This powerful response again reminds the therapist of how any stimulus may precipitate reactions that take on a life of their own, and thus may arouse anxiety as well as strong motivation.

Despite this strong, almost overwhelming response, I decided to read the children a story about how medieval knights once sword-fought without rules, often resulting in the deaths of the participants. I described how the knights evolved the rules of fair play as a means of controlling the aggression that had almost destroyed them and their sport of jousting. Instead of perpetuating the raw violence, ceremonial mock battles were realistically staged with great fanfare. Knights as well as spectators could then fulfill their need for aggressive discharge, without becoming destructive. I then proposed a project in which the children would create their own knights and war-horses, as well as a jousting field. By creating works which required figures as well as enactment, I hoped to show the children how ritualization provides an equivalent for the need to discharge aggression vigorously without becoming destructive.

Using self-hardening clay, the children were directed to sculpt their own miniature knights. After forming the details of the horse and rider, each figure was wrapped in aluminum foil to approximate the armor and chain-mail (Figure 25). The war-horses were fitted with blankets and head-dresses fabricated from colorful felt, which was hot-glued on the figures once they were hardened. To approximate the jousts, we chose drinking straws, as their light, strong shafts were blunt-ended rather than sharp and weapon-like. Once the figures were completed, the children turned their attention to the creation of the jousting field, an activity facilitated by then art therapy intern David Pitts. Pitts had the children rake the gravel lake shore where the children could construct a cardboard grandstand decorated in felt flags and pennants. He then refereed the jousting tournament, which consisted of sliding the horse and rider models past each other in a playful bid to knock the opponent off its horse. With careful monitoring, each child was victorious in at least one of the "heats." Much excitement ensued as the children animated its knights with sound effects and gusto. Each knight in full regalia rode thunderously towards the other, jousts at the ready to upend their foe.

*Figure 25: Learning to channel strong affects such as aggression through
ritualization was the focus of this group project. The children carefully
sculpted and clothed their knights in armour, and then animated them
during play "jousting" matches.*

In bringing these sculptures to life the children's creative process assumed
playful, artistic, and symbolic meaning. By animating their sculptures the
children were able to discharge their aggressive impulses through con-
trolled, rule-governed means. Ritualization served to bind aggressive or
destructive impulses as a critical form of displacement activity, one that
provided intra-psychic tension relief. This discharge also cemented social
bonds as the children practiced abiding by the rules of fair play. With
rules of engagement put into place, the children were able symbolically to
act out and gain mastery over a range of intense affects in a protected
setting. We hoped that such sublimations would be generalized into the
children's behavior outside the jousting field. With greater self-awareness
and control over their impulses we hoped to enhance the children's
quality of play and relating towards others.

Architecture and building community

In the previous vignette, the children practiced appropriate forms of impulse control through symbolic enactment. It was a group project inasmuch as once the children finished their individual models, they were brought together to work cooperatively and collaboratively. This form of group work via individual effort is preferred to projects such as murals where clients have to negotiate a common space. Art is by nature a solitary enterprise, yet it can be used to build a sense of community, as the following case will demonstrate.

At the same summer camp another project was instituted which explored how we can build community through individual and coopera-tive effort. A group of eight- and nine-year-old children, with the same conditions cited in the previous vignette, were directed to wade into the shallow lake water. Facing the shore I brought the children through a guided-imagery exercise in which they were to imagine that we were dis-covering a new land. The theme soon took on its own life as several children imagined they were ship-wrecked sailors who were deposited on a desolate island. Once ashore, our first task was to build shelter from the tropical sun and the predators that might roam this new land.

After showing them examples of domed huts, yurts and igloos from a variety of cultures, I demonstrated how a ball of clay could be pinched out into a bowl, which could be then inverted to create an igloo-like shelter. After forming the dome-like structure, each child embellished his or her house with found materials such as grasses, rocks and bark. Most of the shelters were tucked away in the rock cliffs that arose over our lake beach. Others preferred building upon the shore. Thus two factions emerged, those of the rock dwellers and the shore people. Soon the two tribes began to argue over territory and rights to the water-ways and access to the beach where they docked their clay-made boats. As the conflict escalated, one threatened Asperger-type child took his dome off the beach, and moved it to an island in the water that he created out of sand and beach pebbles. After the two factions negotiated a truce, with the therapist's assistance, the Asperger child spontaneously added a causeway that led to his shelter (Figure 26). Our RAD child, Connie, was also disturbed by the discord between groups and had built her building up high upon a rocky hill. Once the conflicts were resolved, she also

*Figure 26: By adding a retractable causeway to his island redoubt, this child
opened the way to increased social interaction with peers – a major
therapeutic victory for a child with Asperger Syndrome (Henley 1999b).*

became more accessible to the group. She painstakingly built a long
ladder up to her perch (much like her bunk bed at home) which allowed
her to survey the situation yet stay removed should conflict or threats
ensue (Figure 27).

In both cases the children utilized their structures as a means of con-
trolling approach–avoidant impulses. By creating the adjustable
land-bridge to his island and the ladder up to her perch, both children
were able to make contact or withdraw from their peers depending upon
the threats posed by the group. In their enacting these measures, the
claywork became a metaphor for their emotional readiness to endure
such peer interaction. Indeed, many of the children adopted the theme of
discovering a new land as a metaphor for their own precarious forays into
being social with their peers. For the majority of the children, coming to
camp was the symbolic equivalent of being stranded upon a deserted
island, with rescue being far off at the end of the camp-day.

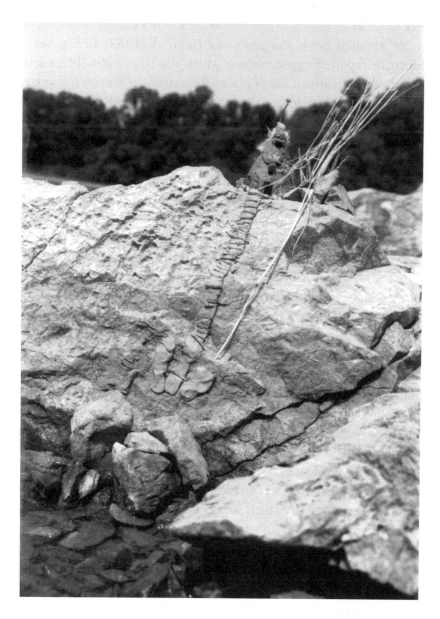

*Figure 27: Social avoidance was also an issue for a girl with attachment
reactivity, as she monitored accessibility by constructing a long ladder for
her mountain perch (Henley 1999b).*

Exploring cultural issues in group clayworks

In her seminal book *Rosegarden and Labyrinth* (1963, 1982), Seonid Robertson reported a group project which also tapped into the anxieties indicative of a "fearful sense of place." Robertson drew upon this anxiety as a form of motivational stimulus, one that carried the art process forward from areas of great resistance, anxiety and other emotional responses. Working as an art educator in a class of children whose relatives worked the dangerous coal-mines of Yorkshire, in the UK, Robertson sought to address these children's chronic fear of losing their fathers, uncles and brothers to mine explosions and cave-ins. This group of thirty "restive and contemptuous" fifteen-year-olds were resistant to school and art in general, as it had little bearing upon their working-class lives. Living with the ever-present fear of a mine disaster, Robertson suggested that they might experience through enactment the darkness, close quarters, and other sensations of entering a tunnel mine. Using chairs, rugs, and table-covers, they created a dark labyrinth within the classroom. By creating such a sensory experience, Robertson aroused these children's haptic or kinesthetic sensations in the hope that it would capture the experience and thus enliven their art. After they spent time tunneling through the darkness, Robertson asked the teens "how it felt to crawl blindly on their knees, imagining themselves hacking at the coal" with their make-shift axes made of broom handles. With such a strong stimulus in hand, the class set about sculpting their miner-figures in almost complete silence.

Although Robertson was an early pioneer in art therapy, this did not diminish the power of therapeutic outcomes elicited through her claywork program. With Robertson's interventions, the modeled figures created by the miners' children were dramatically animated. They were posed crawling laboriously through the dark tunnel, weighed down by their packs and tools. Robertson found that the figures were sculpted with unusually pronounced shoulders, hands and feet, with particular emphasis upon the heavy clogs which the men wore into the mines. These emphasized elements Robertson attributed to the children's idealized identification with the powerful physiques of their fathers. Despite their macho physiques, Robertson also observed that the figures had a "curious look of a blind burrowing animal about them" (p.12). Robertson felt that

the children's exaggerated use of form held metaphorical connotations: that by being expected to go deep into the earth to extract coal, they had ultimately become "less than men" (p.12). This deflated sense of the ego-ideal was not surprising, for many of these children witnessed over the years the slow decline of their fathers' powers. In turn the children were witness to the domination of their mothers and possibly also domestic abuse and other outcomes of the poverty, sickness, and ignorance of the time.

It is interesting that Robertson initiated interventions which also elicited negative outcomes. In one instance, a boy had exaggerated the legs, based probably upon his haptic perceptions. For whatever reason, "the legs tapered away to small insignificant feet, almost without a representation of a heel" (p.12). Without thinking, Robertson pointed out this obvious distortion as a design flaw. Instantly however, she realized the error of her comment. The intervention was made without much empathic regard, but was instead an impulsive, critical statement that was inconsistent with the artist's intentions – which clearly had more to do with metaphor than realistic visual accuracy. Robertson must have cringed as the boy "lifted his eyes from the model and looked up at my face with an almost dazed, unfocused look… Into his absorption, in which for the moment no one else existed, I had intruded" (p.12).

Despite these isolated misguided interventions (which we readily forgive), Robertson had succeeded in awakening their senses to a compelling theme. She elicited works of power and relevance to these children's lives. Beyond their personal identification as a motivational stimulus, Robertson also acknowledged the archetypal significance of the cave theme, as being part of these children's collective unconscious. She writes: "Caves are unfathomable places of the earth, drawing one in curiosity and fear, in excitement and apprehension. Through them we go into the bowels of the earth, into the secret places" (p.55). For these children, who would inevitably work the mines themselves in a few short years, such an exercise might have contributed to a mastering of personal apprehension, of anger and perhaps regret, while also creating a sense of community that would strengthen individual resolve in the face of such a bleak future. Claywork served as a conduit for these feelings, sensitively recording each feeling and idea in a way that illustrates the universal

timelessness of the medium. For children will forever be confronting the dark caves of their psyche. Whether real or imagined, such themes remain archetypal in their power to evoke strong feeling, to which the clay responds.

Magical thinking and reality-testing in group process

During an art therapy clayworks session, an overriding theme emerged from a group of bright yet autistic-like youngsters that was a powerful as that of our miners' children sixty years before. These children often struggled to control their withdrawal into fantasy or day-dreaming, and had difficulty responding to the demands of reality. For many of these children, the two worlds were often inextricably bound together. As reality becomes infused with magical thinking, the end result is usually distractibility or attention deficits in school, bizarre ideas that alienate relatedness to peers, and generalized poor decision-making or judgment. In more severe cases there is the danger that the child may withdraw from reality and retreat to a magical inner life as a defensive measure. In some this regression is intractable, as the child remains locked away within an unreachable autistic world.

To address this common problem, therapeutic art educator Dawn Henley devised a clay animation project which explored the interface between reality and fantasy life. The illustration shows a collection of polychrome plasticine characters which were animated using a digital video camera. This plasticine clay was the perfect choice for this project, in that the bright colors translated into brilliant video images, while the soft pliable nature of this material allowed for robust manipulation during animation.

The group also wrote dialogue for the script which followed the boys' train of thought, from fantasy-laden ideation, to their return to reality. The first scene begins as one child drifts off into a day-dream while in class. He imagines he is in a secret laboratory, where a beaker of magic potion spills, letting loose the creation of monstrous creatures such as the Hydra, and Cyclops (Figure 28). These were then animated by the technique of "claymation," meaning each of the figure's movements

Figure 28: Creating claymation characters out of plasticine allowed a child with autism to share his inner world with peers and thus make his ideas more palatable for group appreciation.

would be changed in small increments, then recorded. After each figure was adjusted the record button would be activated and then immediately stopped. Five minutes of video required that the characters be moved almost one hundred times. This tedious work paid off since once the scene was played back, the figures gave the impression that they were in motion.

The scenes were also embellished by a scenic backdrop. Each scene would be shot against a "set" which was drawn and colored by the children. In this way locations could be changed by cropping or zooming in, or they could be panned at a greater distance which took in the entire vista. With the manipulation of the set, different scenes could be shot with many combinations of backgrounds, which enlivened the action.

Interspersed between the moments of fantasy, the script included segments that featured the adults in their lives, i.e., mothers, teachers, coaches. The role of the adults was to call out to the child, interrupt the day-dream, and then cue him back to the real task at hand. The group leaders played these roles according to the children's script. In the most effective art therapy sessions, the art imagery, or in this case, video, would yield insight into the children's issues (Henley 1991a). It was significant that most of the video centered upon the elaborate fantasies in the narrative, such as children identifying themselves as the "hero" of the story. Egocentric and given over to fantasies of omnipotence, each child needed to be the one who saved the day in the story, while the adult inter-ruptions (which attempted to address this fantasy grandiosity) were given sparse treatment. Life mimicked art, as the facilitators had to cue the boys numerous times to include more reality-based aspects to their stories. Without such interventions the boys would almost certainly have remained stuck in their fantastic stories. In the end, this claymation video increased these boys' motivation to engage sensitive topics while allowing for the appropriate discharge of fantasy material. As a collabora-tive project, each child struggled to cooperate in the group effort. Here again the power of the primary process would reign, as each child fought off the inclination to play alone or in parallel, focusing solely upon his own scenario. The project forced them to be responsive towards their peers, which facilitated social interaction.

Camouflaging pathology in the inclusive setting

In the last vignettes we encountered a group of individuals for whom reality-testing remains so tenuous, that they require self-contained classes with other children of similar pathology. Among their like-minded peers, perceptions and thoughts that are unbelievably fantastic mix with others that are rooted in real-life events. Because many current events may be at times stranger than fiction, it may be difficult for certain clients to discriminate between what constitutes a threat from either the real or imagined world (Henley 1994, 2001). Unlike Robertson's mining children, whose "fearful sense of place" was an integral part of their culture based upon a very real, palpable danger, these autistic-like children are subject to delusions that are dominated by magical reasoning. Within the group dynamic, where children share common distorted thought processes, magical reasoning becomes ego-syntonic – meaning that among like-minded peers, fantastic ideas become the norm, like the fantastic video story involving spontaneous combustion. These ideas and perceptions are then reinforced by the group's own pathology, like the mass hysteria created when a few religious zealots hallucinate the Virgin Mary shedding tears on an abandoned billboard. Before long other impressionable or fragile individuals are making pilgrimages to the site, where they too delude themselves into believing in such irrational, magical phenomena.

As long as one surrounds oneself with like-minded peers, such distortions may persist without conflict. However, conflicts arise when the majority culture does not share in these distorted perceptions, thoughts or feeling differences. Thus when such individuals are mainstreamed into public institutions such as clubs or universities, the task becomes one of assimilation. This is often accomplished by attempts to camouflage the pathology as effectively as possible.

In one example, a nineteen-year-old college freshman with unspecified neurological involvements (probably high functioning Asperger Syndrome) was mainstreamed at Long Island University in a clayworks course given by Professor Frank Olt. As a gifted sculptor, this young man created a model of his high school as part of a architectural ceramic sculpture design problem (Figure 29). This piece was sculpted complete with a detailed brick facade, interior walls and furnishings, which to the

*Figure 29: Inner and outer meaning was revealed in the sculpture of a college
freshman with Asperger Syndrome. His depiction of his high school was
unremarkable in form, yet its private meaning revealed fantasies in which
teachers transformed into ghoulish monsters who engaged in torturous
murder and other acts of annihilation.*

layman's eye are not overtly distorted in either form or content. During
interactions with his peers, this bright young man was able to work in the
studio in a relatively appropriate manner. Although his behavior was at
times odd, his civic-minded peers were quite tolerant and supportive.
During critiques they would engage him about his work without patron-
izing, and their questions were accessible enough that he could appropri-
ately respond – questions pertaining to technique and material for
instance. However, other questions seemed innocuous enough but could
have been emotionally loaded. One young woman in the class asked
whether he drew upon the memory of his high school out of fondness
and longing. Since this question dealt with emotion it might have rattled
him, as those with Asperger Syndrome often have difficulty responding
on an affective level. It also hinted that he might *not* have remembered his
school fondly, or that he might still long for high school since college
remains too difficult for him to handle. True to form, he intellectualized

his response, explaining how his memories led to an interest in the archi-
tectural styles of turn-of-the-century design, ignoring any personal or
emotionally-based aspect of the question. Little did the students know
that this work held a secret meaning that was quite different from its
public persona. Only after being asked to critique his work in a more
intimate, therapeutic-like process of journal writing did this young artist
feel secure enough to devulge the work's fantastic ideation, meant to
satisfy inner needs as well as those meant for public consumption.

On one level, the artist meant to demonstrate his competency in
creating a realistic representational sculpture of equal or superior crafts-
manship to his peers. In this way he could display to his classmates his
capacity to assimilate in their world as just another student surviving his
freshman year of university. His success at such assimilation probably
rested with his many years of special education, caring parents and
long-term psychotherapy – each of which supported his bid to function
for years in the inclusive setting. In the ceramics studio, Professor Olt had
created an atmosphere of complete acceptance and accommodation
which allowed him, and many other students with special needs, to par-
ticipate without feeling rejected or alienated – despite their eccentricities.
With such support, he was able to become comfortable within the studio
environment. He was also developing sufficient observing ego that he
was finally beginning to step outside his own subjective experience and
sense what was appropriate behavior. He continued to work on gaining
an awareness of how he was perceived by others. Professor Olt's unobtru-
sive cues assisted him in regulating in-class behavior in accordance with
the group norm. Yet on a more private level, he was able to work through
more disturbing issues including that of a "fearful sense of place."

In revealing the private meaning of his sculpture, he cited a popular
exploitation horror film titled The Faculty, in which blood-thirsty aliens
masquerade as normal-looking teachers and school personnel. Through
mind control these hideous creatures terrorize the student body. After
much gratuitous blood-letting and gore, the young man wrote that "a
geeky student named Casey kills the main monster which robs all of the
other aliens of their powers, thus saving the day."

In interpreting this work, we might begin by assuming that this
handicapped young man may have indeed harbored deep-seated anxiety

regarding his own secondary school experience where he had been mainstreamed with otherwise normal students. Perhaps he himself felt "alien" like the monsters in the film, or "geeky" like its hero. Such a dual identification reminds us that defenses such as projective identification are highly fluid: that interactions between primary process and secondary processes create ever-changing combinations of fantasy and reality. Thus one can imagine oneself as falling prey to the horrific monsters, yet at the same time, identify with these aggressors who wield the power over the weak. Idealized identification is also in evidence, as it is the "geeky" character who is eventually empowered enough to save the day. The fantasy makes use of a popular, archetypal theme, in which evil forces prey upon the weak, yet are ultimately vanquished by the virtuous underdogs. It was, without doubt, the client's identification with these archetypal themes and characters that provided the emotional fuel to give meaning to this work.

We might find that the form as well as content provides insight into this young man's world. The "facade" of the building in particular might have metaphorical connotations. Its carefully modeled, realistic design offers no hint of the tumult within. The peers in his class, who might have expected bizarre imagery from this autistic-like young man, were to find only a well-sculpted, yet otherwise unremarkable structure. Yet metaphorically speaking, a facade is nothing more than a "front." The rigidity of this hard-edged architectural form almost certainly betrays it as part of a defensive system as it ingeniously contains the anxious content and tenuous reality testing within, while warding others away. Yet his attempts to create a functional inner design of the school seem hopeful: the front is not just window-dressing but has substance within. Although somewhat rigid, the form is strong, with no indications of underlying weakness. Indeed, it is interesting that the use of clay in this process did not precipitate regression: on the contrary, the medium enabled this young man to channel his anxieties and thus compensate for his fragility. The solid, well-crafted structure fully sublimates the inner turmoil that comes with successfully negotiating the expectations and pressures of the outside world.

10. Claywork in the Community

In the last chapter claywork was considered as part of the group dynamic in different guises: at a therapeutic summer camp, in an English school during the Second World War, in a contemporary elementary school, during a clinical art therapy session, and lastly, within the setting of a university ceramics class where a student with special needs was integrated into the campus community. In this chapter, I shall continue my emphasis upon working within diverse communities in a bid to bring claywork to the public in a number of guises. In this way we can become involved with hundreds of individuals who may be creating pieces from intimate to monumental scale.

Bringing clay into public service

One of my avocational interests is preserving wildlife in my native New Jersey. Despite being one of the most densely populated states in America, New Jersey still has a remarkable diversity of wild creatures only one hour's drive from New York City! As part of a volunteer initiative, I have been traveling to schools and giving workshops as part of an organization called "Woodlands Wildlife Refuge" which cares for and then releases sick and injured wildlife. Recently, there has been an increase in the black bear census in the area, which has resulted in some uncomfortable encounters given our rural area's march toward surburbanization. Hence the director of the refuge, Tracy Leaver, and I have developed workshops that entail taking clayworks outside the art studio into class-

rooms and scouting troops where we discuss "Learning to Live with Bears."

Aside from the slide show, display of bear artifacts, and a glimpse of the orphaned bear cubs under our care, the last part of the workshop involves creating small animals such as bear sculptures that are fashioned after the Southwestern pueblo Zuni culture. In this pueblo "fetish objects" employed as magical charms were objects of wish fulfillment for the different fetish-makers: farmers hoped for abundant rainfall, hunters a productive kill, women a safe and easy birth, and so on. After describing how the Zuni lived with, hunted, and even worshipped the bear as a source of power and introspection, we would then discuss whether they themselves ever identified with animals as a source of inner strength or self-protective medicine, like those practicing the Zuni culture. I then suggest that we might create some small fetishes in the form of the bear or other animals. That through such creativity, we might better remember that our reverence for nature, respect for all living things and civic responsibility go hand-in-hand.

The Zuni fetish figures were created from self-hardening clay that made use of simple one-piece designs, which can be pinched, carved or modeled. Once the form begins to air dry, participants are encouraged to burnish their bear sculptures, which is also in the Zuni and other Southwestern Native American pottery tradition. Burnishing entails rubbing a polished rounded stone over the piece when it is in the leather-hard stage, which creates a high gloss on the surface. In the Pueblan culture, burnishing stones are often prized as heirlooms. The ritualized aspect of giving a polished gleam to the object is part of the Pueblan method of endowing their pieces with a magical significance beyond that which is achieved from the sacred content, such as creating bear effigies.

After burnishing, the participants are asked to applied found objects to their sculptures. Bits of wood, wild flowers, rocks, or even manufactured objects such as beads or charms are then secured with twine directly to the back of the animal form. Once secured to the damp clay form, they harden onto the piece as it dries. Working hands-on during the creative part of the workshop meant that the participants could eventually take something meaningful away. By personally crafting their bear effigy, we

hoped that the spirit of our message – that of preserving our wildlife heritage – would be kept "in-sight and in-mind" long after we had gone.

Despite our good intentions, the outcomes of this project remained mixed. As in many of the therapeutic or educational activities I devise, there is often an element of morality that runs through the presentation. This is often overt or implied in the theme or approach to the project. In this case I utilized Native American culture as a structuring theme – one that implied a spiritual "ideal" of a reverence and conservation of wildlife. Drawing upon this culture was in fact an intervention that was intended both to facilitate investment in the process and to lend structure to the over-all workshop activity. However, when bringing such material into larger groups in the community, these moral elements may be questioned, for many values held in the community may be culturally diverse and even in conflict with one another. During one workshop for instance, a twelve-year-old boy politely informed us that he planned to hunt bears as soon as he could apply for his license. With this fetish in hand, he hoped to increase his chances of killing one, for isn't that what early hunting people used their amulets for – to ensure success in the hunt? This clever, precocious child advanced a position that appeared to be in direct conflict with the supposedly benign message of our "live and let live" program. Other children, particularly the girls, were aghast at his plans and soon a spirited argument ensued. A follow-up intervention on our part involved staying out of the debate. Instead the children themselves were left to argue their respective positions.

Another issue when bringing clayworking into the community is related to "cultural ownership." We must question under what guise it is appropriate to draw upon the belief systems of another culture which we sometimes tend to romanticize (Henley 1999a). We may also only possess a superficial understanding of their cosmological/spiritual mores. Viewed from the perspective of Native Americans, such an appropriation is seen as potentially as exploitive as naming a baseball team the "Indians." All of these issues require assessment, with a balance sought between being creative, using history to inform and enrich or experience, while also remaining sensitive when other cultures are utilized. Jung (1931) was very clear that the Western concept of the psyche is very different from that of our Eastern counterparts (as Native Americans are

essentially Siberians from the far East). He felt that meditation, for instance, which was based upon redemption through ego-loss, was destructive to Westerners. Such a state of ego-lessness could be experienced by some as a regression that could reach even psychotic proportions. I am not stating that introducing the idea of the creation of animal amulets would drive the cub scouts insane; only that the outcomes of such dabbling in hunter-gatherer/animistic belief systems with magical charms, totems or amulets may be questioned by current politically correct factions in education and psychotherapy.

In the end, there was only minimal criticism or concern over these or any other issues by the parents, administrations or others who participated in these workshops. Success seemed to lie in the neutrality of our interventions, which allowed for socially or emotionally loaded topics to be engaged through respectful dialogues without actually controlling outcomes. In this way we brought a lively topic to the community which was made artful through the creation of small intimate sculptures of a big, black, beautiful animal.

Claywork as conflict resolution

Community issues can also be addressed through group sculpting experiences which double as a socialization program. In one such initiative, figure sculpting became a means of facilitating conflict resolution between teenage gang members and others struggling with violence in the inner city. Art therapist Erich Preis conducts such conflict resolution sculpture groups at the School for Social Change in the Bronx, New York City, where violence is a way of life. Rather than working from an emotion-based or expressionistic standpoint, Preis's approach is highly academic, with his young men and women working in classical techniques of realistic figurative sculpture. Because teens are often concrete-minded, they seem to respond to art which is also quite literal. For many adolescents it is developmentally appropriate for them to be naturally narcissistic and thus idealize their figures. They will also equate a sculpture's realistic qualities, particularly the cut of the figure's musculature, with a sense of their own burgeoning sexuality, mastery and self-esteem. In Preis's sculpting sessions, groups of gang-affiliated teens

discuss their grievances, mediate differences and socialize, all while working their figures. Taken from a gallery-announcement card, the illustration shows a group of young men engaging in dialogue while busily working on various figures (Figure 30). The sculptures are shown interacting as well. They are posed interacting in a spirited and animated exchange that is ultimately peaceful. Because Preis himself is severely learning disabled and dyslexic, he exemplifies how one can overcome issues such as illiteracy and anger, and channel strong feelings through a pro-social and creative outlet (Kountourakis 2001). The success of this program has earned Preis a number of sponsors who will ensure that this important work will be supported in the future.

Figure 30: Clay programs with community-based themes were devised by artist-in-residence Erich Preis. In this gallery notice Preis is shown working with disadvantaged teens sculpting during a conflict resolution group.

Balancing intimacy with public expression

Issues related to the adolescent's body-ego and healthy narcissism were also engaged while working with a group of college non-art major freshmen. These students were given the assignment to cast a series of their own body-parts, which were later to be assembled into a group installation. The students all had various learning or social difficulties and were thus assigned to me as a "therapeutic-minded" professor. The process first entailed choosing a body-part to cast using a latex compound to make a negative mold. The students were to paint the heated latex directly on to the body-part, then remove the mold when cooled. A jacket of plaster of Paris would then cover the mold to keep the rubbery material from becoming distorted when being handled. Liquid clay slip would then be poured into the negative until firm, at which time the positive cast would be removed and refined using modeling tools. This slip was commercially prepared with the necessary chemicals which ensured a fine-grained texture that recorded the finest details. The slip was also formulated to be crack-free in drying and would survive the low-temperature fire without distorting the body-part casts.

The assignment to cast one's own body-part was of course a provocative intervention. Casting elements from one's own body could become an emotionally loaded issue for eighteen-year-old freshmen, many of whom had special needs. I anticipated and was ready to accommodate much inhibition, resistance, and/or acting out given the provocative theme. However, the group had been given over twelve weeks to bond and during this time, most of the class had become comfortable with each other and secure within our environment. The selection of body-parts was sensitively devised to accommodate those with inhibitions or resistance. For instance, students could choose parts which were neutral and benign, such as casting a hand or elbow. Those few inhibited students usually chose their hands, and often emphasized their jewelry and other non-body elements in the composition. One might think that the young men would have chosen provocative body-parts to cast (as indeed they promised), but this was not to be the case. It was several of the young women who would boldly cast erogenous parts such as their breasts, lips, pierced navels and other elements of femininity. Several of the men were evidently taken aback by these free-spirited women who were clearly

comfortable with their own bodies. In contrast, several of the men created homages to their scarred-up arms and knees that had once been sutured or operated on due to various skateboard accidents and athletics injuries. For the most part, both sexuality and other sensitive themes were handled with complete taste. A number of the works successfully balanced the need to vent their libidinous energy with other adolescent concerns such as their sense of immortality – all through a deft and creative handling of the process. What could have been a dull inventory of body-parts was transformed into a unique assemblage of small visual poems – with each verse speaking volumes about the sensuality, the vulnerability, the insecurity of the changing figures of these young adults. The students were challenged to confront the delicacies of their body-ego, which often required much courage and fortitude – such as the young woman who cast her protruding teeth with orthodontic braces, and the young man who immortalized the scar of his football career-ending knee injury. Handling this potentially loaded material required that the students make it palatable for an "in-house" exhibition (Henley 1997b). While not a public audience per se, the gallery-goers were made up of other professors, the students' guests, and interested school administrators. Despite the sensuality and intimacy of some of these pieces, many of the female students took great pleasure in pointing out their contributions to this collective work.

Devising a community mural

In another case reported by Ryan (2001), issues related to group exhibition were dealt with on a larger scale while working with over two hundred children and adults attending a therapeutic summer program. As an artist-in-residence, Ryan and his partner were to collaborate with the clients to create a wall installation of ceramic masks. Ryan's challenge was to compose a bas-relief mural with clients who had a disparate range of functioning levels and pathologies. Some clients were infantile, learning disabled, and autistic, while others possessed intact or even superior cognition, but suffered from emotional disturbances. Masks ranged from basic mandala-type gestalts, to fully embellished expressionistic faces. The task then was to integrate disparate skill and developmental levels

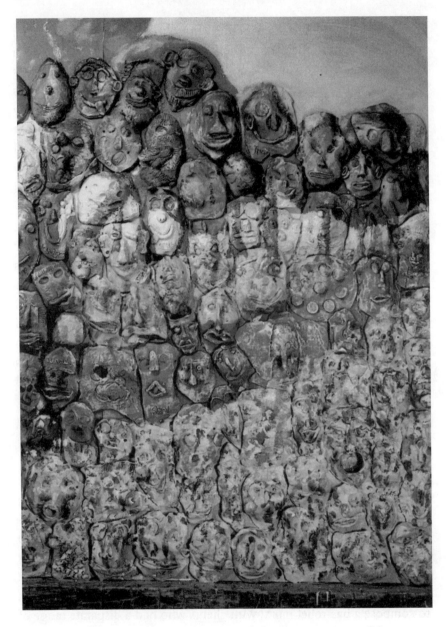

Figure 31: Artist-in-residence Tim Ryan worked with a community of diverse populations to create this monumental landscape bas-relief which is composed of countless ceramic masks.

into a mural of professional quality that was appropriate for long-term public appreciation. It was up to the artists-in-residence to ensure the work's aesthetic viability, while also ensuring that individual efforts were duly celebrated.

In composing the two hundred or so masks in this installation, Ryan's method was not unlike Hartshorn's riot of frogs. The mural's visual impact depended upon an immense wave of the gaping faces. Each mask would be fitted so closely together onto the wall that almost no negative space was left on the mural. Ryan and his partner then used the solid wall of masks as a ground for painting a landscape mural which was superimposed over the masks (Figure 31). This might be considered a provocative intervention, since this could have been construed by some as a kind of doctoring or even worse, defacing the work of their clients. This brings into focus issues that are often raised in creating a public work for the whole of the community. Individual expression would need to be held in balance with the expectations of a critical viewing public. It needed to be a work of professionalism, regardless of whether the work was created by those with learning disabilities.

Ryan has written that the project drew upon the concept of creating a "gestalt," in which the whole of the mural would be greater than the sum of its parts (2001). Although the clients delighted in identifying their own works, they also appreciated their achievement as something that went beyond individual effort, but had made invaluable contributions to the community. The finished painted installation bears this out, as the landscape unifies and homogenizes the wide disparity in the skill levels amongst the different masks. The painting simplifies and settles down the wild cacophony of faces whose eyes bug out by the hundreds, which in turn contrasts with the quietude of the bucolic setting. Ryan's solution invites the viewer to interact more actively with the work, as one moves forward to examine the masks, then retreats backward to take in the whole of the vista.

Whether or not one might object to the idea of two artists painting on and over the work of their clients, this intervention ensured that the mural would stand the test of time and be appreciated by the public for years to come. Few murals seem to pass this test, as many seem dated or are wearing to look at on a daily basis. Ryan's solution avoids these pitfalls.

He balances the interests of individual and institution, and in the process, has contributed something special to the lives of both artists and community.

Bringing clay into the community

Everyone is fascinated by observing an artist demonstrating sculpture or a potter making pots on the wheel. For decades my colleagues and I have volunteered our time at street fairs, charity events and local and national Very Special Arts Festivals. In this way children become better exposed to the arts and their own capacity for creativity. To work effectively in this "one-time" setting, one must endure endless distractions, breakdowns of logistical services, and over-eager teachers used to doing the projects for the children. In Figure 32 we see a student volunteer at Very Special Arts Chicago working on a child's self-hardening clay jewelry project despite the bedlam around her. Staying attuned to one child while a hundred

Figure 32: Conducting one-day clay workshops requires the flexability to adapt techniques and themes for a wide variety of populations and functioning levels – often amidst chaotic working conditions and limited time.

others are working and creating is one of the challenges of working in this venue. It is, however, incredibly energizing and gratifying to serve so many children in one's own community during a day's festivities.

In another volunteer setting, artist James Pruznick reports conducting finger puppet-making workshops at his neighborhood school where they sculpted simple polymer figures. Small coils were rolled out, sculpted with faces and arms, then fitted onto the children's thumbs. They were then encouraged to interact with each other by animating their puppets. Videotaping the puppet-play was another means of extending the creative possibilities of the claywork. Pruznick then had the children create scenery and narrative in the way Dawn Henley had done in her claymation project. He reports that children who had not previously interacted with others established new relationships using the puppets as intermediaries. They were able to take their puppets home with them as a keepsake that reminded them of their new-found friends. By volunteering at his neighborhood school, Pruznick was able to become involved with his community and contribute his expertise with video, which made an immediate connection with children who were already fascinated with this technology.

Another project worthy of mention is the "Open-Studio Project" developed by Pat Allen, who rented a store-front in Chicago as a studio which, during its years of operation, invited people off the street to participate in self-exploratory art experiences. Allen's approach is unique, as she utilizes a strictly "art as therapy" model rather than clinical approaches (Allen 1992). In Allen's program, participants range from street people to grandmothers, babies, school children, shoppers, local artists, all of whom utilize the space to meet their needs in their own way. A similar open-studio drop-in program is run by Janis Timm-Bottos in Albuquerque, New Mexico, where homeless or street individuals can come to a well-equipped studio and make art in a family-like, community atmosphere. In visiting this space with my students from the University of New Mexico, I was struck by the self-directed work-ethic of these fragile clients, many of whom are chronically mentally ill. Here they seemed to flourish, working with a sense of dignity and composure on a remarkable series of masks. Using self-hardening clay and mixed media embellishments, individuals of diverse cultures including Native Americans,

Mexican immigrants, homeless transients and their children, all infused their masks with a mixture of cultural and individual eccentricity.

Other community projects focus not so much on in-house programs, but are one-time, outreach experiences where we bring art to the public. This outreach may take the form of demonstrating our craft and inviting the public to try their hand at making a pot. On one memorable occasion while in residency at the University of Canterbury in Kent, UK, British potter Carol Foster and I volunteered to demonstrate throwing at an "Oyster Festival" in Whitstable on the North Sea coast. Long lines of children waited patiently with their parents while their peers spent ten minutes on the wheel. Six hours and sixty children later, our hands were limp and raw, yet the glow of that place, and the children's wide-eyed amazement at this process, still remain clear and fresh today.

Working on a one-time basis with children seems difficult to imagine given the technical challenges posed by the throwing process. Yet there is the potential for a creative, even therapeutic outcome, if one can circumvent the children's initial inhibitions. Children are naturally reluctant to take the hands of a stranger who is covered with clay-like slime, even if the process seems fascinating. Such trust cannot be so immediately earned. With their parents in close proximity, however, almost every child sat down without requiring any preparation or encouragement whatsoever. Out of sixty children seen at the Oyster Festival, only two could not overcome their reluctance and refused to work hand-over-hand with me to create a pot. In one such case the issue was centered around getting a summer dress soiled, which was a reasonable concern. The other involved an autistic child who refused even to turn his head towards the wheel as he sat clutching his mother. I had her turn around so that the little boy could observe my doings while he looked over her shoulder. To gain his interest, I threw a tall cone-like cylinder, which I opened into a small bowl, which I then squished together to form a wide, fat-lipped mouth. A few embellishments later it became a clown face that smiled as it spun around in slow dizzy circles. Being autistic, spinning things were probably a fascination for him – so much so that he could not take his eyes off the rotating sculpture and its ridiculous grin. Slowly he released his grip on mother and though he never touched the material, he seemed to wave his hands excitedly at this "new friend."

To demonstrate and facilitate the throwing process in this situation requires an almost immediate rapport with the children. Several interventions attempt to meet this challenge. I try to crouch down and become smaller than the children themselves. I try to remain attuned to the child's need to sit comfortably at the wheel and be in their own space, without being bothered by my constant attention. Just allowing the clay to run through their fingers seemed to be enough of a novel, stimulating experience. When working "hand-over-hand," I try to remain unobtrusive as we work, guiding the children's hands almost in a ghost-like way. I prefer to place my hands upon theirs so that they can *feel* the movement and pressure required by which fingers at what times, as opposed to explaining these technical procedures. So understated is my touch, that some children have remarked that the "pot was making itself" – or it was in fact the children themselves who had brought up their cylinder. Particularly when centering, the children's demeanor changed noticeably as the wobbling mound of clay, with a seeming mind of its own, would finally be brought under the potter's control. This process of "finding the center" once again becomes a metaphor for nurturing both art and spirit, as even the youngest or most handicapped child plies the sacred circle.

Claywork as community

For hundreds of years potters practiced their craft not solely as individuals, but as part of a greater community of artisans. The symbiotic ties between the individual and the community in Japan, for instance, were forged by the common purpose of cooperatively dividing labor such as clay mixing, wedging, throwing and glazing, and firing the huge Anagama climbing kilns – all required intense cooperation. In this way each village developed a stylistic identity, many of which remain unique to this day. The late Soji Hamada's community in Mashiko, Japan is one such exemplary community. Pots of unsurpassed grace and functional beauty were created in concert with activities such as gardening, carpentry, cooking, the tea ceremony and other aspects of communal life. Little distinction was made between these activities and potting for they existed on the same continuum of rural life that had been practiced since feudal times.

This model of communal work has been tried out in other utopian forms, particularly in the Steiner community of Camphill, Pennsylvania. It was here that M.C. Richards lived and made pots among those with developmental disabilities as well as others in the village. Richards embraced the ideas of Rudolf Steiner, whose "anthroposophy" or "science of the spirit" informed her practice of both pottery and poetry. Richards' work became a living example of the community's emphasis upon creativity, simplicity and communal effort. Grace Ann Peysson, a colleague and collaborator at Camphill Village, refers to Richards as a "soul-giver." It was her sense of humor, gentleness, and respect for all that elicited creative expression from even the most disabled residents. While not a therapist per se, Richards' presence was itself soothing and stimulating to those who worked in her studio or alongside her in the garden. Her work was more than practicing art and poetics, but was more a striving "toward wholeness" – one that found both functional and metaphorical meaning in the potter's art.

11. The Ceramic Vessel

Plying the sacred circle

At the center of the functional ceramic form is the circle: that unending mandala that appears in the art of cultures since the beginning of civilization. Our affinity for the circle appears to be neurologically hard-wired. Its configuration is perhaps linked to our deepest instinctual drives that strive for expression as we emerge out of the womb. Observations in animal and human ethology suggest that the circular gestalt of the mother's breast signals to the neonate that it must seek out its life-giving sustenance if it is to survive (Eibl-Eibesfeldt 1989). Cognitive theorists have proven that the shining face of mother elicits immediate affective and mnemonic responses, as the newborn mirrors its mother's expressions almost immediately after birth (Meltzoff and Moore 1977). Psychodynamic practitioners such as Spitz (1965) and Mahler, Pine, and Bergmann (1975) maintain that the quality of "molding" to the mother's body/breast facilitates bonding with the infant. The mother's face becomes associated with this contact comfort as an expression of love. The quality of this attachment and other object relationships resonates in all later forms of human endeavor. A secure attachment sets the stage for later self-exploration including the creative risks that are central to the art process (Henley 1999a). The circular mandala form exerts an attraction from the earliest scribblings of the youngest child to the art of the modern master.

Jung (1931) focused upon the mandala as the centerpiece of his theory involving the collective unconscious. He found, in his cross-cultural studies as well as in his work with psychiatric patients, that

the circle was universal in all forms of art, craft and religious iconography. Like the Taoists before him, Jung asserted that the mandala's yin/yang form represented the "union of opposites" and was seen by cultures and individuals alike as an organizing force. Art therapist/critic David Maclagan (1977) surveyed the universality of the mandala in depictions of creation myths across culture and history. From the indecipherable spirals and radial patterns of Paleolithic rock art, to the Christians who placed Christ at the center of both halo and heaven; from the ancient mandalas Tibetans use as the locus of their meditations, to the creation mythological sand paintings of the North American Navaho; to the seventeenth- to nineteenth-century utopian society of New England Shakers whose artistic productions from delicate needle-point samplers to massive stone barns were built in circular or cylindrical form so that the "devil could not hide in the corners" (Promey 1993) – each of these examples of the sacred circle is a matter of spirit transformed by form and function. In contemporary culture modern artists such as Klee and Miro seized upon the circular forms of the ancients, using this iconography to launch the era of modern art. They became fascinated by the earliest markings of children, of psychotics and autistics who sometimes remained captives of their circular spinnings and repetitive schemas. Artists such as sculptor Robert Smithson bulldozed large-scale earthworks into spiral motifs, while Andy Goldsworthy continues to find elegant mandalas in fallen leaves.

In both function and design, the circle is the fundamental form in the ceramic arts. The first circular forms in utilitarian pottery were thought to have originated from the burned-out remains of Paleolithic seed baskets. Thirty thousand years ago these clay-smeared basket linings were all that was left after they had been incidentally fired in the ancient cooking hearths. The now hardened circular forms still sported their pressed cord and plaited textures of a basket weave – a motif which is still at the center of many ceramic styles. This early form of slump or press molding technique, which requires the clay to be forced into a mold until it dries hard enough to support itself, is still used in studios today. Thus, one of the hallmarks of the ceramic arts is indifference to technological advancement, as pots of elegance and power were created eons ago without the benefit of modern technique.

Ceramics as an art-form began eight thousand years ago, when Middle Eastern and Egyptian potters began to form round-bottomed containers by using the coil method. Like the earliest basket-formed pottery, this ware was already being slip-painted and fired in primitive open pits. Dating back to 6,000 years ago in the ancient Persian cities of Ur, Susa, and Kashan, pots were already being thrown on wheels of diverse designs. The different styles that emerged between wares made in these settlements were due in part to the different wheel-throwing techniques. Most were decorated with coatings of slip or liquefied colored clay that, when incised into the clay bodies, allowed the potter to paint and draw imagery onto the pot. In keeping with the earliest motifs found in human history, most of these decorations consisted of spirals and other circular motifs that might have had magical significance. These designs were embellished by the process of burnishing in which the pieces were hand-rubbed with a polished stone until achieving a satiny sheen. As was previously mentioned, burnishing stones were sometimes regarded as being "magical" in themselves and were often handed down over the generations. Much of our archeological understandings of ancient cultures is derived from the figures and historical narratives that were painted on these vessels over the millennia.

By 1000 AD North American potters were pit-firing bowls that were meant to have both utilitarian and magical significance. In the Mimbres culture of New Mexico potters coil-built their bowls for food service as well as to map their cosmic mythology. The inner surfaces of these bowls were meant as "sacred space" where everyday reality freely interacted with the magical/spiritual universe (Townsend 1992). In this metaphorical territory of magical potential, artisans conjured deities, mythological animals and spirits, and hunting visions, as well as historical narratives that celebrated both the mundane and sacred tasks of daily life (Figure 33). These prayers, incantations, and histories sought to unify the temporal and spiritual worlds of the Mimbres. Unification was achieved by using the bowl for both utility and as a prop in religious burial rites. It is thought that after the vessel's owner died, the bowl had fulfilled its earthly mission and was then converted to a mortuary urn. This magical transformation occurred after the Mimbres shamans "killed" the pot — meaning that the bottom of the bowl would be perforated to allow the

deceased's spirit to depart safely. The pot was then broken to sherds and buried under the clay floors in the family pueblo. In this way a simple pot assumed the metaphor of transformation from the physical body to a

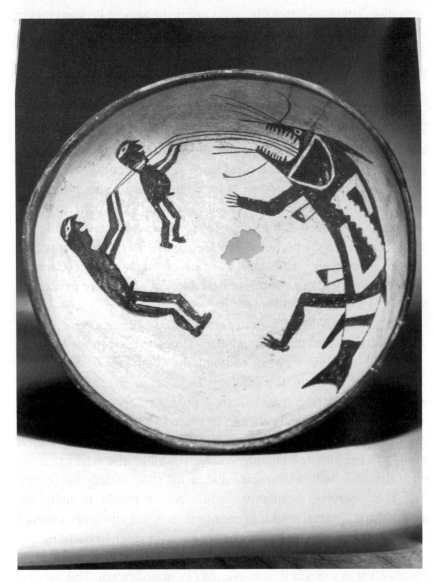

Figure 33: A bowl from the lost Mimbres culture of 1,000AD, New Mexico, a culture which melded beautifully designed functional ceramics with magical rituals of the spirit world.

powerful spiritual container – one that celebrated the miracles of life and death.

Latter-day Pueblan potters such as Maria Martinez of San Ildefonso resurrected the techniques of black-on-black burnished pottery, as she rediscovered the motifs of the lost Mimbres culture (Trimble 1987). Martinez is credited with breathing new life into the legacy of her ancient ancestors as well as influencing ceramic masters such as Soji Hamada and Bernard Leach, both of whom visited Martinez at San Ildefonso in the 1920s (Peterson 1974, 1977). In their contemporary pottery, the Mata Ortiz people of Mexico have taken this art form to even higher levels of craftsmanship and imagery, eclipsing even the Pueblan potters in their ability to create coil-built and slip decorated ware of astounding refinement and sophistication (Lowell *et al.* 1999). This art remains the standard of quality which many contemporary Western ceramicists emulate in both spirit and design.

Influences of the Far East

Around the era of the Mimbres another great flowering of ceramic expression occurred in China and Korea – one so profound that work from this epoch continues to influence the most advanced aesthetics of contemporary functional pottery. Most prominent era among the long, rich tradition of Chinese ceramics is that of the Southern Sung Dynasty that reigned from roughly 1126–1280 AD (Tanaka 1973). This mostly wheel-thrown ware is still considered by many as the pinnacle of ceramic expression. The aesthetic of this period asserted that even the most modest, anonymously potted bowl could be endowed with great cultural, spiritual, and cosmic importance (Valenstein 1975). Nelson and Burkett (2002), among others, rhapsodize that ware from the Southern Sung is steeped "in strength and vitality, accentuated by sensitive restraint" (p.18). In a bid to recreate the mysterious Sung glazes such as the elusive "hare's fur" or "oil spot" Temmoku glazes, Grebanier (1975) writes of an advanced aesthetic that is seamlessly melded to the Buddhist tenets of sober meditation and reserve. The result is a miraculous unity of form and function that remains highly revered to this day.

Eventually Chinese Buddhism reached Japan, where it flourished as a separate sect known as Zen Buddhism. Inextricably tied to the aesthetic

of Zen was the cult of the tea ceremony. During the Southern Sung, powdered green tea was introduced to Japan as a stimulant – a means of keeping monks awake during meditation. By the fourteenth century, tea had reached cult status among Zen Buddhists and had spread to the samurai and ruling sects of society. Here it became codified into both a social ritual and a highly advanced aesthetic built around Ch'an Buddhism and the styles of the Southern Sung in China. Connoisseurs of the ceremony required tea utensils which exemplified the teachings of Zen Buddhism, which is embodied by the aesthetic sensibility of the revered "tea bowl" (Hisamatsu 1971). Whether pinched, carved or wheel-thrown, the tea bowl captures the Zen attributes of quiet strength, tranquillity, spontaneity, and modesty. Reverently valued, some bowls are still passed down through generations along with their poetic names such as "Snowy Heron" or "First Blossom." Certain potters earned legendary status, such as Chojiro, who in the fifteenth to sixteenth century was the originator of the "Raku" method of firing tea-bowls. In the mid-seventeenth century, the samurai swordsman, Zen scholar and aristocratic Nonomura Ninsei combined the earthiness of Raku ware with delicate enamel painting of the most refined degree. Along with the most renowned tea-bowl artist, Okata Kenzan, all of these potters earned legendary status through their feudal lords as "Tenka-ichi" or "Foremost in the World" (Fujioka 1973). The bowl pictured which is by Kenzan (1663–1743) (Figure 34) has a Zen-inspired slip-painted motif of a waterfall rushing through a gorge of rocks. Each element is boldly suggested by a few broken brush strokes that celebrate the spare and austere Zen-style. The poetic inscription on the other side reads:

> Billowing forth white like snow,
> then a river that flows for all eternity.

Beyond its elegant surface treatment the structure of Kenzan's piece is powerfully built but its proportions are carefully understated. Its broad straight sides flare slightly outward, creating an expansiveness that suggests the infinity of a horizon-line and the sky. The walls curve softly downward to the carved raised foot, which lifts the body slightly into space, further accentuating a sense of levity, lightness of being, and quiet transcendence. The slightly irregular undulating lip offsets the symmetry

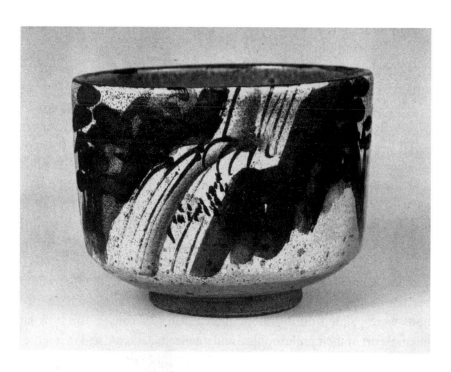

Figure 34: A tea-bowl with loose calligraphic brushwork by the master Ogata Kenzan (1663–1743), whose work exemplifies the "Zen" aesthetic of the tea ceremony.

that grounds the rest of the piece. The economy and restraint of this form is contrasted with the free-flowing brushwork. Interaction between the two creates a dynamic relationship that breathes life into what might otherwise be considered just a modest drinking bowl.

The culture surrounding tea and the creation of tea-bowls would eventually not only be limited to potters but become part of the larger social rituals of the artistic élite or "literati" for hundreds of years of Japanese, Korean and Chinese cultures. Any cultivated individual of this time was expected to have mastered the art of sumi brushwork and calligraphy. Tea-bowl painting parties would invite the literati to gather together and paint haikus onto prefabricated bowls. These gatherings became ritualized into performances that would rival those of the contemporary art-world. As early as the fifteenth century, poets, painters, scholars, samurai, politicians, and monks alike took part in what would become drunken, raucous scenes of creative fervor. Zen-inspired inscriptions were painted during these altered states of consciousness as an integral part of their philosophical and intellectual discourse. Their loose, bold brushwork of calligraphic characters or landscape motifs often rival those created by modern-day abstract painters. New York school painters such as Kline or DeKooning aspired to a similar set of values where sublime inspiration and debauchery went hand in hand. Although separated by centuries, each group shared the romantic ideal, where free-spirited spontaneity and eccentricity bordering on madness remained an integral element of the aesthetic (MacGregor 1989).

The most prized tea-bowls were those whose glazes were accidentally altered by kiln accidents or other effects that were beyond the potter's control. Forms that were asymmetrical, lop-sided, or even cast-offs were preferred over those of technical perfection. Bowls which had blown up in the often violent quick-fire method of Raku were sometimes rescued and painstakingly glued back together using liquefied gold lacquer in order to illuminate, rather than hide, the cracks. While self-discipline and serious study were a prerequisite to practicing this wild, Zen-inspired approach, the spiritual values remained a constant: that by relaxing the judgmental ego and the preciousness that such self-consciousness brings, we can become closer to what Suzuki (1948) termed "perception of the highest order." Perhaps the equivalent of this

state of Eastern transcendence can be found in Western psychoanalytic literature. In Winnicott's concept of the "true self" (1965) the ego undergoes a transformation whereby pressures of societal conformity give way to insights of inner truth and strength. The renowned Tea-Master Sen No Rikyu once hung a scroll in his 16th century tea-house that read with a flourish of characters:

> The true taste of the heart,
> is to find taste in nothing itself.

(Hayashiya, Nakamura and Hayashiya 1974)

The true self also finds itself in contemporary thinking on the spirituality of clay and the turned circle. M.C. Richards (1962, 1989) espoused a continuity between the physicality of clay and its metaphorical significance as a process which also has its roots in Eastern thought. She writes of the process that feeds mind, spirit and body:

> Is this not centering, to feel the ideal energy and thrust and equilibrium in the moment's concreteness? The centering experience is an experience of the soul, whether we get it primarily through hands or eyes or imagination, and this is its compelling strategy. When we are on center, we experience reality in depth rather than in partition (p.53).

With these thoughts in mind, we might begin to apply this rich historical and modernist legacy to our work with clients in art therapy. As we shall see in the case material, metaphors abound in these timeless ideas which can, in turn, guide and inspire our work in both clinical and studio settings.

12. The Functional Form in Art Therapy

Counting the petals

We often never know what clay processes might resonate most with the eccentric preoccupation of our clients. One nine-year-old boy with obsessive–compulsive disorder and a slight visual impairment was fascinated not so much by the wheel-throwing or handbuilding process, but the preparatory process of wedging. He delighted in watching me roll and knead the clay, sometimes for a hundred rotations. The rhythmic motion of my hands as they gently rocked the mass of clay back and forth created a spiraled ball that Beittel has romantically termed the "ram's head" (1989, p.48). Kneeling eye-level with me on the floor (where I always wedge to utilize my back muscles most efficiently), he would mimic these hypnotic repetitive movements, which perhaps satisfied his own need to self-stimulate through repetitive motion. Here he could safely exercise his obsession as I squeezed, twisted, wrapped and folded over the clay with a soft kneading motion not unlike the paws of a kitten massaging out its mother's milk. The wedging forms themselves can be things of beauty as each rhythmic movement is recorded as petal-like forms which the Japanese have named "chrysanthemums." Like many children with obsessional interests, this boy could not seem to broaden his interest beyond this one activity. Therefore he would almost exclusively wedge during his sessions and from this one limited activity, he would create small yet lovely spirals which I would help him hollow out and then mount as sculptures.

In working with this child, I came to a better appreciation of the inherent beauty of something I have long equated with drudgery and back-straining work. To take the airy, uneven clay and work it "until it begins to sing" is itself an art-form with its own aesthetic and spiritual beauty.

The wheel as sensory experience

Fascinated with the electric potter's wheel, a seven-year-old legally blind boy hums in delight as I place his hands upon the wheel head. He focuses intently upon each of the concentric circles that spin underneath his tiny hands. Anchoring fifteen pounds of clay, I begin to center for him, forcing a tall narrow cone into the air that further excites his senses. Placing his hands upon the volcano-shaped mound, he explores the slippery feel of the lubricating slip. As I raise the piece he excitedly knocks the top knob slightly off kilter which sends the whole piece into a wobble. "This is the door knob," he shouts unexpectedly. I inquire further: "She was supposed to leave the door closed, not open, that's why 'he' hit his head and yelled at mother," he exclaims in a sing-song voice. Like many blind children with autistic features he has a strange modulation to his voice and refers to himself in the third person. "She" was the new housekeeper who had not learned all the nuances of door closings and other household rituals required by this sensitive child.

Next I open the mound and drill a center opening down into the core. With me guiding his hands, he eagerly enters deep into the "mouth" of the pot-to-be. Feeling around inside, he coos contentedly. No other verbal associations or commentary are forthcoming, only the sensory experience of penetrating this wet, cool cavity. As his hands were often self-stimulating in his mouth (which was the organizing center of this blind child's sensory impressions) the clay displaced this need for oral stimulation through appropriate means (Fraiberg 1977). Here in the bottom of the well he lingered in quiescence, lost in the soothing whirl of the clay.

In the following week's session, I placed the same cylinder of clay on the wheel (using a wooden bat that would lock the piece back to the wheel-head). He easily remembered our tower and immediately began to

sink his arm up to the elbow into the thirteen-inch deep hole. He sat quietly as I relubricated the now slightly stiffened piece and then began to run my fist up the outside wall to raise the cylinder further. As the walls became dry from the friction induced by this pass, he exclaimed: "This is the yard felt during recess, after he fell and scraped his hand." It seems that he associated the sandy textured grog in the clay with the sandy ground in a recent school-yard fall. He continued by stating how "no one noticed" and that then "he brushed himself off" but his "hand continued to hurt." He began to make what he called deep "cuts" in the thick cylinder using a wooden serrated rib. He said he was "scratching the clay." Using a wet elephant ear sponge he began to seal the cuts over, referring to his action as "cleaning it up." He then pushed the sponge into the waist of the cylinder, creating a wide, soft groove. Running his hand over this indented surface brought forth another association. He described how his mother had bought a lamp of this shape. Then perhaps confusing pot with person, he states "She's curvy." This was a clear reference to the developing object relationship with his mother, who was then being trained by the other therapists to provide the needed contact comfort that it was hoped would draw him out of his otherwise autistic-like state (Fraiberg 1977). After voicing his associations about mother he began a discussion of how much light he needed to make his way around the apartment. This particular lamp, he informed me, had several settings which allowed the bulbs to have "different brightness which helps the boy see."

In these two sessions, the potter's wheel was employed as a stimulus which aroused his tactile and visual sensations as well as stimulating verbal free-associations. The cylinder which I created was more of a "process" than the production of an object. The outcomes were diverse and substantial despite his autistic functioning. He was able to generate a range of themes and issues useful for our therapeutic work, while enjoying a novel experience with the machine and clay that created a sense of physical intimacy during the activity. Like many blind children with autistic features his sense of object permanence was distorted or incomplete. Often the only way that these children can ascertain that the therapist remains present, or even continues to exist, is by maintaining constant conversational contact throughout the duration of the activity.

Although this child has some residual vision, he enjoyed the reassuring banter as well as the hands-on tactile sensations. These led to explorations of issues which formed the basis of our therapeutic themes. Feeling safe with unfamiliar people unused to his disability (the new housekeeper) and during less structured activities on the school playground became fertile topics of personal relevance as each was triggered by this growing tunnel of clay. The need to satisfy oral as well as contact comfort needs brought forth issues related to developing object relationships. His figurative association with the waist of the clay cylinder as the maternal body, in all probability referred to the ongoing therapeutic work of developing a bond with his mother. Like the boy who also free-associated using clay "spaghetti" as a stimulus, the throwing process too could stimulate rich associations for analysis leading to a unique therapeutic outcome.

Symbiotic attachment and the coiled cup

For those with sensory handicaps or developmental disabilities, including features relating to autism, we explored a case in which the concept of creating objects was beyond my client's reach. Instead I used the potter's wheel as a vehicle for sensory stimulation and verbal free-association. In the next case we shall see how the idea of creating a product was taught to the client through repetition and demonstration. In this case, skill acquisition developed along with establishing new relationships that would address the child's severe abandonment anxiety.

In this research study (Henley 1986) I followed the development of a multiply disabled child with autistic features that included self-injurious behavior, in a twenty-week clayworks program that was supervised by then teacher/consultant Lou Johnson. As a result of severe anxiety, this child would bang his head if any of his select few caregivers (such as Johnson) left him behind with new staff such as myself. After three sessions Johnson gradually began leaving the child with me which precipitated violent protest (Bowlby 1969, 1980). On one occasion he flipped the table and physically attacked: biting, spitting and screaming like a wounded animal. After the fifth session, this abandonment protest was turned inside out. At the end of our sessions he began to clutch at my

hands as a means of imploring me not to abandon him! Our uneasy attachment enabled us to begin playing around with the material, such as rolling out coils, forming rings and other toys, and animating clay balls. At twelve years of age this child was developmentally arrested at a pre-art stage of clay-smearing and eating that was more appropriate for a child of two. In the initial sessions he seemed to lack any appreciable awareness of the objects that we were creating, since he was still preoccupied with gripping my hands to ensure my continued presence. Often, I struggled just to extricate myself from his grasp enough so that I could help him to manipulate the clay.

Several interventions were necessary to create an environment where he could begin to feel secure and stimulated. The first intervention was to devise a project that centered around creating a common, household object: I chose to have him coil-build a drinking cup. The everyday familiarity of the cup would, I hoped, make the theme developmentally accessible since it is associated with nourishment and nurturance. It also allowed us to create rituals around drinking tea and other refreshments together, which further cemented our bonds.

The next series of interventions involved setting up our space. Portable canvas boards, simple tools that were safe to use, and clay of the proper consistency were all set up for use. I then seated myself across from him, staying within his field of vision. I remained close enough so that he could reach me as I monitored his movements (to discourage eating the material) while I rolled out the coils needed for our cup project. I allowed him contact as long as he was touching or engaged with the clay — otherwise I would back away (which initially resulted in panic/enraged head banging). With this strategy in place, he was eventually able to make the association that his need for contact comfort could be most effectively satisfied when he was working cooperatively on task. With this unspoken behavior contract in the works we could begin to fabricate our cylinder. Over the course of the twenty weeks, this child eventually learned the sequence of movements needed to roll, wrap, and then stack each coil around a rigid cardboard tube. This tube gave the child a target on which to weld his coils. The firmness of the form prevented the cylinder from collapsing under the pressure of welding his coils together (given his poor fine-motor control the coils would often break apart). The tube was

also effective at absorbing the tremendous aggression that arose when he was forced to separate from me and instead stay on task. This channeling of affect served as critical displacement activity, one that absorbed aggressive discharge through the appropriate means of squishing coils together.

Another important adaptation was the use of a banding wheel. This small portable wheel provided another visual target besides the tube to guide the sequence of actions. It also allowed him to dispel the pent-up tensions by spinning, which became another means of discharging self-stimulation through appropriate activity. This array of round objects – the wheel, the tube, the coils – each became the organizing center of focusing his attention. As he learned the process and his attachment became less anxious, our work together became almost meditative in quality. Though not meditation in the truest sense of the word, our ritual-ized activity sometimes lulled him to a state of quiescence.

During our work I would try to convey to him the concept that we were engaged in creating a useful object. To convey this idea I would have us both drink from one of the finished cups. I emphasized our movements – lifting it to our lips, pouring, sipping, putting it down – which all became elements of the ritual. I would pause to remark upon the beauty of the cup, its balance, the colors, the strength of the handle, then com-pliment the tea's warmth, its flavor, color – not unlike the tea-master's stylized movements in the tea ceremony, where savoring each moment with a special tea bowl is part of the social/aesthetic experience. Our tea-drinking together at the end of each session became our moment of shared reflection and rest after our working together. It also signaled the end of our time together, which precipitated renewed anxiety. I would sometimes present the cup to him to bring back to his classroom as a symbol of our bond. The cup perhaps functioned as a transitional object, one that buffered his loss with an object of lasting permanence and symbolic nurturance. His teachers were encouraged to use the cup as well – as though drinking from this little cup would magically lessen the anxiety panic when in transition to the care of others. As his attachment became secure, he seemed more capable of enduring such transitions with less self-injurious behavior. Perhaps he finally began to internalize the

consistent and secure nature of our bond that the cup symbolized, despite the termination of our session.

In potting together, his emotional needs for security and comfort had found a common ground in the clay. The cup, our presence together, and the rituals we devised, went beyond deploying transitional objects and entered the realm of "transitional space." Within this space we were able to take greater emotional risks, practicing separation and other anxiety-provoking experiences. As we played around with material and form, eventually arriving at a recognizable and comforting product that fed us a beverage, we entered this magical realm. Here was a "sacred space" reminiscent of the pueblos, where an object of unremarkable utility was magically transformed into metaphor – to something intimately special and permanent.

Throwing on the wheel and facilitating attachment

In the last case, we observed how the art therapist functions as part of a team which provides a consistent and trusting relationship that allowed the child's development to move forward. This next vignette plots the maturational development of another autistic-like young man of 21, whose disturbed behavior was overcome by his close relationship to his therapist and his fascination with the potter's wheel (Henley 1989).

This young man, whom we shall refer to as Juan, incurred emotional disturbances that resulted from trauma and neglect during early childhood. Probably autistic from birth, Juan's Haitian parents were convinced that his disability was their "punishment from God" and accordingly kept him locked alone in their basement during all hours of the day. His parents would then let him out in the evenings to roam unsupervised in the streets, where he went undetected as a feral child for several years. Eventually he was picked up by police and was sent first to a state psychiatric hospital where he was diagnosed as being psychogenically deaf (meaning that the impairment was of mysterious origins since his hearing was physically intact). With this new understanding, he was then placed at the nearby state school for the deaf, where I was to work with him for the next four years.

As with many individuals with autism, this young man resisted inter-
acting with people. Instead his passions revolved around his relationships
with mechanical objects. Evidently during the long nights of roaming the
streets he had collected all kinds of mechanical junk which he would
bring back to his basement lair and experiment with during his hours of
isolation. He was not only a whiz at fixing broken electrical appliances
without any prior instruction, but he could combine different compo-
nents to create altogether new and often bizarre machines. This
savant-like capacity has been described by other therapists such as
Bettelheim (1967) whose case of Joey and the "car-machines" also
involved mechanical obsessions. Building upon his attachment to electri-
cal objects, I decided to have then art therapy intern, Anne Johnson,
introduce him to the potter's wheel (1985). Oblivious to its function,
Juan immediately began to check out the wheel's electronics, obsessing
over the motor, the bearings, the drive shaft, the electrical circuitry, and so
forth. Upon turning the wheel on, he would caress the spinning
wheel-head, shrieking with delight, as though he was making a new
friend. When Johnson placed clay on the wheel and began to center, Juan
was invited to try his hand at throwing. He found to his frustration,
however, that no amount of mechanical skill could enable him to center
with the same success. Almost defeated by the vexing mound of clay, Juan
reluctantly allowed Johnson to place her hands upon his. Her hands-on
intervention enabled Juan to experience the subtle yet forceful
movements necessary to coax the clay into the center. Such contact for
this autistic individual would ordinarily meet with avoidance which
could escalate into wild bouts of biting and spitting. It was his intense
desire to master this machine and the nurturing attentions of Johnson that
enabled him to endure the intimacy of this intervention. As M.C.
Richards observed of the simultaneity of this teaching and healing
process: "... the 'they' will disappear into the 'we'" (1962, 1989).

Teaching throwing mechanics

Centering clay on the potter's wheel is a paradox: it can be at once effort-
less and impossible. For beginners it may be a tortuous, frustrating experi-
ence that takes years to master. However, once it is learned, only a few

touches are needed to center the clay. Throughout the historical and clinical material, the metaphysical and spiritual dimensions of centering have been emphasized. While the centering process is worthy of its many metaphors, it is essentially a mechanical function. The body must function as a tool – one that performs a series of repetitive hand and arm operations. Tremendous localized force needs to be applied with minimal movement of the hands, wrist and forearm. Elbows need to be firmly planted against the ribs or thighs, so that they are immobilized while the hands force the clay to be quieted. With the body braced, the back muscles can support the wrist and arms so as to strengthen and stabilize the exertion of this force. Hands need to be still and slightly cupped, with one placed on top and the other forcing the clay from the side. Once pressure is applied and the piece is close to centering, the hands must be carefully removed without "pushing off" the clay – which can have the frustrating effect of negating any centering progress. To communicate this exacting sequence of movements to an autistic or otherwise handicapped individual is a challenge indeed. Within weeks, however, Juan began to center with less frustration provided that Johnson maintained her hands-on support. Eventually he began to develop his own throwing mechanics as every potter does, working in a repetitive, almost robotic style as though he himself was a "centering machine." Yet this mechanical skill remained inextricably tied to the hands-on relating that developed with his therapist. Like the magic cup of the child before, it seemed as if the wheel and the warm gentle hands placed so carefully upon the clay had entered the realm of transitional space. Within this space Juan would flourish at the wheel.

Juan's drawings of the time reflect his growing capacity to form rela-tionships while developing his new skills. First, Juan drew Johnson from life as she was centering on the wheel. It is significant that his representa-tion of her palls next to that of the electrical elements of the wheel itself. Elaborated in detail is the clay's rotation, the power switch, the rotation of the spinning drive shaft, bearings, flywheel, and motor, complete with an unplugged cord (Figure 35). Weeks later, as their relationship formed, a second image shows a dramatic reversal of elaboration, with Johnson now becoming the center of focus (Figure 36). Her body is carefully rendered from life in a complex three-quarter position that includes her

kicking the flywheel rather than using the wheel electrically. It is signifi-
cant that Juan drew the motor unplugged, which in itself may be a
metaphor for his burgeoning separation from mechanical object rela-
tionships. Johnson faces the viewer, her firm eye contact, broad smile,
and accurate hair style all indicating the strong affective bond forming
between artist and model. She is also shown modeling the correct
throwing position with her elbows tucked close to her body. Much
emphasis is placed upon the mound of clay and the position of the hands.
In contrast to Figure 35, the elements of the wheel have been
de-emphasized, with a more schematic treatment of its electrical compo-
nents. In a side-bar Juan drew a schematic cartoon-like sequence of
Johnson "doing the magic." As the cone of clay is being centered, he
carefully shows the animated motion of Johnson as she brings the
material up and down. In the third and most extraordinary drawing,
(Figure 37) created a month later, Juan portrays both Johnson and
himself at rest posing casually in their throwing aprons. Both figures are
exacting and almost lovingly rendered. The detailed components of the
wheel are now almost completely dispensed with. It is drawn in an x-ray
style which allows Juan to explore his own body, which can now be fully
seen in the composition. It is the relationship with his teacher/therapist
that is being celebrated, which has in turn enhanced his own sense of
self-awareness. Both are rendered in a moment of repose. Their struggle
– trying to tame the uncooperative clay, having uncomfortably caked
and slimy hands, losing piece after piece – appeared to strengthen their
bond and investment in the process. As a postscript in this image, Juan
added a ceremonial element to the composition. Therapist and client are
shown exchanging their pencils in a touching moment that celebrates
their efforts. In this case, the wheel acted as a bridge from autistic
isolation to a relationship of almost profound intimacy. The sequence
bears witness to the often indivisible relationship between psychic
healing and the artistic process as both progress, paralleling growth on
simultaneous levels.

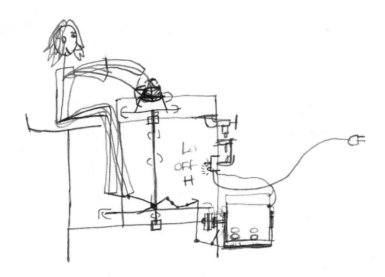

Figure 35: This figure (and figures 36 and 37) show that drawing about the process of learning to throw was central to the therapeutic work of a young man with autism. The progression clearly tracks the development of more bonded and "constant" object relationships.

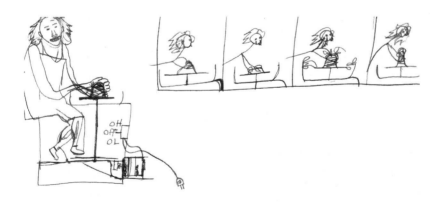

Figure 36

Figure 37

Adaptation and wheel production

For clients with orthopaedic involvements, ordinary techniques of wheel-work may be out of reach. Other adaptive techniques may need to be devised which allow for a productive, creative throwing experience despite severe handicapping disabilities. In one case, the only help needed was centering and steadying the client's hands. Despite his cerebral palsy, this young man became quite adept at the wheel with only minimal adaptations. In a more severe case, a sixteen-year-old girl we shall refer to as Nina suffered from spastic cerebral palsy and quadriplegia that robbed her of the capacity to move or speak. Despite these debilitating handicaps, Nina possessed an indomitable spirit and a fierce will to succeed. Our relationship was one of such intimate trust that in our sessions she would try anything, even throwing on the wheel. It was up to me to formulate the needed adaptations so that wheel-work, in some form, became possible.

The first task is to reframe the idea of throwing as a process requiring manual strength or dexterity. For Nina, hands were not only useless, but they needed to be strapped to her side in order to minimize the disruptive effects of spasticity. Therefore, the wheel had to become a piece of equipment that no longer required hands, but only tools that one would use on a lathe. In this way a mound of pre-centered clay could be turned by different shaped tools as though a piece of wood. The occupational therapists fitted Nina with a stylus which could be attached to a soft helmet. In this stylus, different loop tools, turning tools, needles and even paint brushes for painting the slip were fitted for each operation. Standing behind Nina so as to quiet the involuntary movements of her head, I assisted her first in opening the mound of clay using a large loop tool to carve out the material. As she nodded her head in a downward motion, she was able to bring enough pressure to bear that a hole was slowly created. More trimming of the inside resulted in a cylinder with progressively refined walls. Once sufficiently thinned, Nina worked the outside by fitting a brush that allowed her to apply a slip decoration to the clay. After much practice, she could independently dip her brush into a cup of slip, then hold the brush still on the revolving piece (which applied the slip onto its outer walls). Once the form was painted, the brush would be exchanged for a decorative sgraffito loop tool. This would allow her to scratch or cut through the slip, revealing the contrasting color of the clay body underneath. These procedures took over a month of consistent practice for her to achieve a modicum of independence. At her highest level of proficiency, she could create a four-inch cylinder with assistance in each forty-minute session. After firing these pieces were used as functional vessels in her daily life. The extraordinary motivation and perseverance needed to overcome such a handicap was directly tied to our trusting relationship. Our bond seemed to propel Nina into taking physical and creative risks that extended well beyond her own self-perceived limitations.

Such a trusting relationship was also developed with another child who was quadriplegic, but unlike Nina, this child could not move at all. Susan had suffered a high break to her spinal column in a diving accident. After several surgeries she was left with only limited function of her facial muscles and vital organs. She could use an electric wheel chair by means

of her breath control, which propelled the wheel upon her blowing into a tube. In this case direct manipulation of the clay was not a possibility. Even working clay into her hands to feel its sensations was impossible due to the atrophy which left her limbs exceedingly fragile and sensitive to any pressure. In this case claywork therapy became "virtual," meaning that our sessions consisted of my throwing *for the child*. I would have her dictate to me what forms she wanted me to create in what style. She would describe in minute detail each of the objects of her desire. I encouraged her to describe and even correct my (somewhat intentional) mistakes as each of the throwing steps of centering, opening, bringing up the cylinder, and so on, were completed. With more involvement in the process, I hoped to stimulate a greater investment in the work, which I hoped would come alive for her through these therapeutic demonstrations.

Process and product in rehabilitation

For some individuals with physical handicaps, throwing on the wheel may be within reach providing that adaptations are devised which compensate for their disability. In one case, a nineteen-year-old college student, whom we shall refer to as Ethan, was left with weakness in his extremities after suffering from quadriplegia paralysis brought on by a virus. After a year of physical rehabilitation, Ethan entered a university ceramics program as an undergraduate where he studied under an empathic and inspirational teacher. At this time, Ethan possessed barely enough coordination and strength to throw. Wheel-work at this point in his rehabilitation was not art therapy per se, as the setting was a state university. Yet this was more than academic instruction. Claywork for Ethan was a form of occupational therapy. It allowed him a productive way to develop his strength as well as his self-esteem, which had diminished during his struggles to re-enter mainstream culture as a student rather than a patient. This transition was particularly difficult since this young man's handicaps were essentially hidden. People couldn't understand, for instance, why he could not use the ordinary stiff clay from the class barrel and required instead the "special" treatment of having his private stash of softened clay. With these kinds of adaptations in both equipment and

method, Ethan was able to develop a throwing style that, while limited in technique, was still unique and creative. Taking a cue from his physical therapy experience, he was able to compensate for his weaknesses through ingenious adaptations of his own device.

The first adaptation necessary was to ensure that the clay was malleable enough to work given the weakness in his hands. Always very fragile, Ethan's atrophied hands had lost most of their intrinsic strength. His manual dexterity and strength diminished even further when exposed to the throwing water for extended periods, hence his water would need to be heated. The preparation of the clay has already been identified as a key adaptive intervention. It needed to be of a well-aged vintage with improved plasticity and durability, as he would undoubtedly over-work the material during the learning process. The clay needed to be soft and movable in consistency, with minimal grog to prevent abrasion to his delicate hands, but enough to lend some "tooth" or added strength to the clay body. With these quality materials, Ethan was only then able to gain the most therapeutic benefit from his claywork experience.

Initially Ethan was able to center only the smallest mound of clay – from two to two-and-a-half inches across. Naturally, the pots of this period were minuscule in scale. They were more like tiny long-necked teapot spouts than bona fide vessels. However, the diminutive size did not detract from their aesthetic viability. The illustration (Figure 38) shows how Ethan used miniature elements to his advantage, as his tiny spouts were beautifully incorporated into larger, organic-type slab-built pieces – a process that was not as dependent upon such exacting manual dexterity. By combining thrown and hand-built techniques, Ethan stayed within his physical limitations yet also extended himself by virtue of his creative ingenuity.

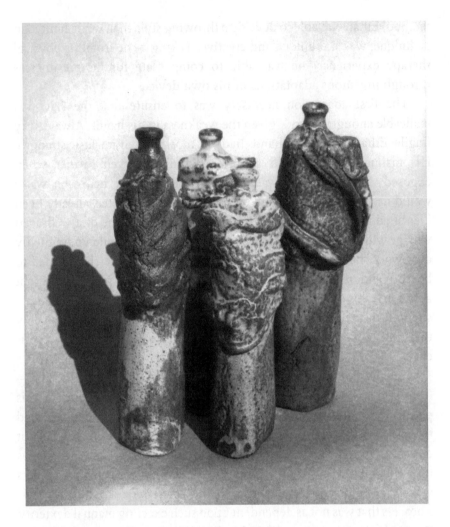

Figure 38: A series of petite sculptural stoneware bottle-forms, thrown and altered by a partially paralyzed college art student.

Each of the pieces shown makes use of three segments: the first, a series of spouts, were wheel-thrown using the smallest amounts of clay possible. These were then placed within a slab that had been rolled around a crushed paper form. This "coat" had been rolled out then "thrown" against the table surface in order to create a variegated texture. By flinging the slab the clay would stretch, with its surface breaking up enough to give it an interesting, almost sculptural surface. Beneath this

middle coat is a cylindrical base that Ethan formed by "marvering" – a process developed by ceramic artist, Sy Shames, and described in Chapter 5, p.62. Created in a series, each slender bottle-like form is glazed with "broken" textures – colors that are mottled as they cascade down the piece breaking up into varying earth tones.

Given Ethan's lack of strength and endurance, these forms certainly stand as metaphors for his physicality of the time. Their delicate stature may symbolize his emotional fragility, that came with re-entering mainstream life. If read as a group of figures, we might surmise that their diminutive scale reflects his own loss of body mass. Because of the profound trauma Ethan had also regressed socially, becoming insecure and highly impressionable by peers within the art studios at the time. Seen as a group, the bottles seem adolescent in their need to huddle together en masse. Their petite bodies, muted tones, and similar forms perhaps reflect Ethan's damaged, fragile self-image or body-ego. Left with an atrophied physique, he now had to adjust to an essentially "new body" – one that was still ego-alien to him. In these little bottles we might follow Ethan's own process of recovery, which seemed to be recorded through the form and content in these delicate clayworks.

As Ethan slowly regained physical strength, he expanded his repertoire accordingly. After six months, he was able to increase his poundage to one or two pounds – about enough to throw a mug or cup. If attempting to throw any more clay than a few pounds at once, his hands would quickly fatigue and lose function for the rest of the class.

Controlling the wheel's speed was also a critical adaptation, as Ethan could not yet move his ankles sufficiently to operate the foot-style rheostat. Thus a hand extension rod was screwed into the wheel's foot-pedal in order to bypass the foot-control. The Shimpo RK-series electric wheel used in this case came automatically equipped with this feature (which is visible in the photograph of the author throwing in Figure 39). Although having to remove one's hands from the piece to adjust the speed disrupts the fluidity of the throwing process, the hand-control is a requisite feature on most handicapped-model wheels.

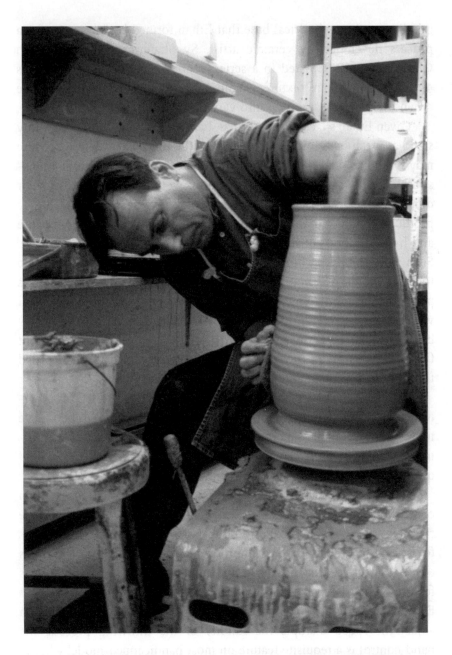

Figure 39: The author throwing on a shimpo electric wheel fitted with both manual and foot controls that allow for greater accessibility for handicapped potters.

In order to brace his weakened hands during the centering and throwing operations, Ethan developed his own splint system composed of bent tong depressors which he bound to the outside of his fingers using elastic bands and duct tape. Once his fingers and wrists were braced, using a commercial athletic wrist brace, he could utilize his biceps, latissimus dorsi, back extensors, and other more powerful muscles to exert more force upon the clay. Long passes were also a problem, as his fingers would tend to cramp into a clenched immovable fist. Yet with time, Ethan used this disability to his advantage as well, as the cramping coincidentally kept his hands steady and quiet while bringing up the clay. Eventually, Ethan became skilled at moving the clay with the continued support and guidance of his university professor and mentor. However as his skills developed new problems arose.

Like many beginning students tasting their first success, it was natural that Ethan would eventually shift his emphasis from the occupational and therapeutic "process" of throwing to the creation of material products. M.C. Richards writes that the possession of knowledge may create materialism of its own (1962, 1989). Ethan became increasingly concerned with the survival rate of his pieces as they dried or were handed over to the fire. Such investment in his work was understandable given the intensive physical effort that was required to create each pot. However this shifting of focus to the materialistic side of potting may lead the student to shy away from taking creative risks. Ethan suffered terribly from this predicament. At this vulnerable stage of development, his work would become overly precious to him, resulting in ware that was tight, self-conscious, and sometimes lifeless. We might interpret this concern over his success rate as a metaphor for Ethan's damaged body and fragile self-image. As pieces might fail, so too might his own recovery. These fears of regression were verbally expressed as well as symbolically acted out in his potting throughout the course of his recovery.

At this point Ethan's mentor stepped in to try to loosen up the anxieties and inhibitions that were blocking his creative development. Here again, attention was turned to the wisdom of the East. Ethan's professor, David Jones, was influenced by the "Black Mountain School" where avant garde artists such as John Cage, Merce Cunningham, and M.C. Richards had developed their innovative ideas. Jones gave him

exercises that emphasized the process – such as throwing by touch with eyes closed, or finishing a piece in only three passes, or intentionally leaving the clay in its fragile raw state without firing. Each of these interventions sought to remind him of the pleasures of just throwing for the sake of throwing. Despite these excellent exercises Ethan remained somewhat inhibited in his wheel-work – a development perhaps related to the previously discussed effects of trauma on him as a recovering quadriplegic. A metaphor emerged that proved difficult to overcome: that the paralysis left an indelible mark or scar, that could manifest itself through both body and mind. Indeed, Ethan's body seemed to heal at a more rapid pace than the emotional effects of the paralysis – a lingering testament to the depth of his trauma as the past continued to assert itself well into the present.

This vignette points to the complex psychological aspects of potting that transcend the process of learning to throw in the context of physical rehabilitation. Issues such as becoming preoccupied with the product, or dealing with emotional inhibitions that constrict the creative process, all formed a constellation of problems that persisted beyond the physical rehabilitation. In art therapy, the fragility of the client complicates this issue further as we attempt to ensure success and instill a positive approach to this demanding discipline. The next vignette will further elucidate these problems in the clinical setting.

The failed ego-ideal

In the last several vignettes the bond between teacher/therapist and pupil provided the support to surmount formidable handicaps. Therapist interventions often spelled the difference between therapeutic victory and disaster. In the next case I shall describe the circumstances when the mentoring relationship became toxic.

This twenty-one-year-old deaf man we shall designate as Hugh had been in jail for a range of offenses including theft, assault and arson. Living in a residential school for the deaf, he came to me as a ceramics student in a last ditch effort to encourage some form of avocative or career outlet – one that channeled his aggressive, impulsive tendencies away from self-destruction. During his first year he impressed me with his

diligent study and ability to maintain a relatively clean behavioral record. He seemed to have found his niche in the clay studio as a skilled thrower. Yet indications of his fragility continued to manifest themselves. Like Ethan, this young man became exceedingly precious with his work, becoming highly agitated if his pieces developed cracks, or a glaze failed in the fire, or losses occurred for other reasons. More emotionally fragile than Ethan, when pieces were lost blame was placed solely on me. His rages suggested that a transference had formed, as Hugh seemed unconsciously to equate the failure of his ceramic process as a matter of my own failings as the parental protector and caregiver. He also counted his pieces (which is always a problem) and was preoccupied by his own quotas. However despite these issues he excelled at throwing and would become a valued assistant in the studio. His school therapist saw this success as the first positive attachment made in his eight years at the school. The charts noted that incidents related to his aggressive conduct and illegal activities began to diminish, leading to expanded privileges and status at school.

On one occasion the noted potter Byron Temple had just returned from managing the Leach Potteries in Cornwall, UK (Leach 1940, 1951). He had volunteered to conduct a wheel-throwing workshop at the school where he would also produce pots for sale as part of a fund-raiser for the ceramics program. Hugh asked if he could assist Temple for the day, helping the master with pre-wedging the clay, fetching boards, and changing the throwing water as needed. Hugh's request was granted and the day went smoothly. Hugh impressed Temple with his keen interest and responsiveness during the demonstrations. Temple threw about one hundred pieces that would form the seed money for our fledgling clayworks program. This, however, was not to be.

The next day I entered the studio and was shocked to find that each of the pieces had been destroyed! Pots were stomped, flattened and thrown violently against the wall where their mangled faces had stuck fast. Playing detective, I surmised that the culprit had climbed through the window during the night clad in running shoes whose tread was clearly identifiable in the clay-dust on the floor. Hand-prints left on the pieces suggested that most of the squishings had been accomplished using the left hand. Sadly, all the evidence pointed to Hugh. Of course he denied

everything in the most convincing manner and was outraged and "hurt" by my accusation given "all that he had done for me over the year." Later that same day Hugh inexplicably went wild yet again, setting fire to several potted trees in the greenhouse. A melée ensued and the police were called. As Hugh was carried off to jail he paused and laughingly confessed to the "pot job" as well. Feeling betrayed I asked him "Why?" He answered in one curt sign: "Blood-lust."

In this case it was disturbingly clear that we were dealing with a individual with sociopathic behaviors: cleverly scheming, with a lack of guilt, a charming, manipulative personality, and ultimately a proclivity to criminal acts. Although the claywork apprenticeship had clearly been productive and therapeutic for Hugh, his long-term capacity to control his criminal impulses remained exceedingly fragile. We felt that the experience working with Temple would bolster his self-esteem – which perhaps for the moment it did. However, being faced with this master potter perhaps unleashed a great rage as well, one fueled by the realization that his moment in the sun would be short-lived. Soon he would have to leave the shelter of the school (being twenty-one) and be forced to make his way in dreary jobs with minimal supports in the community. Faced with this prospect, he perhaps acquiesced once again to his powerful criminal impulses – an enterprise in which he had long distinguished himself. Tasting a bit of Temple's and his own success probably only intensified his feelings of inadequacy.

The warning signs of this violent outcome were visible in the fragility of his potting. We have already discussed how many students experience feelings of loss when pieces are destroyed or lost in the firing and thus they become somewhat precious about the work. For an individual with weak defenses, the sense of loss may be overwhelming. Handling such set-backs requires that the individual possess the inner resources to reassert the effort needed to create new works. It was clear that Hugh lacked such inner strength, as each effort was tenuous in itself and thus each pot was precious.

Again, I have long discouraged in my students a materialistic attachment to their pots. Under ideal circumstances, pots should "spring up, uncounted in happy profusion" (Rhodes 1973, 2000). Yet for clients in therapy, such "letting go" may be an unrealistic expectation. Even the

healthiest student may succumb to a "product-driven" approach to potting – which inevitably disappoints the potter and robs the work of vitality.

Kramer (2001) has said that when the ego-ideal is within the potential of the client, this identification may fuel the individual to higher levels of productivity. She cautions however that if the ego-ideal is instead unachievable, tragic outcomes may be expected: from a deflated sense of self-esteem, to the rage reactions that we witnessed in the disheartening case of Hugh. Therefore, keeping goals and objectives achievable remains an issue of critical importance for teacher/therapists. The teacher or therapist may need to be seen as a "benign" role-model as opposed to an omnipotent ideal that the client could never emulate. Our values and subsequent interventions must focus on finding neutral ways to stimulate productivity without setting up our clients to fail. In some cases, then, it may be prudent to focus on the sensorial and process-oriented approaches to clay. Such an approach is embodied by the Eastern concept of the ego, in which "letting go" of the material world enhances both the vitality of the aesthetic and the mental health of the artisan.

In Zen, the essence of clayworks may reflect not the material world as much as the transience of all things – a product of the "empty mind." This mindset is exemplified by the following Zen parable:

> One Zen master showed early promise. Brought to a temple to begin his apprenticeship as a monk, he was charged with taking care of the Master's prized tea bowl. Upon wiping its surface clean he inexplicably dropped it, the sound of the shattering pieces echoing fear into his heart. Upon the Master's return he displayed quick thinking by posing the following question: "Master, what is the nature of all things?" The Master answered: "All things that exist must pass to dust." The wise young disciple then offered: "Master, it was time for your tea-bowl to pass."

Feelings of emptiness and the thrown dish

The physical exertion required during the throwing process has already been identified as a means of displacing aggressive or anger-related

affects. In teens who suffer opposition to authority, narcissistic injury, failed relationships, sexual frustration and other travails of adolescence, wheel-work can be an effective release of pent-up affects. In this vignette, we shall explore the process of throwing dishes or platters whose flat interiors are ideal for graphic design. Portraits, figure studies, landscapes, or abstract designs can all be created by using engobes or colored slips. Slips can be brushed directly onto the wet clay right after throwing, which lends immediacy to the sometimes urgent process of tension release. Two techniques are most effective in working on flat forms: using the slip to make a painting on the clay, or covering the entire interior surface with slip, then cutting through this layer to expose the contrasting clay body. In this case, the sgraffito method was used with a nineteen-year-old teen whom we shall refer to as Luke. Like many suburban young men, Luke found few productive outlets to vent his testosterone-charged energy. Beyond competing in school athletics, most young men who are frustrated or angry have limited appropriate options to vent through productive means. Instead this energy is often discharged in unproductive ways, with substance use, fighting with peers and opposing parental authority being common forms of acting out. With few meaningful rituals that facilitate passage into adulthood, many adolescents in therapy seem to present with a sense of hopelessness and generalized nihilism. In Luke's case one of the few interests that he had developed in his junior college was learning the basics of wheel-work. Thus I tried to exploit this one interest as a means of structuring our individual therapeutic sessions. After some initial time talking and "checking in" we began the throwing activity. Given his tenuous self-confidence he was understandably tentative when I suggested the platter form as a new technique to try. To address his initial trepidation I intervened by again utilizing Lowenfeld's closure method (1957). Instead of allowing Luke to become frustrated and struggle with centering, I asked if I could start him off on his piece. Probably relieved, he silently accepted this intervention. By pre-centering the clay for him I attempted to allay his performance anxieties and fear of failure by circumventing those technical difficulties that could get in the way of his therapy (Kramer 1986). This third-hand intervention sought to bolster his fragile ego without humiliating him or hurting his sense of pride in the process. As he developed the

necessary confidence to master these difficult steps, I slowly withdrew my assistance. This weaning process began by my (intentional) complaints about the fatigue in my hands. I then requested his help in centering, opening or raising the cylinder. In this way he could save face and still receive my support.

After ten sessions, he was handling ten pounds of porcelain and expressed a desire to throw the shallow plate form. I suggested that we might create some images on the platter forms which could work through his sense of alienation and anger. Porcelain was chosen as a novel material, whose creamy consistency and super-white coloration was ideal for slip-painting images. For the paint medium I chose a black slip that would give dramatic contrast against the pure white porcelain. Porcelain is usually considered an inappropriate material for beginning throwers, as its poor plasticity leads to the clay's fatigue and eventual collapse – especially when over-worked by beginners. However since plates are not thrown upward but are pulled out in a low, outward direction, there is little concern over raising walls that might fall apart. By simplifying the technical process, Luke could then concentrate on creating imagery. To apply the slip we used a wide four-inch Japanese "hake" brush, which has soft natural hairs mounted in a sturdy bamboo handle that is ideal for slip-painting (Simpson, Kitto and Sodeoka 1979, 1986). Images can be cut through immediately after throwing, though ideally one should wait until the piece reaches leather-hard stage.

Luke approached the drawing (sgraffito) process with great trepidation and ambivalence.

At first he experimented with cutting spiral designs which created optical effects that were pleasingly hypnotic. After slipping and then erasing five op-art type designs, I encouraged him to try a figurative image. The transition from decorative, abstract design to that of a figure was exceedingly difficult for Luke. He resisted the intervention. Motivation and perseverance began to diminish. After much discussion and numerous erasures he finally drew a circle with schematic eyes, nose, and mouth. Trying the closure method once again, I took the fork tool and drew light abstract tooth lines down from the mouth that seemed in keeping with his design. He then countered by deepening my lines, then drawing angry expressions around the eyes and mouth, finally adding

two horns atop the head (Figure 40). While the resulting mask-like form was graphically bold with its calligraphic slashing lines and contrasting textures, Luke hated it. He intimated that he would destroy it if given the chance. Because the piece was drawn by both of us, I sensed his reluctance to risk offending me by obliterating our shared effort. Reluctantly he left it intact at the session's end.

Figure 40: One of a series of "anger plates," thrown and then slipped over. The client then drew a devil-like figurative form by scratching through the coloured slip to reveal the contrasting clay body underneath.

It is debatable whether the interventions employed in this session advanced the therapeutic process. Given Luke's depressed position, I probably moved too quickly in exhorting him to create a representation that could perhaps mirror his negative self-image and other raw feelings. In this way both Lowenfeld's "closure method" and Kramer's "third hand" may be too provocative for our more vulnerable or fragile clients. Only after long periods of practice and a furthering of a secure attachment can

there be sufficient trust between client and art therapist to withstand such trespassing into the inner "sacred space" of the piece. This anecdote illustrates how therapists sometimes lapse in their attunement to their clients. I failed this child by moving too quickly, regardless of his clear signals that such movement would be too ambitious and premature.

Process as product

By exhorting clients to explore more advanced techniques and images, we may lose sight of the possibility that the very process of throwing may elicit strong imagery in itself. In cases involving our younger or more disabled clients, the case material demonstrates that the throwing process need not always culminate in a finished product in order for the experience to be meaningful. Indeed several vignettes showed how over-emphasizing productivity and facility can lead to creative inhibition, blockage or even destruction. One art therapist and ceramicist who celebrates the "space between" process and product is Sarah Glenn of New Orleans. As part of her art therapy training at the Eastern Virginia Medical School, Glenn produced a mixed media piece entitled "Function of Psyche" (Figure 40a). In this work two modeled hands are posed in the act of throwing a cylinder. Inside a small circular mirror was installed within the wet walls of the still raw clay. Surrounding this sculptural element Glenn painted a thick impasto sea that glistens in the light of the ocean air. Sand was then added to suggest the formation of a beach, which is anchored at the bottom of the composition by an assemblage of sea shells. Glenn makes a clear reference to the potter's connection to earthen elements as metaphors for psychic forces. She writes that by assembling these materials the artist attempts to clarify and focus her perceptions upon the sensory aspects of the process. The elements evoked naturally erode, shift and blow into infinite forms and textures. These forces symbolize the forces in which both material and self undergo transformations that dwell in the "unknowable depths of the psyche." Glenn poses the hands lovingly cradling the growing pot. As it emerges from the sea-scape, the mirrored form seems a kind of offering – one that presents a moment of reflection, peacefulness and insight. It seems poised to withdraw its gift back to the ocean depths at any time.

Figure 40a: Art therapist Sarah Glenn created this multimedia piece in which she incorporated thrown elements with found objects. Glenn then painted the bas-relief in acrylic as she explored the "transitional space" between process and product.

Depicting these transitional spaces seems a difficult concept and design problem to solve. Yet Glenn succeeds in mapping out an experience that relies more on ritualized gesture than concrete object. The work marks a moment in time when the artwork seems still in a state of gestation or dreamy repose – not fully realized as a formal work of art, yet comfortable reveling in the margins between process and product. To attend to these ephemeral aspects of the ceramics process offers the art therapist a source of rich psychological aesthetic potential, as the throwing process enters the "fourth dimension." With this conceptual work as our guide, we can begin to look for efforts during art therapy which are purely ideational, experimental and ephemeral and thus constitute a viable form of ceramic expression. No longer bound by the product but buoyed instead by a momentary feeling or idea, this itself may be liberating for both potters and clients alike.

When the product is the point

This dynamic tension between product and process leads us once again to Jung's ideas on the "union of opposites" which comes into play whenever we begin to emphasize the production of objects as an integral part of the therapeutic process.

Appreciation for the product can be therapeutic in itself, as I have found in a number of situations. For instance, the child pictured incising his piece enjoyed throwing for the sheer sensory and physical process (Figure 41). A vigorous boy of six, he came to therapy by way of his brother, whose attention deficit disorder necessitated some therapeutic work on sibling conflict. This sensitive child had just learned that his best friend had been severely injured in a car crash. He requested that he designate one of his pieces to be a special convalescent gift to his hospitalized friend. It became clear that the therapeutic objective had shifted from process to producing a viable product. As his therapist, I needed to respond to this shift of intentionality and ensure that his pot would survive the drying, glazing and firing process and be suitable as a gift. This meant that I needed to supervise all phases of the finishing process. His main contribution in this process was personalizing his pot by decorating it with loving care. The act of giving was therapeutic in itself, as it

perhaps allayed this child's own fears of car-crashing as well as the sense of loss that arises when a friendship is in peril. For a child of six, whose sense of object permanence and constancy has not yet matured, his gift offered a concrete reminder or symbol of their friendship despite their being apart. Once again, the gift might have become a form of sympathetic magic – one that helped the healing process along through the emotional power invested in this specially made pot.

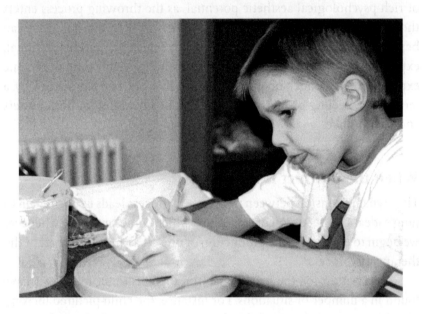

Figure 41: Creating ceramic products as gifts to others can be therapeutic in itself.

Even the commercial aspects of creating a product can have therapeutic implications. While working with inner city teens in impoverished schools in Chicago, I learned that my own middle-class values and ideas on aesthetics did not apply to these poverty-stricken teens. In suggesting ceramic projects to these high school students, their initial response was that making pots was a worthless waste of time unless their production possessed monetary value. For these young people, art for its own sake was an élitist idea which applied only to those who could enjoy the luxuries of aesthetic objects. For those who are deprived and impoverished, creativity was meaningful as long as it improved one's status,

prestige, or material wealth. Clayworks seemed a limited prospect according to this value system. However I persevered, and developed a modest line of salable items which beginning students could accomplish. These included slump-molded dishes or ashtrays, slab-built flower containers or weed-pots, and small, thickly thrown paperweights, each of which was within this group's ability, given the proper adaptations. After two months of work, the teens held a small sale at the school which was supported by most of the staff and faculty. Students were allowed to keep half of their proceeds – some of them were delighted, while others felt short-changed!

The interface between a materialistic approach to claywork and the concepts which make art meaningful was bridged by Welty-Green while practicing art therapy in a summer camp in Florida (cited in Goryl 2000). As a gesture of empathy, Welty-Green was able to accommodate those individuals who chose ash-trays as their project of choice, while also furthering the therapeutic aims of her program. Her solution to the ash-tray problem was a project she ingeniously termed "healthy ash-trays." In this project Welty-Green turned the concept on end by creating ash-trays for an anti-smoking campaign. Upon giving these ash-trays as gifts to their relatives or friends, they would find that some ash-trays had text written into the clay with anti-smoking messages. Others made their point by constructing their pieces so that it became impossible to place a cigarette onto the surface. Although the outcome of these objects could never be verified once the pieces were brought home (Welty-Green assumes that some were probably used as ash-trays), there was evidence that the children's self-awareness regarding the dangers of smoking had become elevated. The key to this outcome was Welty-Green's willingness to meet the clients on their terms while also trying to "move" them towards more healthy modes of functioning.

Welty-Green also reports another significant outcome with this project which is similar to that of Ryan's "mouse boy," who surreptitiously masked the meaning of his work in order to mislead his teachers and further his own obsessions with mice. In Welty-Green's case, one boy led the art therapist to believe he had created a sculpture of a Volkswagen with bucket-seats. However, this teen later admitted it was fully intended to function as an ash-tray – that was by no means meant to be

anti-smoking in its message. He later presented it to his art therapist as a gift. He almost certainly knew that Welty-Green would not use it as it was originally intended. Thus, it is possible that his strong connection to his therapist influenced this young man who amended his intentions to fall in line with her expectations and preferences.

Between commerce and therapy

In the last vignette, the client's intentions began with creating something of personal significance, which became a means of subverting authority. It finally served as a gift of reconciliation and an expression of attachment for his art therapist. As the artist's intentions evolved, so too did the therapeutic outcomes. It is a common practice for clayworkers to give their works away, which in some cases can become part of the concept. In creating works for others, the concept of gift-giving can become integrated in the form and content of the work itself. For instance Councill (2001) reports the creation of ceramic tabletop fountains crafted by patients, families and staff members at a pediatric hospital's oncology unit. All of the fountains were donated as gifts to be placed in the exam and treatment rooms to create a more relaxing atmosphere amongst the sterility and seriousness of the setting. With these gifts, therapeutic outcomes occurred on both ends of the giving/receiving continuum.

In some instances the gift is not so much about giving an object to another, but purely a matter of its making. For instance, the master-potter Toshiko Takaezu became renowned for closing off the top of her ceramic forms, creating rounded spheres or egg-type forms. Some years ago I made a pilgrimage to the master's studio and found her in the garden. There she was harvesting beans and flowers, moving fluidly through the plantings in her straw peasant hat. Soon we found ourselves touring her studio, where I happened upon several of these closed pieces which had recently been off-loaded from her newly constructed mammoth-sized kiln. As Toshiko went to prepare tea, I found myself impulsively picking up one of the still-warm pieces and found immediately that they were remarkably light. This was not so surprising since Takaezu is known for throwing even massive forms with eggshell thinness. But more amazingly, the piece made a sound when handled. A small chiming ring, like that of a temple bell, emanated from this mysterious pink and

lavender sphere. She had intentionally left a small bead loose inside the piece before closing it off. Holding that small unassuming piece was at once affirming, magical, and meditative. I found myself stroking its satiny smooth shoulder which gently swelled into the fullness of its belly. The rhythmic throwing ridges seemed to reverberate around the form. As the master re-entered the kiln room and found me cradling her work, I could only bow my head slightly and sheepishly smile. No words were uttered, but only a long, deeply fulfilling silence held that moment together. A gift had been given and received that transcended the physical object. I did not need to own this pot in order for it to be a gift. Instead I had entered a transitional realm where object and person existed in wholeness.

Figure 40: A thrown, faceted and burnished jar fired in a sawdust sagger with fossilized camel's tooth added as a decorative lid element, by the author. A votive prayer written on a scrap of paper was placed into the jar prior to firing. Once combusted, the scrap of text existed only as a thoughtful gesture and a minute trace of ash.

In creating my own works, which are almost always made for gift-giving rather than commerce, I have taken Takaezu's lead and include a small conceptual or ritualized element as part of the piece, as shown in Figure 42. After throwing and altering the jar-type form into cut facets, I slipped a piece of paper much like those found in fortune cookies, on which I had written a small inscription. The piece shown was fired in sawdust within a *sagger* which was placed in a high-fire gas kiln. On the outer walls of the piece, the sawdust had left swirls of grayish tones, as smoke and air were left etched upon the surface. Within the jar's chamber, the slip of paper was consumed in flame and left as a trace of ash. I like to think that this small symbolical gesture seemed to release a wish not so differently from the sherds of our exploding Venuses. After firing, I added an element to the lid – a twenty-thousand-year-old camel's tooth. This small offering was cradled within the concave surface of the nest-like lid. Given away, it serves as a remembrance of an important moment – one which continues to live on through this small charred pot.

13. The Culminating Fire

In the last vignette, part of the concept involved the rituals that were included in the firing. Working with fire in this way was a kind of alchemy, whose archetypal power contributed a sense of transformation and culmination to the process. However, most of this text deals with the use of an electric kiln, which is a firing method that, although safe and clean, is rather sterile. The static atmosphere in an electric kiln, with its automatic shut-off devices and canned fire, simply does not lend much creativity or drama to the process. Electric kilns are basically overgrown toaster ovens with wire heating elements which bake the clay to maturity without the benefit of a real fire. There is no flame, smoke, gases, smell or other sensory by-products. While those art therapists who work in sterile hospital settings might not have the luxury of choice, they may still yearn for a more primal firing experience.

The fire as metaphysics

The metaphysical, transformative aspects of the more ancient forms of kiln-firing are beautifully explored in Nathaniel Hawthorne's short story *Ethan Brand* (1937, 1965). The story's namesake is a mysterious figure who works firing a lime kiln in eighteenth-century New England. The process entailed melting chunks of marble down to the pure white lime used in the cement and fertilizer of the time. Years of staring into the yellow-hot chamber of flames have left Brand mysterious and remote. One night he inexplicably abandons his fire and disappears, stating only that he will embark upon a spiritual quest for the "unpardonable sin." Decades

later he reappears at his kiln – a ghostly visage who terrifies the new kiln-sitter, who promptly runs off to the village to collect the townsfolk. He bids them to come hear of Ethan Brand's journey and to learn which sin was utterly "unpardonable." Brand then describes his mystical search – one that was based upon years of meditating on the nature of humankind and the transformation from mind to spirit. Brand came to realize the futility of feeding the soul through the intellect alone. Brand's search led him to ponder the "fiendish" split between heart and mind: from the moment his moral nature fails to keep pace with the intellect, Brand's soul "ceased to take part of the universal throb" (p.1194). With the realization that he squandered his knowledge by allowing his heart to perish, Brand sought purification and redemption by becoming "one" with the fire.

It is no coincidence that the metaphor at work in *Ethan Brand* is as timely today as it was in Puritan New England. The transcendentalists foresaw our culture's inexorable, yet misguided march toward technology, in which information is somehow equated with wisdom. Like Thoreau, Emerson admonished those who mindlessly embraced every new technology without equally questioning our moral capacity to wield this power humanely, with insight and empathy.

Like Hawthorne's Ethan Brand, potters have long romanticized about their kiln-fires as metaphors for their own brooding existential experience. Throughout my own formative years as a young potter, firing the self-made catenary-arch gas-fueled kiln was often a "fire by ordeal." Like an old embattled married couple, firing meant accommodating the kiln's idiosyncrasies – at times cranky, compliant, mean-spirited, benevolent, forgiving, inspiring. Through all hours of the night, my partners, Michael Jennings and Tim Ryan, cajoled, pleaded, and cursed this hulk of brick to reach its appointed temperature without incident. Small gargoyles called "kiln-gods" were mounted above the crown of the arch to watch over the flames late into the night (Figure 43).

Figure 43: A kiln-god stuck to the crown of the kiln arch offers up a talisman for a good fire. Such light-hearted rituals add a bit of fun and magic to being a potter and a kiln-firer.

Despite these tributes the fire seemed to do as it pleased. One kiln-log of the time revealed the usual notations over the burner settings, atmospheric pressure, and fuel consumption, along with minor alarms over melting wires, and electrical black-outs. What was not stated in this log were my anxieties over the expected, dreaded temperature stall. During almost every fire, upon reaching 2,000 degrees Fahrenheit, the temperature would fail to advance. Reading this one log, I notice that technical notes soon gave way to increasingly "loose" associations. One entry read: "... reprimanding the air intakes, dirty fire belching from burner-port, fire is groaning, seems tired." As I made the necessary adjustments to advance the faltering temperature, more alarming, stream of consciousness rantings poured forth, seemingly fed by the contentious fire. I prodded the flames to advance beyond their gaseous orange color, pleading for a hundred degrees. Then I bargained for another hundred. Dozing off, I dreamed of a blinding white, pyrotechnic climax. As the fire inched toward temperature, I recall becoming inflamed myself – as the

sleep-deprived hours of searing heat seemed to conjure visions of deeply held memories. Feverish images flooded my senses: did I really see the flame-blackened kiln-god blink and yawn? At 2,200 degrees Fahrenheit the cones finally began to slump, their bodies at first bending, then in a flash they seemed fused into one. Staring through the hazy gases, I could just make out their languid silhouettes, as though caught in a post-coital embrace. Hours later, after the last cone finally fell (probably not from the fire as much as sheer exhaustion), I curled up to sleep next to the burners, my body shivering in the cold early dawn. I imagined Winnicott, that kindly old baby doctor, gently patting my head, whispering assurances that all was well. With my energies spent, I drifted off into the "space in between," feeling alone yet fully quenched by this radiance of fire, once fuming and boiling, now come to rest, its chamber darkening with the coming dawn.

Back to the fire-pit

Creative encounters with fire are not limited to adult ceramicists. In a slim volume titled: "Beginning at the Beginning of Clay," Seonid Robertson led a group of English schoolchildren on an excursion to mine clay in the red sandstone cliffs of Devon (1965). As part of her lesson on self-reliance and resourcefulness, Robertson sent her students off to prepare their materials for pottery-making, including a shallow pit to fire their wares using peat as a solid fuel. Using spades to dig the peat and shovels to excavate the pit, the children soon created a kiln almost identical to the first kilns of prehistory. The children's rudimentary yet effective kiln comprised a shallow hole into which raw pots made directly from the local clays were stacked, surrounded and covered by peat – a common fossil fuel in parts of Britain. After covering the air-dried ware with the peat, the turf grass was then placed back upon the pile of pottery to seal the pit. Using the dried grasses as kindling, the fuel was lit and the fire commenced. The slow-burning peat was ideal for advancing a mellow slow-burn which would both insulate the fragile green-ware from thermal shock, while burning hot enough to vitrify the ware. After 24–48 hours, the kiln would reach seven to nine hundred degrees Fahrenheit – more than enough to create a hardened decorative or ritual pot.

Photographs from this 1950s field-trip show Robertson's proper yet game English students swinging picks and digging the clay in shorts, knee-socks and ankle-length dresses. Yet these children were engaged, as they became intimate with the forces which brought about both geologic and creative transformation.

Sixty years later I am taking a group of deaf elementary school children on a similar jaunt into a grassy field where custodians years before had burned garbage when incineration was still an appropriate means of disposal. Our fire-box was a fifty-gallon drum cut to a height of thirty inches. On the sides were holes which allowed air to be entrained into the fire, making combustion of the solid fuels more efficient with less smoke and thus less noxious fumes. Pots were placed around in a pile not unlike the ware stacked by the Cro-Magnon potters of the Paleolithic, and Robertson's schoolchildren. The ware was covered with sawdust retrieved from the wood shop, which was made up of hard and soft woods, some of which had nails and other debris contained in the mix. Into the mix were thrown some chicken bones, horse hair, coarse straw, an old leather shoe, and a box of baking soda. Around the ware, students stacked pieces of broken pottery and other sherds which provided a refractory cover that shielded the work from the cold air above and hot flames within. Camping nearby, I tended the smokey fire for the next twenty-four hours. It seemed that the windy conditions were heating up the kiln well beyond the temperatures that a smoldering pit-fire could attain on its own without the additional forced air. It reached a glowing red and then dull orange color, at which time the fuel had been exhausted. Another day of cooling and the children were gathered around to uncover their work in an atmosphere that was not unlike Christmas morning. Despite the low-tech firing, some of the surviving works that emerged were jewel-like in appearance. The addition of organic matter such as the straw and bones created small flashes of orange and black, which contrasted with the subtle gray clay body. Metals from the nail heads and copper scraps created deep liver-rust-colored markings, while the fine, densely-packed oak sawdust from the school's floor sanders was pitch black in contrast with the lighter flash-marks. "Happy accidents" abounded as the children marveled at the spontaneous designs left by the straw and old shoelaces which criss-crossed some of

the pots. During the day part of the fire I had the children write kiln-logs which recorded a stream of thoughts and reflections in free-form verse (which also kept them busy and engaged). One deaf child, whose ADHD often left him acting impulsively, admitted his own "unpardonable sin" of coopting a left-over pot belonging to someone else. He confessed that he was reluctant to part with his best pieces to experiment with such an uncontrollable, primitive process. Amazed that he wrote such an admission without prompting, he later confided his guilt over finding to his horror, that his "best" piece of that fire was the one that had been "borrowed" for the occasion – and now he would "probably have to give it up." (Actually that piece was abandoned from the previous semester and no longer belonged to anyone – hence, with consideration over his honesty, he kept the piece.) This occurrence was as instructive as a Zen koan, in that many pieces that are fussed over often do very little in the fire, while those that are forgotten about inevitably seem to be the "jewels."

Other writings were just as confessional. Another eleven-year-old child, whose written English was weak, amazingly wrote at length in his journal (remember that for most deaf children, their native language is American Sign (ASL) which has a syntax all its own – hence, writing English is like learning a "second" language). This otherwise quiet child described a long-repressed wish to light fires and see things burn (and seemed to hint he had set fire once before). He wrote: "Grandpa true lit back-yard fire. It burned and burned. I true light the fire if he let me." This ASL inflected writing demonstrates the lack of concern over conjugating verbs. The word "true" is routinely substituted for more articulated verbs. Tense would ordinarily be conveyed by virtue of where the signer placed his or her hands in relation to the body. To convey past tense the hands would be behind to the side of the shoulder. It was interesting that journal writing prompted a relaxation of defenses in which issue-laden material, rarely dealt with in therapy, began to surface.

An interesting, creative, deaf thirteen-year-old girl, whose history included being sexually precocious among her middle-school peers, wrote a telling comment in her journal. She wrote in perfect English that in tending the fire: "…the glowing orange pots inside seemed soft and creamy to lick." For these children, working in the field with the elements

of fire, wind, clay, and earth was inherently educational and therapeutic. Writing reflective journal essays which attempted to describe their experiences and immediate sensations created a sense of resonance after the field-work had been completed. Motivation, self-investment, physical exertion, and social collaboration were all objectives that were achieved by the majority of children involved in this project.

However, like any other intervention, primitive firing is subject to assessment. The liability of working with such primal elements demands highly structured, closely monitored supervision throughout the process. Exposure to smoke and fumes should be minimized, while open flames (if there are any) should be kept completely contained by the pit, staying well below grade level. Water must always be nearby, and combustibles such as dry grass or wood cannot be anywhere near the firing container. In the firing just described high winds hastened the fire and created highly volatile conditions. Extra supervision and other steps were taken to minimize risk and keep the experience within the appropriate boundaries of a residential school experience.

Raku and Haiku

Another alternative firing method, that of Raku, is more appropriate to those in upper secondary school grades or university, since open flames and higher temperatures are part of the process. Raku has already been introduced as a quasi-spiritual ceremony. The aesthetic is one that prizes simplicity, spontaneity, bold action, introspection and intensity of sensory awareness to the elements of nature. In this process, tea-bowls and other bisqued pots are created with coarse clays that can withstand thermal shock. Once glazed and decorated (usually by Zen-inspired brushwork or calligraphy) these pots are pre-heated to be readied for firing. Once they are hot to the touch they are grasped by metal tongs and are placed in a small kiln which is already heated to at least a thousand degrees Fahrenheit. Carefully, the kiln doors are opened and the ware carefully placed in the orange-hot chamber of flames. The preheated kiln makes Raku a quick fire – after twenty minutes or so, the glaze begins to melt. Once the glaze matures, the pots are again snatched from the kiln (using heat resistant gloves, heat shield and other safety wear) and are

placed in a can of combustible material such as straw or sawdust. Flames immediately erupt from the contact between the red-hot molten pot and the dry kindling, necessitating that a lid be placed over the can to snuff the flame and smoke the pottery within. Once smoked, the still red-hot ware is taken out and air-cooled, or, for the adventurous, the pieces can be plunged into cool water. This violent contact between 1,000 degree pot and cool water creates a dramatic thudding explosion and a plume of steam. After cooling, the piece is removed and cleaned of the organic material using cleanser. Reduction smoking renders the glaze almost unrecognizable. Blue glazes may come out a liver red. Whites may be opalescent purple, then fade to a heavily crackled silvery white. Iron glazes may be flaming yellow to burnt red to deep sea green – despite it being identical glaze with identical application.

The intensity of the Raku firing can be exhilarating for those clients who need strong stimulation with even a sense of danger being part of the concept. For instance, middle and high school boys often need expe-riences in which there is some personal risk, through which they can prove themselves. During my work at a residential school for the deaf, a number of boys who were otherwise disturbed and untrustworthy rose to the occasion during Raku firings. Some students were athletes who had never set foot in the studio before the kilns starting spitting fire (Henley 1987). Many of these wayward young men became entirely competent and dependable when handling the kilns and pots of others (particularly if the work belonged to the girls in the class). These young men exhibited significantly less interest in the claywork or art process than the firing. Because Raku involves building with masonry materials, setting up plumbing, wearing safety shields and gloves, these elements suggest a strong masculine image: a "blue collar" sensibility. The enactment itself requires exposing oneself to tremendous heat while finessing pots into flaming drums, each of which requires coordination, strength and resolve. Clements and Clements (1984) refer to such projects as possess-ing a quality of "resistance" – not in the clinical "defensive" sense, but meaning that such materials and processes offer the individual physical obstacles and healthy hardship. The technique requires one to overcome 2,000 degree temperatures, clumsy gloves, molten pots and flaming barrels. Any one of these impressive operations can be viewed as a form of

"display behavior." In observing the students, many of whom seemed miscast for an art enactment, these deaf auto mechanics and soccer goalies seemed to revel in wrestling their pots from the kiln inferno. In this there was certainly a sense of libidinous and aggressive release of energy that had been partly neutralized by the ritualization of the process. These displays were clearly meant to pose a self-challenge, as well as to impress other "lesser" males and desirable females with the displayer's power and desirability (Eibl-Eibesfeldt 1989). As I stated earlier, in contemporary culture there seem to be fewer opportunities to "prove" one's manhood beyond athletics, certain manual labor or social clubs. As to the latter, such club-type organizations may lapse into potentially destructive forms of socialized aggression such as in gangs, or fraternity hazing. Working with the controlled fires within kilns, then, may assuage this need to "risk everything." Like many aspects of the ceramics process, Raku fire seemed an ideal conduit for such drive discharge – all through artful, robust, socially constructive means that fully approach sublimation (Henley, cited in B. Moon 1998). Building fires satisfies a need that is universal and archetypal in proportions. For eons, men and women have built fires to ensure the survival of themselves and their loved ones. Culture itself was born when fire was brought under control. Memory traces of these crucial evolutionary imperatives remain active, deep within our collective psyche.

The Raku fire does not only lend itself to a machismo display of brutish force. It can also be appreciated for its refinement and delicate sense of ritual that promotes introspection and spiritual transcendence. When the vessel's calligraphic designs or poetic verses come together to meld into the fire, metaphors abound. In one project, Professor Frank Goryl instituted a group tile project at Seton Hill College in Pennsylvania, that was entitled "The Woman's Journey." In this project, a group of undergraduate women explored themes of transformation from "girl to woman." Each individually designed tile was then mounted en masse as a frieze. In one of the tiles, a sacred circle swirls in subtle nuance, its gentle currents of cream and umber glaze floating within the mandala's iron-blue borders. Regarding this process, one student's journal entry read: "It is a tapestry of our kindred female spirits blending together as a

driving force. The piece to me, the finished installation, I call a poem without words."

The possibility of shared illumination became apparent during another memorable Raku project in which a group of troubled teens, college students and parents came together to fire at the end of a summer workshop. Haiku poems written on the spur of the moment were read into the flames and smoke, as each piece was pulled from the fire – poetic words and orange glow blazing against the darkened lake-shore. We could plainly see that the metallic brushwork on one of the participant's "beggar's bowl" was still molten as it sliced through the night into its bed of smoke. In a voice made small by the dark of the night, this young woman recited her haiku written to capture the magic in the moment:

> within the smoky cloud
> a bowl of light shines silver
> or is it the moon

Glossary

Additive methods: Sculptural techniques which involve adding elements to one another.

Bat: A wooden or plaster circular form which is attached to the wheel-head of the potter's wheel. Bats allow the potter to remove the pot without distorting it in the process.

Bisque or bisque ware: Clay which has been fired from the raw state, usually in electric kilns.

Bone dry: A phase of the drying process in which the clay has no absorbed moisture other than natural humidity.

Burnish: Polishing the raw clay surface with a smooth stone or metal (silver) spoon.

Clay: A compound of decomposed rock containing silica, alumina and traces of organic matter which becomes a plastic modeling compound when hydrated.

Clay body: A mixture of different clays, grog and colorants formulated in accordance to their function.

Coil: A snake- or rope-like form created by rolling clay with the palm and fingers.

Cone: A small triangular pyramid made of ceramic materials that are used in kilns to detect firing temperatures. They are formulated to bend at an exact temperature.

Damp room: A place with high humidity used for storing clayworks in progress.

Earthenware: Clay that remains somewhat porous, since it matures at a low firing temperature.

Edible clay: Clays formulated with dough, salt, corn starch and food coloring that may be cooked or mixed cold.

Electric kiln: A furnace comprised of stacked insulation bricks contained within a metal jacket that is fired in an oxidizing atmosphere using electricity as fuel.

Engobe: Liquefied clay with added oxide colorants which may be brushed onto raw clay as decoration.

Extruding: The process of forcing clay through different dyes which yield different shapes used for sculptural hand building.

Faceting: The technique of cutting flat planes onto round ceramic forms.

Fat clay: Clay that is highly plastic and malleable.

Fettling knife: A slender knife used to carve or trim excess clay.

Firing: The process of heating clay to sufficient temperature, which transforms it from a raw material into a hardened state.

Flux: A glaze ingredient which increases the melting of a glaze.

Foot: The bottom or base of a ceramic object.

Glaze: A compound composed of milled silica, alumina and oxides which melts and fuses to the clay object when fired to temperature.

Glaze fire: The second and final firing in which bisque ware is fired sufficiently to melt the glaze.

Greenware: Clay objects which remain in their unfired state.

Grog: A sand-like material composed of fired and milled clay particles which is added to clay bodies to add strength and "tooth."

Kiln wash: A mixture of kaolin and flint which is coated onto kiln shelves to prevent glaze from adhering to the shelf.

Leather hard: A phase of drying in which the clay is so firm that it can no longer be bent or moved, but only cut apart, trimmed, carved or glued together using slip.

Lip: The rim of a pot.

Marvering: A technique in which a solid coil of clay is penetrated by succeeding sizes of dowels and then rolled on its side, thus hollowing out a form with necessitating a seam.

Open clay-body: A clay-body which is porous and less dense than other clays because of fillers such as grog.

Over-glaze: Glaze or oxide decorations applied onto the surface of another glaze.

Oxidation fire: A fire in which the kiln has enough oxygen for a clean burn, resulting in bright, commercial-like coloration of the ware.

Oxide: A compound containing oxygen and metallic elements which impart color in a glaze.

Pinching: A hand-forming process using the thumb and fingers to hollow out a solid ball of clay.

Plasticity: Clay that is malleable and maintains its shape without cracking or fatiguing.

Porcelain: A white, dense, non-plastic clay body that matures at a high temperature.

Porosity: The capacity of a clay body to absorb moisture.

Press mold: A mold made of plaster in which clay elements are forced into and then assume the shape of the mold's interior.

Pug mill: A machine used to recycle and mix clay.

Pyrometer: A thermometer used to discern temperature in kilns.

Raku: A firing technique developed in feudal Japan in which glazed ware is fired in a pre-heated kiln to low temperatures and then removed from the kiln when the glaze has melted. It is often reduced in a smoky atmosphere using combustible materials which create lusters and various other glaze effects.

Reduction fire: High-firing ware in a smoky atmosphere deprived of oxygen which alters and varies the coloring affects of the glaze.

Refractory: Ceramic materials which do not readily melt.

Sagger: A container made from refractory material that protects ware from open flame. It may be filled with combustible material such as sawdust to impart blackening effects on the clay body.

Sgraffitto: A decorative technique in which slip is applied then incised or cut into to reveal the underlying contrasting clay body.

Shards: Broken fragments of already fired ceramic objects.

Short: Clay which is poorly aged, non-plastic and does not hold its shape when worked.

Slab: Clay which has been flattened by rolling pin or commercial slab rolling machine.

Sling or slump mold: A mold usually made of canvas into which a slab is draped and thus shaped by the angle of the material.

Slip: A mixture of clay and water blended to the consistency of pudding and used to adhere leather-hard elements together as a kind of glue.

Slip and score: A method of gluing together leather-hard clay elements. The surfaces of each clay element are deeply scratched and then loaded with slip before being welded together.

Soap brick: A brick or "stilt" used to support kiln shelves.

Stain: A watery treatment of oxides or pigments used as decorative surface treatment applied to either raw or bisqued clay.

Stoneware: A high-fire clay body most often used for functional ceramics.

Throwing: The process of forming ceramic objects using the potter's wheel.

Tooth: Clay which contains sufficient grog to strengthen and roughen the body.

Trimming: The process of carving away excess clay from the ceramic object, usually during the leather-hard phase of drying.

Under-glaze: Oxides or pigments used in decorating bisque, which then shows through the finished translucent or transparent glaze.

Wax resist: Wax emulsion or melted paraffin which is used to resist glaze, thus ensuring a clean foot prior to firing as a decoration. Areas touched by wax will repel glaze thus creating decorative effects.

Wedging: The process of kneading a mound of clay in a rhythmic motion so as to remove most of the air pockets which may compromise the forming and firing ceramic processes.

Wheel-head: The flat circular part of the potter's wheel which accepts the clay for throwing.

Bibliography

Allen, P. (1992) "Artist-in-residence: An alternative to 'clinification' for art therapists." *Art Therapy: Journal of the American Art Therapy Association 9*, 22–29.

American Psychiatric Association (1994) *Diagnostic and Statistical Manual of Mental Disorders, 4th Ed.* Washington, DC: American Psychiatric Association.

Beittel, K. (1989) *Zen and the Art of Pottery*. New York: Weatherhill Inc.

Bender, L. and Woltman, A.C. (1937) "The use of plastic material as a psychiatric approach to emotional problems in children." *American Journal of Orthopsychiatry 7*, 283–300.

Berensohn, P. (1972) *Finding One's Way with Clay*. New York: Simon and Schuster.

Bettelheim, B. (1967) *The Empty Fortress*. New York: The Free Press.

Bowlby, J. (1980) *Loss. Vol. III*. New York: Basic Books.

Bowlby, J. (1969) *Attachment. Vol. I*. New York: Basic Books.

Brown, E.V. (1984) "Developmental characteristics of clay figures made by children: 1970–1981." *Studies in Art Education 26*, 1, 56–60.

Brown, E.V. (1975) "Developmental characteristics of clay figures made by children from age three to eleven." *Studies in Art Education 16*, 3, 45–53.

Brown, J.J. (1975) "Therapeutic developments in clay and imagery with a regressed schizophrenic." *Art Psychotherapy 2*, 1–14.

Cardinal, R. (1988) "Within us traces." *Art Brut: Madness and Marginalia 27*, 46–51.

Clements, C. and Clements, R. (1984) *Art and Mainstreaming: Art instruction for exceptional children in regular school classes*. Springfield, Il: Charles Thomas, Inc.

Councill, T. (2001) "Lombardi Cancer Center annual patient art exhibit." *Art Therapy: The Journal of the American Art Therapy Association 17*, 4, 299–300.

Councill, T. (1993) "Art therapy with pediatric cancer patients: Helping normal children cope with abnormal circumstances." *Art Therapy: The Journal of the American Art Therapy Association 10*, 2, 78–87.

Dissanayake, E. (1999) "Hands and minds." Lecture delivered at the Royal College of Art, November 29, 1999.

Dissanayake, E. (1992) *Homoaestheticus.* New York: The Free Press.

Eibl-Eibesfeldt, I. (1989) *Human Ethology.* New York: Aldine de Gruyter Inc.

Fraiberg, S. (1977) *Insights from the Blind.* New York: Basic Books.

Freud, S. and Burlingham, D. (1943) *War and Children.* New York: International Universities Press.

Fujioka, R. (1973) *The Arts of Japan: Tea ceremony utensils.* New York; Tokyo: Weatherhill/Shibundo.

Gimbutas, M. (1991) *The Language of the Goddess.* San Fransisco, CA: Harper.

Gleick, J. (1987) "Quiet clay revealed as vibrant and primal." *The New York Times. pp.C1.*

Goldsworthy, A. (1990) *Andy Goldsworthy: A collaboration of nature.* New York: Harry Abrams.

Goryl, F. (2000) "A study of clayworks by art therapists in the American Art Therapy Association." Unpublished Doctoral Dissertation, Rutgers University, New Brunswick, NJ.

Goryl, F. (1995) "Research findings: Art therapists' preferences utilizing artistic media." *Proceedings of the American Art Therapy Association 27th Annual Conference,* San Diego, CA.

Grebanier, J. (1975) *Chinese Stoneware Glazes.* New York: Watson-Gupthill Publications.

Hawthorne, N. (1937, 1965) *The Complete Novels and Selected Tales of Nathaniel Hawthorne.* New York: Modern Library.

Hayashiya, T., Nakamura, M. and Hayashiya, S. (1974) *Japanese Arts and the Tea Ceremony.* New York: Weatherhill.

Henley, D. (2001) "Annihilation anxiety and fantasy in the art of children with Asperger's Syndrome and others on the autistic spectrum." *American Journal of Art Therapy 39,* 4,

Henley, D. (2000) "Blessings in disguise: Idiomatic expression as a stimulus in group art therapy with children." *Art Therapy: Journal of the American Art Therapy Association 17,* 4, 270–275.

Henley, D. (1999a) "Reveling in the margins: Towards the art therapist's true self." Video Performance Poem. *Plenary Session, Proceedings from the 30th Annual Conference of the American Art Therapy Association Conference,* Orlando, FL.

Henley, D. (1999b) "Facilitating socialization within a therapeutic camp setting for children with attention deficit hyperactivity disorder utilizing the expressive therapies." *American Journal of Art Therapy 38,* 2, 40–50.

Henley, D. (1998) "Art therapy in a socialization program for children with attention deficit disorder." *American Journal of Art Therapy 37,* 1, 2–13.

Henley, D. (1997a) "Expressive arts therapy as alternative education: Devising a therapeutic curriculum." *Art Therapy: Journal of the American Art Therapy Association 14,* 1, 15–22.

Henley, D. (1997b) "Art of disturbation: Provocation and censorship in art education." *Art Education 50*, 4, 39–45.

Henley, D. (1994) "Art of annihilation: Early onset schizophrenia and related disorders of childhood." *American Journal of Art Therapy 32*, 99–107.

Henley, D. (1992a) *Exceptional Children, Exceptional Art.* Worcester, MA: Davis Publications.

Henley, D. (1992b) "Facilitating artistic expression in captive mammals: Implications for art therapy and art empathicism." *Art Therapy: Journal of the American Art Therapy Association 27*, 4.

Henley, D. (1991a) "Therapeutic and aesthetic applications of video with the developmentally disabled." *The Arts in Psychotherapy 18*, 5, 441–447.

Henley, D. (1991b) "Facilitating the development of object relations through the use of clay in art therapy." *American Journal of Art Therapy 3*, 67–73.

Henley, D. (1989) "Artistic giftedness in the multiply handicapped." In H. Wadeson (ed) *Advances in Art Therapy*, pp.262–272. New York: John Wiley & Sons.

Henley, D. (1987) "Art therapy for the hearing impaired with special needs." *American Journal of Art Therapy 25*, 3, 81–89.

Henley, D. (1986) "Emotional handicaps in low-functioning children: Art education/art therapeutic interventions." *The Arts in Psychotherapy 13*, 35–44.

Henley, D. A. (1993) "Claywork and child life." Unpublished clinical notations.

Hesse, H. (1925, 1965) *Demian.* New York: Harper and Row.

Hisamatsu, S. (1971) *Zen and the Fine Arts.* Tokyo: Kodansho International.

James, B. (1989) *Treating Traumatized Children.* Toronto: O.C. Heath.

Johnson, A. (1985) "Art education/art therapy as applied to multiply handicapped deaf children." Unpublished master's thesis, Lesley College, Cambridge, MA.

Jung, C. (1931) *The Secret of the Golden Flower: A Chinese book of life.* New York: Harcourt, Brace & Jovanovich.

Kellogg, R. (1969) *Analyzing Children's Art.* Palo Alto, CA: Mayfield Publishing Company.

Kohl, M.F. (1989) *Mudworks: Creative clay, dough, and modeling experiences.* Bellingham, WA: Bright Ring Publishing.

Kountourakis, J. (2001) "Channeling aggression through art." *Northport Journal 127*, 37, 1–6.

Kramer, E. (2001) *Art as Therapy.* London: Jessica Kingsley Publishers.

Kramer, E. (1986) "The art therapist's third hand." *American Journal of Art Therapy 24*, 71–86.

Kramer, E. (1973) *Childhood and Art Therapy.* New York: Schocken Books.

Kramer, E. (1977) "Art therapy and play." *American Journal of Art Therapy 17*, 1, 3–11.

Kramer, E. (1971) *Art as Therapy with Children.* New York: Schocken Books.

Kramer, E., Williams, K., Henley, D. and Gerity, L. (1997) "Art, art therapy, and the seductive environment." *American Journal of Art Therapy 35*, 4, 106–117.

Kris, E. (1952) *Psychoanalytic Explorations in Art.* New York: International Universities Press; 1964, New York: Schocken Books.

Kuspit, D. (1988) "Stephan De Staebler's Archaic Figures." *Ceramics Monthly*, September.

Laing, R.D. (1969) *Self and Others.* New York: Pantheon Books.

Langland, T. (1988) *Practical Sculpture.* Englewood Cliffs, NJ: Prentice Hall.

Leach, B. (1940, 1951) *A Potter's Book.* London: Faber and Faber.

Lisenco, Y. (1971) *Art Not by Eye.* New York: American Federation for the Blind.

Lowell, S., Hills, J., Rodriguez, J.Q., Parks, W., Wisner, M., Humphreys, W.R. and Stancliff, R. (1999) *The Many Faces of the Mata Ortiz.* Tucson, AZ: Rio Nuevo Publishers.

Lowenfeld, V. (1957) *Creative and Mental Growth*, 3rd edn. New York: Macmillan.

Luccesi, B. and Malmstrom, M. (1980) *Modeling the Figure.* New York: Watson-Guptill.

MacGregor, J. M. (1989) *The Discovery of the Art of the Insane.* Princeton, NJ: Princeton University Press.

Macks, R. (1990) "Clay as a medium for anorexic and bulimic patients." *Pratt Creative Arts Review 11*, 22–29.

Maclagan, D. (1977) *Creation Myths: Man's introduction to the world.* London: Thames and Hudson.

Mahler, M., Pine, F. and Bergmann, A. (1975) *The Psychological Birth of the Human Infant.* New York: Basic Books.

McNeilly, G. (1983) "Directive and non-directive approaches in art therapy." *The Arts in Psychotherapy 10*, 4, 211–219.

Meltzoff, A. and Moore, M. (1977) "Imitation of facial expression and manual gestures by human neonates." *Science, Vol. 198*, 75–78.

Moon, B. (1998) *The Dynamics of Art as Therapy with Adolescents.* Springfield, IL: Charles Thomas Inc.

Naumburg, M. (1966, 1987) *Dynamically Oriented Art Therapy: Its principles and practice.* Chicago: Magnolia Street Publishers.

Nelson, G.C. and Burkett, R. (2002) *Ceramics: A potter's handbook* (6th edition). Stamford, CT: Wadsworth, Thomson Learning Inc.

Nigrosh, L. (1980) *Low Fire: Other ways to work with clay.* Worcester, MA: Davis Publications.

Peterson, S. (1977) *The Living Tradition of Maria Martinez.* Tokyo: Kodansha International.

Peterson, S. (1974) *Soji Hamada: A potter's way and work.* Tokyo: Kodansha International.

Promey, S. (1993) *Spiritual Spectacles: Vision and image in mid-nineteenth century Shakerism.* Bloomington, IN: Indiana University Press.

Pruznick, J. (2001) Personal communication.

Qualley, C. (1986) *Safety in the Artroom.* Worcester, MA: Davis Publications.

Reif, R. (2001) "Was he crazy? If so it was like a genius." *The New York Times,* Arts and Leisures, July 8 2001, p.33.

Rhodes, D. (1973, 2000) *Clay and Glazes for the Potter,* 3rd Ed. Iola, WI: Krause Publications.

Richards, M.C. (1962, 1989) *Centering: In pottery, poetry and the person.* Hanover, NH: Wesleyan University Press.

Robertson, S. M. (1963, 1982) *Rosegarden and Labyrinth.* Dallas, Texas: Spring Publications.

Robertson, S. M. (1965) *Beginning at the Beginning with Clay.* London: Society for Education Through Art.

Rubin, J. (1978, 1984) *Child Art Therapy.* New York: Van Nostrand Reinhold.

Ryan, T. (2001) "Art-in-residence: Very Special Arts Indiana." Unpublished report.

Schlossberg, I. (1983) "The ego organizing qualities of various media in an acute psychiatric population." *Pratt Creative Arts Review 4,* 22–28.

Simpson, P., Kitto, L. and Sodeoka, K. (1979, 1986) *The Japanese Pottery Handbook.* Tokyo: Kodansha International.

Soffer, O. and Vandiver, P. (1993) "Case of the exploding figurines." *Archaeology 46,* 1, 36–40.

Spitz, R. (1965) *The First Year of Life.* New York: International Universities Press.

Sutterlin, C. (1989) "Universals of apotropaic symbolism." *Leonardo 22,* 1, 65–74.

Suzuki, D.T. (1948) *The Zen Doctrine of No Mind.* New York: Samuel Weiser, Inc.

Tanaka, S. (1973) *The Tea Ceremony.* Tokyo: Kodansha International.

Thompson, S. (1999) *The Polymer Source Book.* London: Hamlyn Books.

Tinbergen, N. and Tinbergen, E.A. (1983) *Autistic Children: New hope for a cure.* London: Allen & Unwin.

Townsend, R. (1992) *The Ancient Americas: Art from sacred landscapes.* Chicago: The Art Institute of Chicago.

Trimble, S. (1987) *Talking with the Clay.* Santa Fe, NM: School of American Research Press.

Valenstein, S. G. (1975) *A Handbook of Chinese Ceramics.* New York: The Metropolitan Museum of Art.

Waller, D. (1996) *Group Interactive Art Therapy: Its use in training and treatment.* London: Routledge.

Winner, E. (1981) *Invented Worlds.* Cambridge, MA: Harvard University Press.

Winnicott, D. (1965) *The Maturational Processes and the Facilitating Environment.* New York: International Universities Press.

Subject Index

Author Index

Allen, P. 153
American Psychological Association 101
Arneson, R. 115

Bailey, C. 115
Beittel, K. 85, 167
Bender, L. 111
Berensohn, P. 56, 59, 60
Bergmann, A. 28, 35, 36, 93, 99, 157
Bettelheim, B. 174
Bowlby, J. 95, 96, 97, 101, 170
Brand, E. 201–202
Brown, E. V. 89
Burkett, R. 38, 42–43, 161
Burlingham, D. 101

Cage, J. 185
Cardinal, R. 113
Children's Hospital, Chicago 99
Chojiro 162
Clements, C. 208
Clements, R. 208
Corker, M. 78–79, 81
Councill, T. 100, 198
Cunningham, M. 185

Darger, H. 112
DeKooning, W. 164
Dissanayake, E. 12

Eibl-Eibesfeldt, I. 112, 157, 209

Foster, C. 154
Fraiberg, S. 124, 168–169
Freud, A. 101
Fujioka, R. 162

Gimbutas, M. 84
Gleick, J. 22
Glenn, S. 193–195
Goldsworthy, A. 15, 16, 17, 21, 28,
 30–32, 158
Goryl, F. 22, 57, 197, 209–210
Grebanier, J. 61

Hamada, S. 11, 155, 161
Hartshorn, R. 112, 113, 114, 115, 116,
 119, 151

Hawthorne, N. 201–202
Hayashiya, S. 165
Hayashiya, T. 165
Henley, D. A. 99, 100, 136
Henley, D. R. 11, 29, 34, 38, 62, 64, 69,
 74, 86, 96, 112, 120, 128, 132, 133,
 138, 139, 145, 149, 157, 170, 173,
 184, 199, 208
Hesse, H. 60
Hisamatsu, S. 162

James, B. 101
Johnson, A. 174, 176
Johnson, L. 170
Jones, D. 185
Jung, C. 145, 157–158

Kellogg, R. 89
Kenzan. O. 162–163
Kitto, L. 191
Klee, P. 158
Kline, F., 164
Kohl, M. F. 53, 54, 88
Kountourakis, J. 147
Kramer, E. 12–13, 27, 28, 31–32, 55, 56,
 76, 77, 92, 104, 122, 123, 124–126,
 128, 189–190, 192
Kris, E. 29, 76, 103, 110

Laing, R. D. 113
Langland, T. 74
Leach, B. 161
Leaver, T. 143–144
Lincoln Park Zoo, Chicago 87
Lisenco, Y. 126
Long Island University 60, 139
Lowenfeld, V. 28, 30, 78, 90, 115,
 117–119, 190, 192
Luccesi, B. 74

MacGregor, J. M. 112, 164
Maclagen, D. 158
McNeilly, G. 109
Macks, R. 127
Mahler, M. 28, 35, 36, 93, 99, 157
Malmstrom, M. 74
Martinez, M. 161
Mata Ortíz Pottery 161
Meltzoff, A. 157
Miro, J. 158
Moon, B. 209
Moore, M. 157

223